Drawing the Landscape

Second Edition

Chip Sullivan

JOHN WILEY & SONS, INC.

New York • Chichester • Weinheim • Brisbane • Singapore • Toronto

Copyright © 1997 by John Wiley & Sons, Inc. All rights reserved.

Published simultaneously in Canada.

This publication is designed to provide accurate and authoritative information in regard to the subject matter covered. It is sold with the understanding that the publisher is not engaged in rendering professional services. If professional advice or other expert assistance is required, the services of a competent professional person should be sought.

Library of Congress Cataloging-in-Publication Data:

Sullivan, Chip.
 Drawing the landscape, Chip Sullivan.—Second edition
 p. cm.
 Includes bibliographical references and index.
 ISBN 0-471-29204-4
 1. Landscape drawing-Technique. I. Title.
NC795.S86 1997 94-12115
743'.863—dc20

Printed in the United States of America

10 9 8 7 6 5 4

To my grandfather, for giving me pencils;
to my father, for giving me determination;
and to my mother, for her faith in me.

The primary tasks of art are, first, to meet and in some way represent nature; and second, to perfect or idealize through artistic judgment the forms found in nature.

EDWARD HILL
The Language of Drawing

Contents

Introduction

After Michelangelo died, someone found in his studio a piece
of paper on which he had written a note to his apprentice in the handwriting
of his old age, "Draw, Antonio, draw, Antonio, draw and do not waste time."

ANNIE DILLARD
The Writing Life

I love to draw! I love to draw almost more than anything else in the world. It brings me solace, excitement, and the thrill of experimentation. When I am feeling low, drawing can make me happy. With a single piece of paper and a mark-making tool, I can create whole new worlds.

Drawing allows you to design environments capable of transporting the viewer. Learning to draw is a gift that brings a lifetime of creative excitement. Drawing is a form of personal freedom. The space around you becomes your possession. Once you have the ability to draw, it can't be taken away from you, for drawing is the ultimate weapon of visual expression. It is also an inexpensive tool, accessible to everyone. The ultimate goal of this book is to introduce and nurture the creative potential for the novice, student, artist, and accomplished professional. The exercises are intended to allow both experienced and inexperienced artists to progressively gain creativity, skill, and confidence in their drawing.

I have always believed that landscape architectural drawing is an art form. Throughout my career I have struggled to get my landscape drawings seen where other forms of art are exhibited. Since the end of Beaux-Arts training, the quality of landscape architectural drawing has declined. Typical landscape drawings are stilted, formalistic, one-dimensional, stylized, and affected. The drawing program I have presented in this book is personal, intuitive, and expressive. I hope that through this process your own personal vision will flourish.

Anyone can learn to draw. All it takes is patience, persistence, and most of all, practice. If you are a beginner you will be frustrated, but you must draw every day to slowly overcome your frustrations. Most of all, you need a strong desire; as you gain confidence in your ideas and abilities you will eventually produce truly magnificent and satisfying work. The ability to express yourself and to gain an intimate connection to your thoughts and subconscious will be yours with practice, and will increase your ability to design innovative landscapes.

When you draw the landscape, you empathize with it; you become part of nature in a way that technology can't. The act of drawing is essential in understanding how to design environments more sympathetic to natural systems. In order to reverse the current state of environmental degradation we must retain the sanctity of hand-drawing as a foundation for building the future. If we can learn to truly see nature perhaps we can gain insight into how to repair it. Leonardo da Vinci, with his instinctive and fluid sketches that combined thinking and visualization, is an excellent role model. Too much design today exists in a world far from the integrated thought and drawing process of da Vinci. A strong faculty in drawing and visual perception should not be abandoned because of a new infatuation with technology.

Today too much of our built landscape ends up looking like computer simulations because designers have been distracted by seductive computer-aided graphics. We must relearn the lessons of Leonardo, as Hofmann said in his book, *Search for the Real.*

> *When the artist is well equipped with conscious feeling, memory, and balanced sensibilities, he intensifies his concepts by penetrating his subjects and by condensing his experience into a reality of the spirit complete in itself. Thus he creates a new reality in terms of the medium. (1967, 539)*

To succeed you must be motivated and self-directed. When I first started teaching drawing I didn't think it was possible to teach students how to draw well. I was quickly proved wrong, for I found that those students who were strongly motivated and who learned the basics produced wonderful drawings. I was amazed that, by the time they graduated, they had filled sketchbooks with magnificent drawings and produced volumes of travel sketches, creating their own powerful vision of the landscape. This ability gave them access to the vast potential of the visual world. So get started now!

Acknowledgments

I would like to acknowledge Kathryn Drinkhouse for her support and input. I am grateful for the support of the Department of Landscape Architecture, College of Environmental Design, University of California. The support of the Beatrix Ferrand Research Fund was an essential contribution for my research. I would like to express my utmost appreciation to my Research Assistant Elizabeth Boults. I would also like to thank Deborah Gerhard, who wrote the original book proposal. Thanks are also due to several instrumental people: Frank James, Joseph Slusky, Rich Haag, Lisa Micheli, and Marc Treib. And finally to all of my students who loved to draw.

I would like to express my deepest appreciation to my research assistants, Catherine Harris and Annie Amundsen, for their invaluable contributions to this revised edition. I would also like to thank Tony Whall for his enthusiasm and his innovative additions to the revised chapter on perspective.

The Essence of Drawing

Drawing turns the creative mind to expose its workings.
Drawing discloses the heart of visual thought, coalesces spirit
and perception, conjures imagination; drawing is an act
of meditation, an exorcism of disorder; a courting of artistic ideas;
above all it is the lean instrument of visual formation
and the vortex of artistic sensibility.

EDWARD HILL
The Language of Drawing

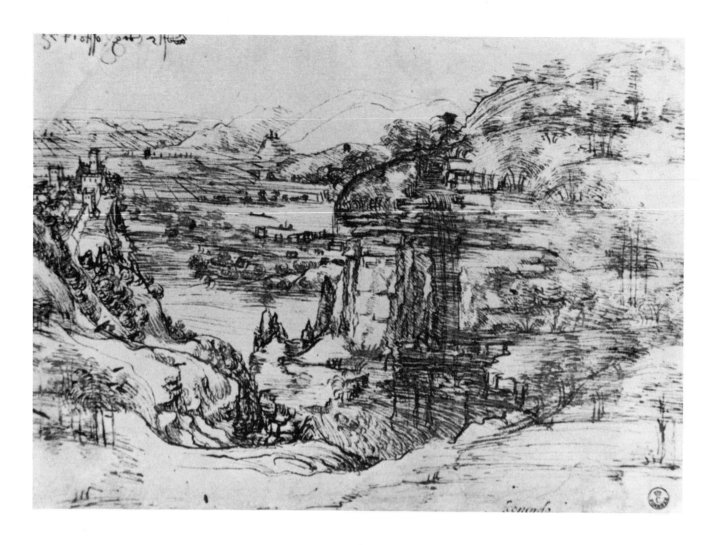

Why do we draw? We draw because it is the act of seeing and thinking clearly. It is an integral part of the creative process, and the ultimate design tool. Carlo Scarpa, an Italian architect, best summed this up when he said, "I draw so I can see." By moving from elevation to perspective, from plan to bird's-eye view, drawing elucidates our three-dimensional world. When I was just starting out, I remember watching my mentor, landscape architect and artist Frank James, pick up a pencil and move it across a sheet of paper; it was like watching an angel fly. Frank's facility for drawing was incredibly inspiring and a thing to behold. His ability to use drawing as an expressive design tool was marvelous.

Drawing allows a concept to evolve. It resides between freedom and structure: the freedom of ideas versus the physical structure that orders our representations of space. It provides the potential to create realistic images.

Drawing can also be a meditation. It can take you into other worlds, creating a transcendent experience. One of the constant themes of Zen art is the expression of the artist's own inner state of going nowhere in a timeless dimension.

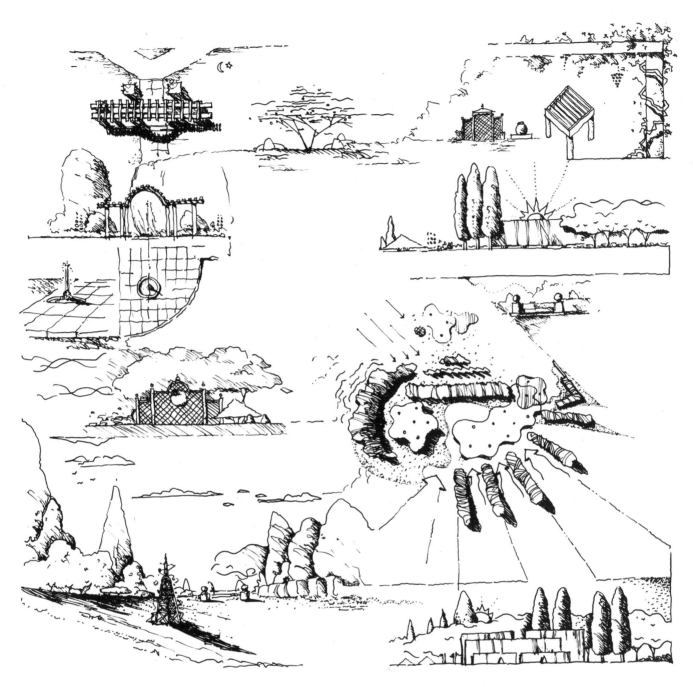

Definition of Drawing

FIGURE 1–2 *Author. Ink on vellum. Drawing allows thinking in three-dimensions.*

Artist and teacher Edward Hill stated that, "Drawing is the act of making a mark, line, or incision on a surface; and in the larger sense, a participation in the language." (1966, 8) A beautifully drawn, pure line arching across a page is a wonder to behold. It can vary from divine simplicity to dynamic movement. Drawing is a tool of exploration, and a single stroke can express thought. The artist or designer imbues line with personality, and thus becomes an inventor. Through drawing, artists are continually redefining themselves and creating a personal image of reality.

FIGURE 1–3 *Frank James, Sasaki Associates. Drawing as expression.*

The beginning of each drawing is the start of an exciting new trip; when you begin, your line takes off on a journey without a map. Learning to draw can be the beginning of a creative journey that can last a lifetime. From the moment of inception to the creation of the image, every drawing has the potential to express an idea. To begin to draw requires initiative; the act of drawing is directed intuition. Charles Burchfield, one of the greatest painters of the American scene, felt that the best drawing was a spontaneous creation. Spontaneity allows an incredible pictorial and emotional range, providing access to imaginative wanderings. If you can capture this spontaneous quality in your drawings, you can make them come alive.

The development of your freehand drawing skills will help you to understand and graphically describe the environment. It is a means of investigating nature, and a tool for designing entirely new ecosystems. As artist and teacher Hans Hofmann said, "The artist is an agent in whose mind nature is transformed into a new creation." (1967, 70)

The beauty of a drawing is that you make it with your own hands; its success or failure rests entirely with you. If you develop a love for drawing, it will be reflected in your work and revealed to others. To achieve

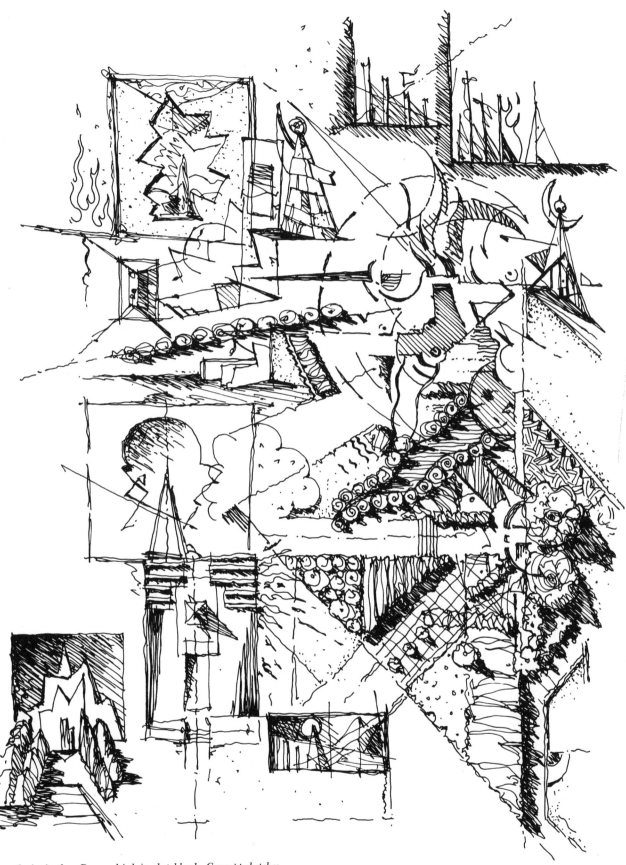

FIGURE 1–4 *Author. Pen and ink in sketchbook. Concept sketches.*

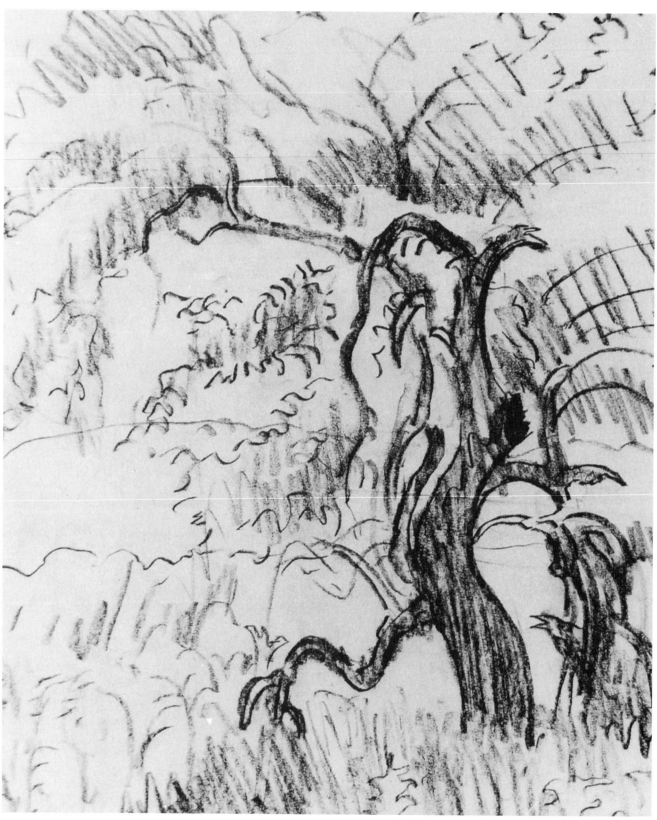

FIGURE 1–5 *Charles Burchfield.* Old Gnarled Tree in a Field. *Pencil on paper. 17"× 22". (Courtesy Kennedy Galleries, Inc., New York City)*

this, try to make each line you draw able to stand alone as a beautiful mark. Before beginning, empty your mind of all other thoughts. Think of yourself as an actor about to go on stage and perform. Slow down, breathe deeply, and think carefully about what you are about to do; it is an emotional response. Grasp the essence of your subject and your drawings will become your greatest teacher. You can learn much from them.

You should work on each of the exercises in this book until you feel comfortable with the results. When you begin to feel pleased with the results of one exercise, go on to the next one. You can also go back and work on several at the same time.

EXERCISE 1–1: *Relaxing*

Find a comfortable chair in a quiet place; stretch out, and close your eyes. Breathe deeply and slowly. With your eyes closed, try to visualize the flow of internal images as if you were watching a movie. Learning to relax will facilitate your ability to draw freely. Eventually, you may find that the drawing itself will become a method of relaxation. Practice this exercise fifteen to thirty minutes a day.

When concentrating, you can become part of the drawing, getting inside it. Concentration is required to avoid getting into a rut, and to push yourself to evolve through experimentation. After developing a successful style, many people just replicate it again and again. Always try to improve your technique; otherwise, you'll just keep repeating your mistakes. When I was in school, I was told that I might have been a good artist once, but I had become lazy and was no longer innovative. That comment lit a fire under me. As Frank James said, when you draw you should always try to "seek the truth, speak the truth, be the truth."

Learning to draw can be a baffling, frustrating experience. It will make you angry; but don't give up. Once you begin to produce satisfying drawings it will be an incredible natural high. Everything you put

FIGURE 1–6 *Author. Double Imperative Landscape. Pen and ink on paper. Composing the landscape with extraordinary arrangements.*

into your drawing will be returned to you. You can learn to draw, but you must first believe that you can. When Frank James was an architecture undergraduate at the University of Washington in 1962, he learned to draw by being inspired by such students as Laurie Olin. According to Frank, "Laurie Olin could draw like Walt Disney on psilocybin on an off-day." Today Laurie is not only an award winning landscape architect but a master landscape artist. Frank forced himself to learn and the results are wonderful. Ultimately, to inspire others to draw you will have to draw convincingly and beautifully. In a sense, you are combining ordinary things into extraordinary arrangements. Stop looking and start *feeling* your environment; strive toward meaning by drawing from within your psyche. Drawing is a bridge between perception and thinking. As Cennino Cennini, fifteenth century artist and author, stated,

> *do not fail, as you go on, to draw something every day, for no matter how little it is, it will be well worthwhile, and will do you a world of good. (Hill 1966, 108)*

EXERCISE 1–2: *Automatic Writing*

The surrealists realized that writing is similar to drawing, in that it is mark-making, and developed this method to link the hand with the stream of consciousness. Begin by finding a comfortable, quiet spot in which to work. Take a pencil and stack of loose paper and set them down in front of you. Clear your mind and relax. Quickly begin to write whatever comes into your mind. Do not worry about spelling or grammar. Let the words and sentences generate themselves. Try to suspend your rational thoughts. Do this for about thirty minutes a day for a week, or until it becomes second nature. You could also expand this exercise into a useful journal.

Drawing as Conceptualizing

All great works of art evolve from a concept. Setting ideas into drawn form breathes life into them, allowing you to dip into the vast space of ideas. From the inception of an idea to its final drawn form, drawing plays an integral part in the creative process. Drawing is a conceptual tool that brings quick form to the flow of ideas.

Sometimes a designer will produce hundreds of conceptual drawings until striking the right form for the idea. These forms develop into thumbnail sketches and then into design development drawings. The final idea will then be rendered as a highly finished illustrative drawing.

Drawing as Seeing

Landscape drawing is not the reproduction of nature. It is an expression of the emotions, sensations, and feelings that the landscape impresses on the artist. It is the creation of atmosphere and space.

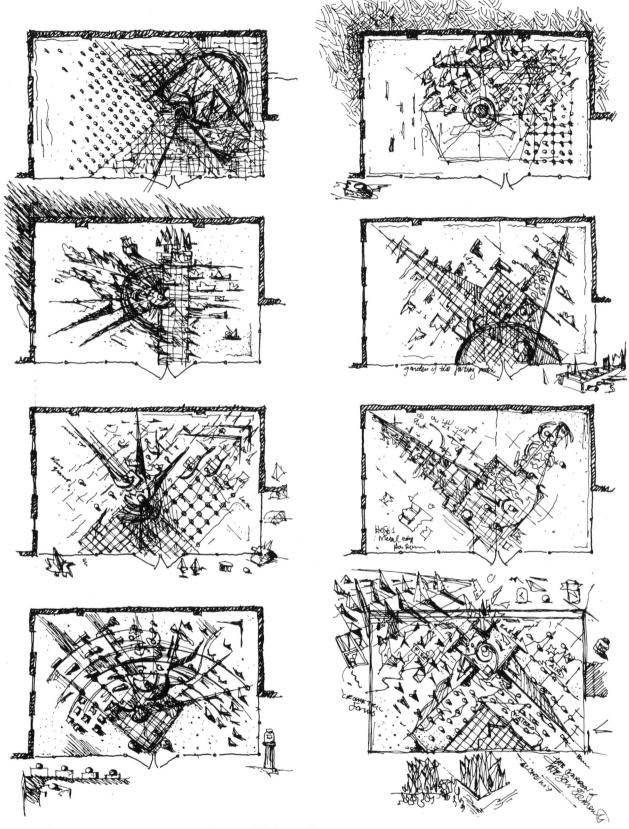

FIGURE 1–7 *Author. Pen and ink on paper. Conceptual design studies.*

FIGURE 1–8 *Author. Pen and ink on paper. Discovering new ways to visualize the landscape.*

Drawing the landscape allows you to visualize it in a new way. As opposed to taking a photograph, drawing the same landscape enables you to really understand it. There is something unique about the hand-eye relationship as you record a subject through drawing. Drawing links your visual perceptions to your subconscious. The photographed image preserves the visual event, but drawing entails the experience of looking: we stop and become part of the subject and its time. Strive toward eliminating the separation between you and the image.

You must be persistent to capture the secrets of landscape drawing. Through the excitement of the moving hand you become part of the mystery of creation. But in order to produce excellent drawings you must have something to say. By dedicating yourself to drawing you will inform your imagination. Increasing your awareness will lead to your own form of expression. By combining imagination, visualization, and drawing, you will invent new landscapes.

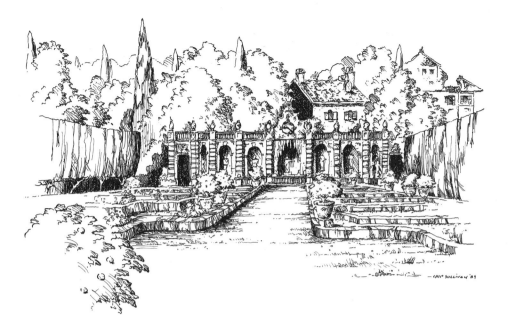

FIGURE 1–9 *Author. Pen and ink on paper. Drawing to enhance the experience of looking.*

It takes passion to attain this level of awareness. Even though Charles Burchfield had a full-time job, he spent every free moment sketching. He would often have to splash water on his face while drawing in order to stay awake. At work he would gulp down his lunch so he could spend the rest of his break drawing. If the ideas were really flowing, he found that after he got into bed he wouldn't be able to sleep, and would have to keep getting out of bed to sketch out his ideas. When the drawings were going well he would find himself overcome with happiness.

EXERCISE 1–3: *Seeing*

Select a flower, a tea kettle, an apple, or another common object, and place it in the center of a table. Next, place a comfortable chair about six feet from the table, facing the object you have selected. Begin by sitting in the chair and trying to relax totally. Then completely focus on the object, ignoring everything else. Observe how the light hits it; use your eye to follow its outline; look at the shape of its shadow and let your eye wander over every single detail. Stare at the object for about thirty minutes, drinking in everything, then repeat this step, moving around the table and viewing the subject and from several vantage points. Move closer to the object and concentrate on its every detail; let it fill your consciousness. Stare at it closely for about fifteen minutes and then repeat this exercise on the opposite side. Finally, move up to the object as close as you can. Take in every detail. Do this for about fifteen minutes. Do this exercise with a variety of objects.

EXERCISE 1–4: *The After Image*

Look at a bright object that is in front of a dark background. Look at it for a few moments, then close your eyes. You may continue to see the original image with your eyes closed. Practice this for about fifteen minutes a day until you are able

FIGURE 1–10 *Louis Sullivan.* Ornamental Study. *1885. Pencil on paper. (From the Louis Sullivan Collection in the Division of Drawings and Archives, Avery Architectural and Fine Arts Library, Columbia University in the City of New York)*

to do it with ease. Charles Burchfield would sometimes look toward the sun and then toward the landscape, and quickly draw the first impression of what he saw.

EXERCISE 1–5: *Finding Your Mind's Eye*

Sit in a comfortable chair in a quiet place. Relax for a few moments, breathing slowly and deeply. Now close your eyes and try to watch the visual images that move across your mind's eye. Seeing is more that just looking, it involves the mind. Do this for about thirty minutes a day until you become proficient and can use it as a warm-up exercise before beginning your drawing sessions.

EXERCISE 1–6: *Making Mental Images*

This form of visualization will help intensify the experience of drawing. Sit in a comfortable chair and relax for a few minutes. Now imagine in your mind's eye that you are in one of your favorite childhood places. Try to see every detail—the floor, the furniture, the pictures on the walls, and each window, and imagine that you are in that place. If your favorite place was a landscape, imagine the plants, the smells, the feeling of the space, and every significant detail. When this is done properly, it should not only conjure up memories, but also emotions. Practice this until you can re-create the space in your mind's eye, then go on and imagine other important spaces from your past.

Freedom and Structure

The realm of drawing is balanced tenuously between freedom and structure. You must first learn the structure and fundamentals, and the ability to control the media, in order to avoid becoming stylized. Build a firm foundation with your hand and do not be seduced by technology.

The key to success is to develop a strong foundation and maintain a balance, then learn when to break all the rules and disrupt that balance. You must discover your natural point of balance between freedom and structure and then challenge it. Explore the struggle between freedom and structure. Do not strive for the perfect center; learn how to control being spontaneous and cautious. Believe in what you draw.

Today it is difficult to get a formal, traditional education in drawing and landscape architecture. Many believe that most schools now teach the "art" of rhetoric rather than the skills of drawing, painting, and sculpting. Picasso, Braque, Matisse, de Kooning, Le Corbusier, Geoffrey Jellicoe, and Garrett Eckbo all had classical educations in the fundamentals of drawing. They could all draw realistically, accurately, and beautifully. Only after they learned the basics could they go on to make the great breakthroughs and unique creative expressions they did.

The architect Louis Henry Sullivan's work illustrates the direct correlation between traditional drawing skills and excellent design. He was trained firmly in the Beaux-Arts tradition. Sullivan's drawings are exceptional works of art. The flowing vibrant lines of his renderings expose his creative genius.

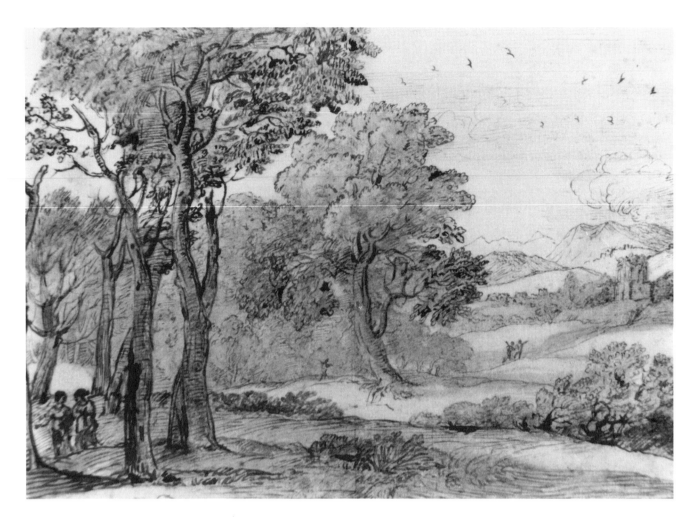

FIGURE 1–11 *Claude Lorrain.*
Wooded Landscape. Pen, brown wash.
176 × 250 mm. (Israel Museum,
Jerusalem)

The inspiration for Sullivan's architecture originated with his love of botany and organic patterns of growth. He studied nature's principles of composition and then abstracted these forms into designs. Frank Lloyd Wright described Sullivan's drawings as "poignantly beautiful rhythms." He would develop his architectural designs from impulsive freehand sketches. There is an almost mystical quality to his drawings; some critics have even described his lines as clairvoyant. To create works of Sullivan's caliber, we must first master the art of drawing.

No matter how fine a school you attend or how nurturing your teacher, all education is self-discipline. You must first take responsibility for teaching yourself to draw.

EXERCISE 1–7: *Looking at Drawings*

Meditate on drawings from books of Louis Sullivan's work. Look closely at the sensitivity of his lines, the variations of line weight, the shadows and the accents. Try to look at his drawings every day for inspiration. Later, search out books by others whose drawings you admire; keep them around you and look at them a little each day for inspiration.

GROUP EXERCISE 1–8: *Describing the Landscape*

This exercise will sharpen your ability to describe the landscape. The drawing group should go outside and sit in a comfortable place that has a view of the landscape. Each person begins by writing a sentence describing the view or an element of the view before them on an 8½-by-11-inch lined sheet of paper. Each person then passes the page to the person on his or her right. The next person adds another sentence describing a portion of the view. Repeat this process until each person's sheet of paper is filled. Everyone then reads the page of descriptions they ended up with. Reading these descriptions will help sharpen your ability to visually describe landscapes. This an important first step in learning how to visualize a landscape through drawing.

GROUP EXERCISE 1–9: *Communication Through Drawing*

In this exercise the group must remain silent for thirty minutes. In a room where the group will not be disturbed, break off into pairs. On a 3-by-5-inch card, each individual should try to draw one of his or her thoughts without using words. After five minutes, exchange cards with your partner. Then respond to your partner's drawing by describing your emotions without words on another 3-by-5-inch card. Continue to carry on a conversation through drawing, exchanging cards every five minutes. After half an hour, stop, put up the cards, and have the participants piece together the conversation by describing the other person's cards and see if they got it right.

GROUP EXERCISE 1–10: *The Exquisite Corpse*

The drawing method called "the exquisite corpse" was invented by the surrealist artist André Breton. This is a good loosening-up exercise to inspire creativity and experimentation without trying to produce preconceived images. Several people create a common drawing of a figure without seeing what the others have done. Each person must be unaware of what the previous person has drawn.

Begin by taking an 8½-by-11-inch sheet of unlined paper and fold it horizontally into three equal parts, like a letter. The first person begins at the top section and starts the drawing—say, with a face and shoulders—for at least five minutes. (Have someone keep time.) At the end of the five minute period, draw just enough information below the fold so that the next person can continue the figure. For example, continue all of the lines you've drawn just below the fold. Turn the top of the paper under so that the next person cannot see what you've drawn. Pass on the paper and continue with the paper handed to you. Again, when you're finished, draw just enough below the fold so that the next person can complete, for instance, the waist, legs, and feet. When this last segment is completed, unfold the papers and display them on a wall. You will be astonished by the unexpected images produced by a range of styles, but unified as a figure.

The Universal Traveler, by Don Koberg and Jim Bagnall, is a handy guidebook on inventive thinking and the design process for your creative journey; it can be an excellent source of inspiration and renewal of energy for the beginning and advanced artist. Drawing practice, when combined with the creative tools and problem solving methods outlined in *The Universal Traveler,* can be extremely beneficial. Additionally, the open-ended approach of the authors can be very helpful, particularly if you get discouraged with your progress. But try not to get discouraged; the creative process takes time and practice. The benefits of a drawing exercise (self-portraits, for instance) become clear only after you've repeated the exercise many times. Be assured that if you are working at it, you are progressing, whether or not your progress is visible at the moment.

The Power of Drawing

Drawings can be powerful tools that influence the future. They have the potential to create and change the world. A good example of this can be found in the impact of the seventeenth-century landscape drawings of Claude Lorrain and Nicolas Poussin. Their style of landscape drawing established the vocabulary for England's romantic, pastoral style of the eighteenth century. Designs derived from these drawings and paintings shaped large-scale modifications of the English garden and countryside. This influence can be seen today throughout the United States in many built landscapes. By understanding these works we can begin to see the effect that drawing can have on our environment.

The drawings taken by themselves show a wonderful sensitivity in their rendering of the landscape. Many were done of Italian Renaissance gardens, and became the basis for larger landscape paintings. Artistic groupings of vegetation were used to create pictorial space. Additionally, each tree was precisely rendered to bring out its individual characteristics. And because these sketches are most often done in pen and ink with sepia washes, you can almost feel the wind rushing through the leaves.

A

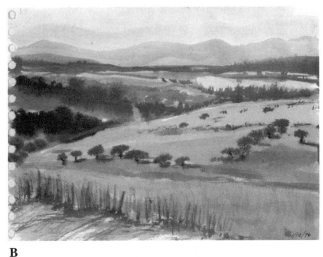

B

FIGURE 1–12 *Everyone can improve through sustained practice. Here are examples of student work over a period of little more than a year. If you are discouraged, draw more, not less. No artist expects to create a masterpiece every time. You will improve your skills when you draw enough that you free yourself from believing that each drawing must be precious. Experiment, attack the page; draw what you think you will be able to capture. That is how you will learn.*
a & b *Lisa Micheli. Ink wash drawings done about a year apart.*
c & d *Laura Jerrard. Ink drawings on paper done about a year apart.*

C

D

The Spirit of Drawing

In a drawing session of this sort, there must be a warming-up period. The first few drawings may be halting or stilted, not getting into the heart of the subject. All at once, everything begins to click, and one drawing after another may come about as if under its own power. I must confess, I love this kind of drawing in the same way as I did some of my paintings, which also seemed to have originated spontaneously. While I am engaged in producing drawings of this sort, a wonderful sense of well-being and contentment comes over me, the feeling that no other activity could possibly be as fulfilling as my reason for being alive.
Charles Burchfield (Jones, ed. 1968)

FIGURE 1–13 *Frank James, Sasaki Associates. Ink on paper.*

Drawing can be an altered state of consciousness, a form of meditation, and a way of evolving to higher levels of awareness; a point in time when your concentration is focused so intently on your work that all distractions disappear. The artist essentially merges with the work. When you draw in this manner you become part of a whole new world, creating your own version of reality. This act of drawing can be a spiritual covenant between yourself and those unidentifiable higher forces. If you become totally involved in the creative act, you are "provoking and being provoked by those images. You get involved in a metaphoric revelation, and witness metaphors emerging from the work." (Flack 1986, 9)

The profession of landscape architecture is a calling. Your art should be a friend that will never abandon you. As Robert Henri, teacher and artist, said, "I am not interested in art as a means of making a living, but I am interested in art as a means of living a life." (1923, 158)

When you draw with total concentration, time will appear to stand still, cutting through reality. If you are able to make this connection with your

FIGURE 1–14 *Author. Pen and ink on paper. Drawing your vision.*

subconscious it can make you a better designer. Your finished product will project this spirit, because you have transformed your individuality and energy into the work. Since you have imparted to it a life of its own, it will exert enormous power and energy on those who view it.

Drawing is also a form of magic. Your hand generates lines capable of making form come alive, magically producing your own personal vision. Just watch children watching someone who is drawing; look at their smiles and how they are awed.

While drawing, work toward attaining a state of being that is different from your ordinary wakeful state. Your sense of concentration should be trancelike. Robert Henri said of this state that "there are moments in a day, when we seem to see beyond the usual—become clairvoyant. We reach then into reality. Such are the moments of our greatest wisdom." (1923, 45) With this heightened sense of awareness of all the elements in the landscape, the true artist will be able to render it as a living thing.

When all parts of the work start coming together, a renewed excitement is generated and builds until the harmony and balance of what you have been trying to accomplish work. You feel like a conductor bringing the full sound of the orchestra to its grand finale. You have reached the peak experience toward which all artists work. (Flack 1986, 14)

C h a p t e r T w o

The Daybook

My habit of keeping a notebook of design began in 1918.
Before I had drawn on scraps of paper which I lost. Then I said to
myself that it was necessary to keep a notebook. Since I always
have a notebook within reach, and I draw no matter what,
I preserve everything which passes through my head. . . .
There is a great appetite to work, and then my sketchbook
serves me as a cookbook when I am hungry.

GEORGES BRAQUE
Theories of Modern Art

FIGURE 2–1 *Author. Italy, 1984. Pen and ink sketch in daybook.*

Leonardo da Vinci kept a record of his thoughts and sketches in a notebook, or daybook, he carried everywhere. The daybook is an important accessory in the designer's repertoire; you will find that many people involved in the creative arts have one at their side constantly. It allows them to continually develop concepts, work out designs, take notes, and sketch.

Da Vinci was the greatest journal keeper of all time. His books show pure genius, and are so immensely beautiful you can almost feel his love of nature as he explored it with unexhausted wonder. The range and diversity of subjects in his daybooks is mind-boggling. They exhibit his sense of composition, his balance of drawing with text, his continuum of invention, and his working back and forth with several ideas at once. Also evident in his text and drawings is a concern for balance, harmony, and proportion.

Ideas are ephemeral. Once an idea is lost it can be gone forever. The artist Robert Irwin stated that "ideas are very potent elements that can radically change your life. Nothing is the same once you accept an

idea." (Weschler 1982, 178) One of the great things about a daybook is that when you have an inspirational moment, you can quickly record it before it fades away. Every thought you have is important, and you will want to record each one in your daybook. Throughout his life, Charles Burchfield kept his "idea notes," which were spontaneous ideas for paintings, in portfolios. These drawings were filed away and labeled for each session with subheadings such as mood, wind, terror, and fantasy. Burchfield found these notebooks to be a fruitful source for his paintings. He said he would make "one drawing after another and it does not matter if the results amount to anything. The artist keeps making drawings until he has temporarily exhausted the idea. They are then put away in portfolios to 'season,' to be taken out later and savored . . ." (Jones 1968, 7)

In your daybook you will want to record your passions, observations, and discoveries. In it you can reflect on your experiences, emotions, and travel observations. When you draw a place instead of photographing it, you learn to see it in a much deeper way. By drawing, you experience nuances and subtleties and participate in your surroundings through observation and personal experience. The designer has to learn not only to perceive form, but also to be able to preserve, analyze, and transmit it.

FIGURE 2–2 *Charles Burchfield. White Owl and Black Winter Spirit. 1961. Conté crayon. 11" × 17⅜". (Private collection. Courtesy Archives of the Burchfield Society)*

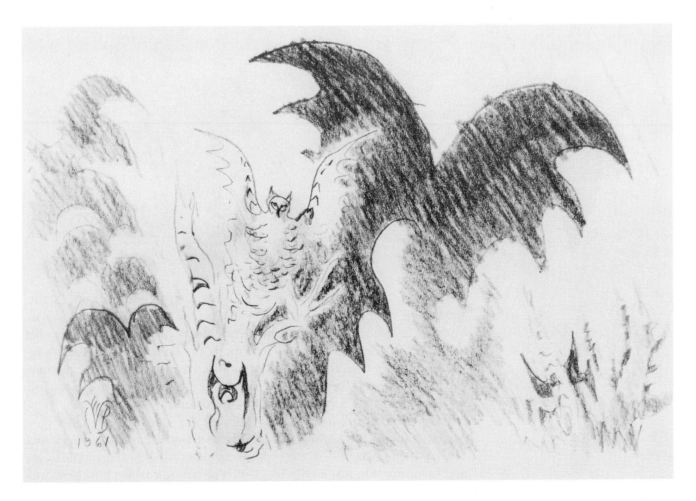

FIGURE 2–3 *Leonardo da Vinci.*
Heads of Two Different Types of
Rush. *c. 1508–1513. Pen and ink over
traces of black chalk. 195 × 145 mm.
(The Royal Collection ©1993 Her
Majesty Queen Elizabeth II)*

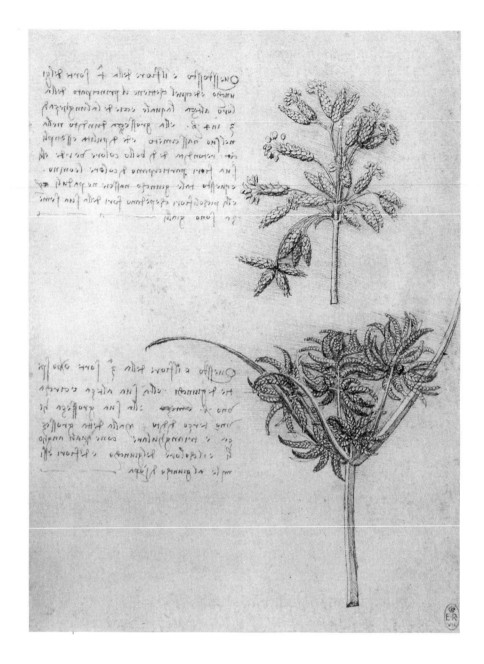

When the English painter J. M. W. Turner first visited Italy in the autumn of 1819, it had an intense effect on his creativity. Turner was so inspired by the landscape of Rome that during his three-month stay he made 1,500 drawings and watercolors in his sketchbooks. That translates into more than fifteen drawings a day, an amazing feat by any standard. When he returned to his studio in England, he produced oil paintings from these impressions and memories.

Although the architect Michael Graves has not published his daybooks, you can find wonderful selections from them in *Buildings and Projects 1966–1981.* These excerpts are studies for buildings, paintings, and furniture. On just an 8½-by-11-inch page you can see how he works

FIGURE 2–4 *R. Crumb. Page from sketchbook. Ink on paper. (Courtesy Fantagraphics)*

through many ideas at once in plan, section, elevation, and mini-perspective. These exquisite little drawings are done with clear, crisp, concise ink lines. They're arranged in pleasant compositions and clearly express his creative process.

Lawrence Halprin: Notebooks 1959–1971 is a first-hand look into this landscape architect's process of generating form. You can see in his designs influences from the landforms of the high Sierras and the northern California coast. His landscape studies and other sketches all have expressive, spontaneous lines that result in very exciting drawings. This book continues to be very influential on the landscape architecture profession.

The underground cartoonist R. Crumb sketches incessantly in his daybooks. People who know him say that he is drawing constantly, even during dinner. His daybooks have recently been published in two editions that contain just a small sample from the many volumes he has filled over the years. In them you can see the development of his characters and story plots, and his visual ramblings. These books are an

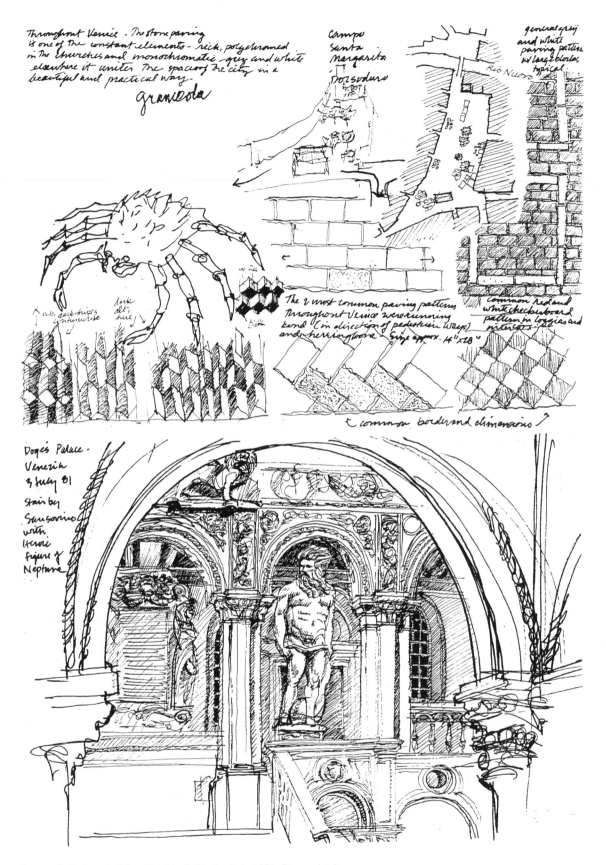

Throughout Venice. The stone paving
is one of the constant elements - rich, polychromed
in the churches and monochromatic -grey and white
elsewhere it unites the spaces of the city in a
beautiful and practical way.

graniola

Campo
Santa
Margarita
Dorsoduro

Rio Nuovo

general grey
and white
paving pattern
w/ large blocks
typical

the 2 most common paving patterns
throughout Venice were running
bond (in direction of pedestrian ways)
and herringbone - Size approx. 14"×18"

common red and
white checkerboard
pattern in loggias and
interiors

← common border and dimensions →

Doge's Palace.
Venezia
3 July 81
Stair by
Sansovino
with
Heroic
figure of
Neptune

FIGURE 2–5 *Laurie Olin. Sketchbook, Venice, July 1981. Pen and ink.*

excellent source for observing a thought process and watching an idea evolve through many stages on a single page.

Today, even graffiti artists carry daybooks with them and fill them with sketches and studies for murals. When they get together with other graffiti artists, they take out their books and discuss and criticize one another's designs in something of a contemporary urban salon.

The daybook is not only a container of experience, but it is also fertile ground for exploring the potentials of drawing. Your daybook should express a continuum of drawing and eventually become something to which you can refer during the design process and throughout your career. If drawing is difficult for you at first, begin by using written descriptions and slowly evolve into sketch form.

I have kept daybooks since high school and have found them to be incredibly valuable. I refer to them often, though it might take five or six years before I go back and develop one of the ideas. This is why it is important for you to record your thoughts; they are seeds that can grow

FIGURE 2–6 *Author. 1964. Pen and ink. Imaginary landscape in high school notebook.*

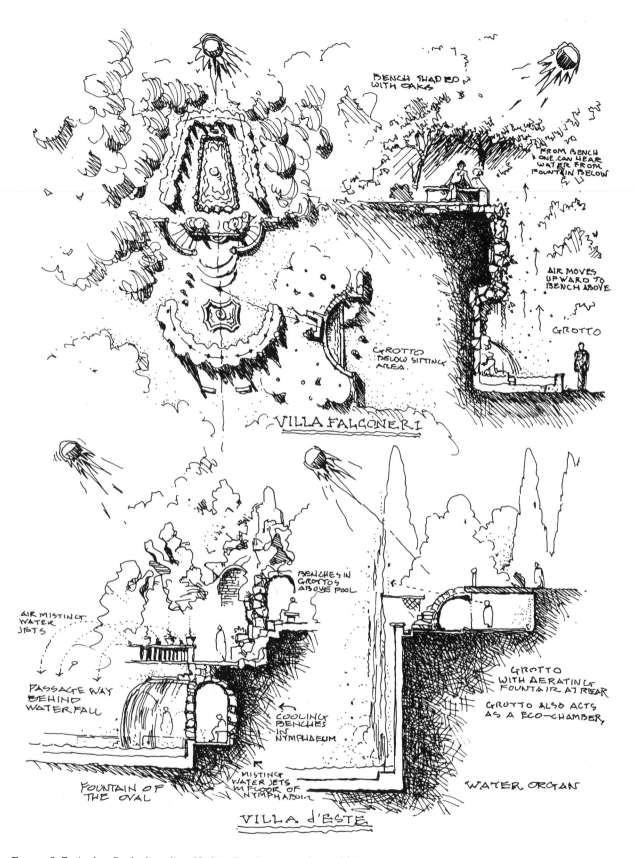

FIGURE 2–7 *Author. Daybook studies of Italian Renaissance gardens, 1984.*

and mature in your brain until you develop them. When I first started to use the daybook as a medium, most of my entries were written. I eventually learned to develop a visual notation, almost a kind of calligraphy, that I could use to record my ideas as rapidly as possible.

In high school, I tended to use my daybook to develop theoretical science-fiction landscapes. Many of these studies were combined later into paintings of surreal landscapes. I've also used it as a travelogue, to record places I've visited, and as an analytical tool, by pacing off spaces and recording the dimensions and details of fascinating forms, such as the architecture of the Anasazi Indians of the American southwest. While at the American Academy in Rome I used it for sketching and studying the passive cooling and heating elements of the Italian Renaissance garden. I've also used the daybook as a way of capturing the essence or emotional feeling of a space. I continue to use it to develop design ideas for exhibitions and ecological installations, and to study compositions that will eventually become gardens or paintings.

Types of Daybooks

There are as many styles of daybooks as there are people who keep them. A journal is a very personal thing, and it is important to select one that will be compatible with your own method of recording.

There are many sizes from which to choose. It will be helpful to try a few different types before settling on one style. You will be referring to your daybook for many months or even years, so a strong binding and a sturdy cover are necessary. It is also a good idea to use a book with acid-free paper so that it will not yellow with age. The standard 8½-by-11-inch black book is very sturdy and will hold up under a lot of wear and tear. Generally I've found anything larger to be unwieldy; it is very important that your daybook be easy to use and easily accessible. The more difficult it is to get out of your shoulderbag or backpack, the more reluctant you will be to sit down and open it, so anything 8½ by 11 or smaller is fine. Other standard sizes are 8 by 7, 5 by 8½, and 4 by 6.

For drawing, anything smaller than 4 by 6 might be too small. Rectangular sketchbooks that are bound on the short side are good for drawing landscapes, and can be held easily. Le Corbusier used to carry this type of sketchbook on his travels. Many of the Beaux-Arts students would use them because of their flexible horizontal or vertical format, and because they're small enough to fit into a shirt or hip pocket.

In combination with a larger daybook, it can be helpful to carry a smaller, pocket-sized notepad. These come in a variety of types but the 3-by-5-inch ruled Boorum Memo Book is quite handy for writing and for jotting down quick ideas or sketches. It is also quite sturdy and withstands heavy use.

Generally, spiral-bound daybooks are not a good idea, because with a lot of use, the pages will become loose and eventually fall out. Also, the metal spiral will sometimes snag and can interfere with the freedom of

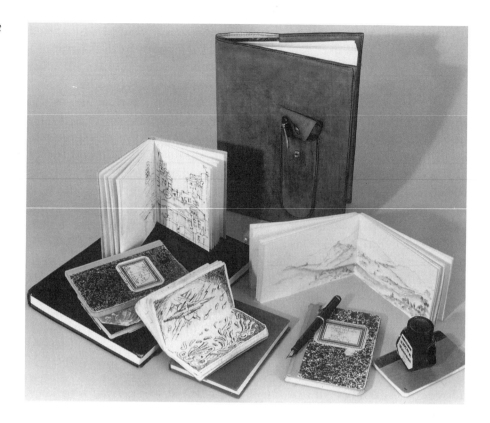

FIGURE 2–8 *Daybook types. Experiment with a variety of sketchbooks until you find one that is compatible with your style. (Photo: Kathryn Drinkhouse)*

your drawing hand. Some sketchbooks come with perforated pages; these will also become loose and fall out. Because the daybook should reflect a continuum of ideas, you want to avoid tearing out the pages. Even if you're dissatisfied with the drawing, you should keep it. It's important to keep track even of the ideas you think are awful. Some artists prefer to use three-ring binders, since they allow you to rearrange pages, which can be a handy way to compose and edit work.

As a way of getting over blank-page panic, some artists use bound books that are ruled or gridded, making it easier to get started by not having to stare at a glistening white sheet. Another way to reduce blank-page panic is to prepare your pages with a light watercolor wash. J. M. W. Turner would prepare the pages of his sketchbook this way before going out into the field to paint. When he was at the site he would first sketch in pencil or ink and then use his watercolors. The prepared page is a good way to get directly into the drawing.

Another unique type of bound book is the small telephone/address book; it is ruled and usually has alphabetical tabs neatly along the side. Ed "Big Daddy" Roth, the car culture icon and designer of custom cars and monster tee-shirts, uses a mini telephone book. He carries one with him in his wallet and when he sees something inspirational such as graffiti or a unique car, he pulls out his book and jots it down. Roth is constantly searching for inspiration for new ideas by studying his surroundings, and is never without his trusty little telephone book.

EXERCISE 2–1: *The Sketchbook*

Select a sketchbook with which you feel comfortable. Make written notes and small sketches of your daily routine and activities. To get started, begin every morning by drawing your coffee cup or some other familiar object. Draw on your way to school or work, and be sure to date your entries and where they were drawn.

..

Media

An inexpensive fountain pen is probably the best instrument to use in your daybook. A fountain pen gives a sense of immediacy and produces clear, crisp, unerasable lines. By creating permanent lines you will not be tempted to spend a lot of time redoing your drawings, which will affect your spontaneity. Pencil tends to smear and get messy, especially if you use your book often. A ballpoint pen is not recommended because of the inflexibility of the pen point, which limits the kinds of drawings you can do. I also do not recommend felt-tip pens, because they will fade over time and bleed through the paper, making it difficult to use the back of the page. Felt-tip points also become soft and spongy, losing their shape when used over a length of time.

Fountain Pens

Fountain pens have made an astounding comeback. When I first started using a fountain pen in the early 1970s, the selection was very limited. Now, almost any art supply store will have an abundance of pens from which to choose. Some stores are even devoted entirely to selling fountain pens. There is something unique about the quality and individuality of the line produced by a fountain pen as opposed to a disposable pen. Even the daily ritual of filling the pen can be enjoyable.

I recommend starting with a medium-priced pen such as the Pelikan MC120. The gold content of the point directly affects the quality of the line. A gold point will be more responsive and allow more flexibility in your line weight, and will eventually conform to your stroke. A gold point evolves with your personal style because it reflects the way your hand moves.

When choosing a pen, go to an art store or pen store with knowledgeable salespeople. Test the pens until you find one you like. Be sure to test different types of points; these can range from fine to italic for calligraphy. Remember that even the same model will vary slightly, so take your time, go back more than once and try other stores. Never use India ink in your pen; use fountain pen inks only, or it will be ruined. And never carry your pen in your pants pocket because it can fall out too easily. It is best to carry your pen in your shirt pocket or in your shoulder bag.

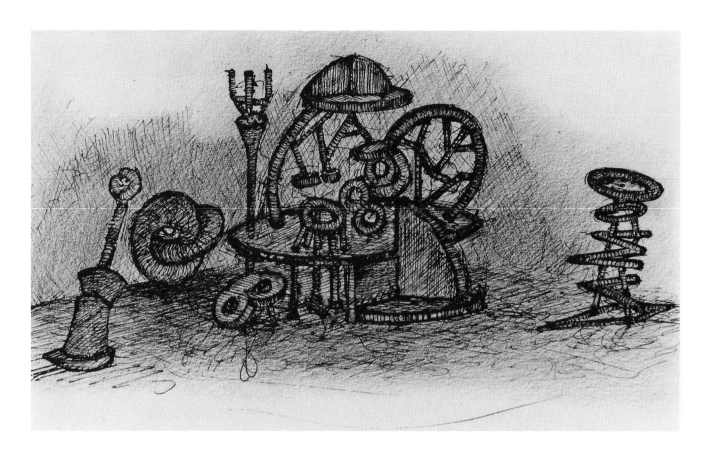

FIGURE 2–9 *Joseph Slusky. Mixed media drawing from daybook.*

Mixed Media

After you become proficient with your fountain pen, you might try using mixed media. Joseph Slusky, an artist and sculptor from the San Francisco Bay area, mixes different kinds of media in his daybook. He uses his fountain pen to produce the under-drawing, then mixes in Prismacolor, watercolor, China marker, pastel, or almost anything at hand, creating drawings of incredible richness. Since fountain pen ink is not waterproof, you can wet a small brush and go over your drawings to create watercolor-like effects. If you don't have a brush, just wet your finger and smudge the lines to get tones.

You can also use your daybook for collage. If you have made drawings or phone doodles in the margins of newspapers or magazines, cut them out and paste them into your book. Some artists I've traveled with make collages from things they collect on their travels: a pack of Camel cigarettes found in a plaza with a nice patina from being rained on and walked over might be glued into the daybook. This can be a unique way to indicate the times and places of your travels. Stamps, wine labels, any sort of ephemeral material can be integrated into your drawings. You can also use photographs or copies of images from books and magazines as the basis or inspiration for a drawing. You can continue to draw right over such an image, working it into a drawing. To facilitate the collage technique, carry a simple glue stick with you.

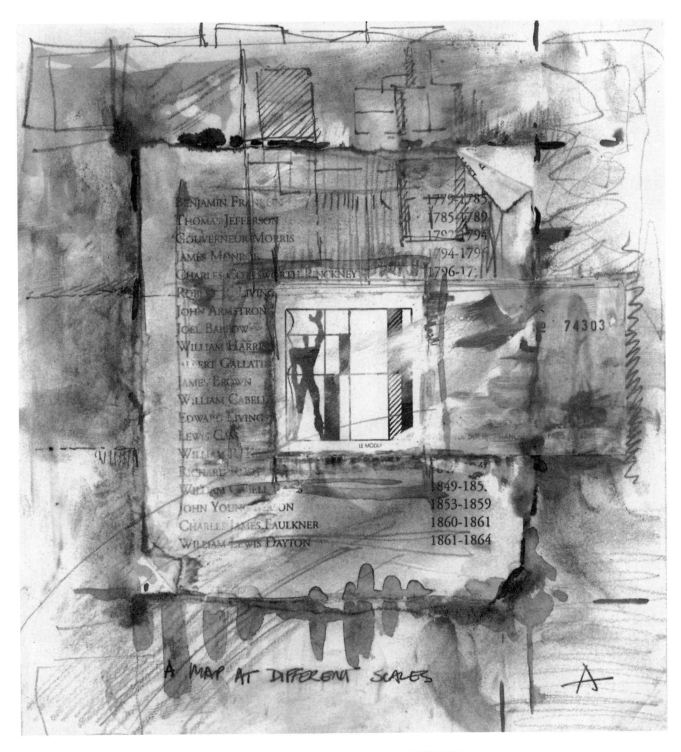

FIGURE 2–10 Annie Amundsen. A Map at Different Scales. *Watercolor, charcoal, ink, and found paper collage.*

EXERCISE 2–2: *Sketchbook Collage*

Incorporate found pieces of paper into your book. Cut out and paste drawings, copies, or photos of things that interest you. Use these collages as a basis for a drawing. Draw over them and integrate them into drawings you are working on.

Doodles

In addition to his idea notes, Charles Burchfield kept files of his doodles from nature. He used these doodles as a way to work through a series of variations on the sounds and moods of nature. Though he considered these to be another form of his idea notes, his doodles focused on his inner reality, and were an unpremeditated way of visually expressing the subconscious.

..

EXERCISE 2–3: *Doodling*

Practice doodling in your book while on the phone, during a lecture, or while watching television. Try to let your hand move subconsciously. Later, sit and observe nature and let your hand move while trying to unlock your subconscious into the drawing.

..

24 Jⁿ '91
2:15 ᵃ·ʰ·
- 2:45 ᵃ·ʰ·

in the green translucence
brown stone tablets keeping
the tides at bay — not sent
— after "B.C." — tidings
glazed up on palimpsests ↵

still everone's waving

2:50 p.m. 24 Jⁿ '91 Thursday
(in the projector)

soul of moving pictures
— imaged as such a² spirit
rivals or equals or
is film collected on
what we push ourselves thru
~~with — in the projector~~
with — using reel as oar

10:55 p.m. 26 Jⁿ '91 Saturday
[after Vigo's "L'Atalante"]

projector

soul of moving pictures
—imaged as such a spirit
rivals or equals or —
its film collected on
what we push with ourselves
through using reel as oar

FIGURE 2–12 *Andrea Hollowell. Page from journal. 1991. Pen and ink.*

Daybook Variations

The Writer's Journal

There are several types of daybooks that can help you develop your ideas. Perhaps one of the oldest forms is the writer's journal or diary. Just like the artist or landscape architect, the writer will use his journal to develop stories. Jack Kerouac kept detailed notes in small 3-by-5-inch spiral-bound notebooks. When working on a novel he kept a journal to organize the details of the plot. Many of his companions noted that he always carried these notebooks and was writing in them continually, recording his surroundings and events. Carolyn Cassady observed:

> *He would intrigue me by his astute observations of the people and places in the passing streets. He'd often jot down these impressions in a little five-cent notebook which he told me he carried at all times to capture details for his book. . . . He still carried a little five-cent notebook in his shirt pocket wherever he went to record his impressions or new ideas which he would type up within a few days. (1990, 29, 161)*

Before he died in St. Petersburg, Florida, he had all his journals chronologically ordered in his bedroom. He had his whole life experiences on paper.

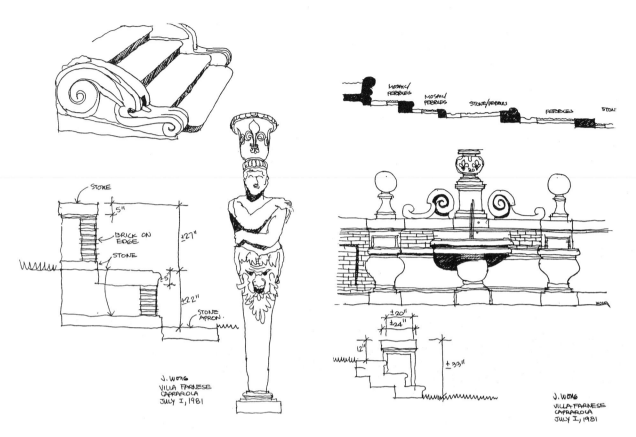

FIGURE 2–13 *John Wong. Measured studies in daybook. Italy, 1981. Pen and ink.*

The Dream Book

Another interesting type of daybook is the dream book kept near your bedside. Recording your dreams is a very good way to tap into the subconscious. As da Vinci asked, "Why does the eye see a thing more clearly in dreams than with the imagination awake?" It is important to keep track of your dream state, because when in this state you overcome the inhibitions you experience in the daytime. Force yourself to jot down your dreams when you first wake up in the morning, or they will be easily lost. It is paramount that you keep a book and pen right next to your bed. Sometimes I've found that in the middle of the afternoon when I become sleepy I will suddenly remember the dreams I had the previous night. Suddenly I'm back in the dream state. This is also a perfect moment to bring out your dream book and sketch or note the things you were dreaming about. Kerouac said that he was always forcing himself "to catch the fresh dream, the fresh thought." (Nicosia 1983, 279)

The Design Journal

The Rome Fellowship, founded in 1894, is awarded annually by the American Academy in Rome to thirty of America's most promising scholars and artists. Each fellow spends a year at the academy, free from financial pressure, with a monthly stipend, living accommodations in a spacious studio or study, and funds for travel. When Norman T.

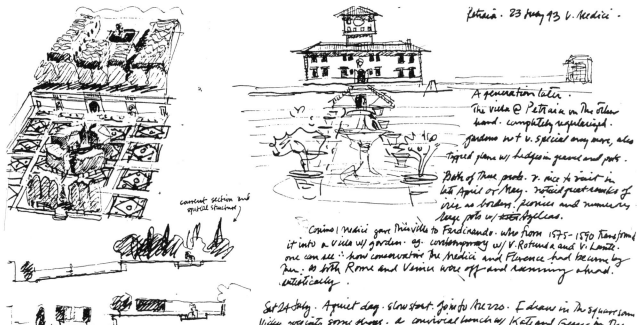

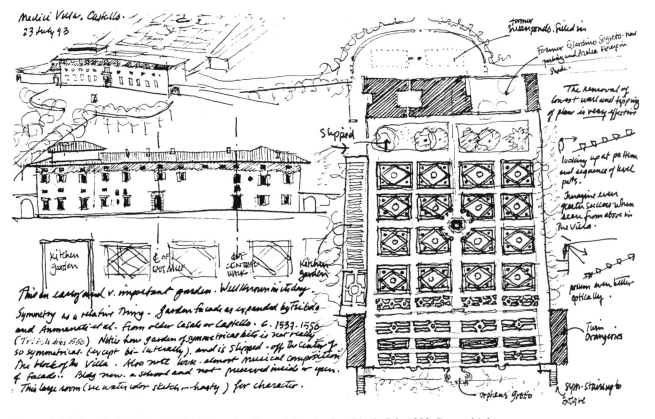

FIGURE 2–14 *Laurie Olin. Two Medici Villas: Castello and Petraia. Sketchbook, July 1993. Pen and ink.*

Newton, author of *Design on the Land,* won the Rome Prize, he kept a design journal. It was a 4-by-6-inch bound book with gridded pages. Newton would also carry a small scale in his pocket. When on his travels he found a space, garden detail, or structure of interest, he would measure its dimensions and draw these to scale in his journal. Back in his studio, he would draft them at a larger scale using a straightedge. This is an excellent method for determining scale, understanding space, and reinforcing what you are seeing. This type of file becomes an extremely important design reference.

You can find excellent results of this process in the drawings of garden details in *Spanish Gardens and Their Patios,* by Arthur and Mildred Byne, published in 1924. When Walter Gropius, who founded the Bauhaus Design School in Germany, took over as dean of the Graduate School of Design at Harvard it marked the end of Beaux-Arts education, which was unfortunately viewed with scorn by the Bauhaus. L'Ecole des Beaux-Arts was established in Paris in 1819. It was a system of architectural study based on learning from classical antiquity. The role of drawing and rendering in watercolor was extremely important.

FIGURE 2–15 *Bill Griffin. Travel Sketches. Pen and ink. (Courtesy Fantagraphics)*

In tribute to Gropius and the modern movement, many of the professors and students ceremoniously destroyed their design journals. What a loss.

The Travel Journal

Another important use of the daybook is as a travel journal, to jot down daily observations and create analytical drawings of places, gardens, and landscapes. These become valuable visual accounts of places you've visited. Travel journals are adjuncts to the design journal. In the 1800s and early 1900s, when artists and architects were taking the grand tour of Europe, they kept daily journals. In the evenings they would gather to discuss the sketches and notes they had been working on that day.

Artists' Travel Sketchbooks

J. M. W. Turner was able to pack in an amazing amount of information into tiny, evocative sketches that become even more remarkable when we realize that each drawing is roughly one by one-and-a-half inches. Turner used the thumbnail sketch as visual shorthand, often drawing in sketchbooks that measured only about four by six. When he made these sketches, he was planning his itinerary for an upcoming trip to Italy by copying illustrations of the sites he hoped to see. The sketchbooks clearly illustrate that drawing can be a mentally transporting experience. Whenever possible you should try and draw the places you plan to visit; it can help you to catalog your expectations and sharpen your imagination.

Samuel Palmer, a contemporary of Turner's, also produced volumes of small sketchbooks; unfortunately, only two out of twenty have survived. His sketchbooks contain a lively variety of drawings and jottings. Like Turner, Palmer often used a small sketchbook. This sketchbook is

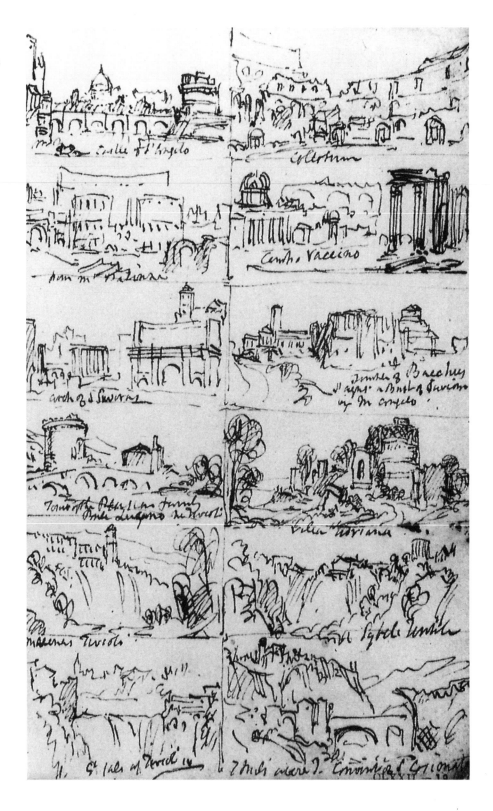

FIGURE 2–17 *J. M. W. Turner. Thumbnail sketches of Italian landmarks from a sketchbook entitled Italian Guidebook. Pen and ink. 6 1/8" × 3 15/16". This particular sketchbook is a visual directory of the places Turner intended to visit; the drawings were copied from travel guide books of Italy. (Tate Gallery, London)*

4 1/2-by-7 7/16 inches. The tree silhouettes really capture the gesture of the various forms, and the contour lines in the thumbnail landscapes contains an incredible amount of visual information. Working small keeps you from becoming too detailed and forces you to concentrate on the

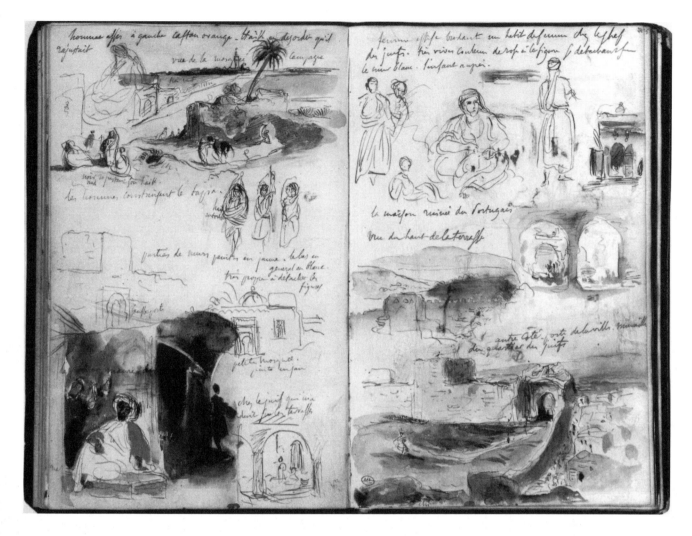

forms and major compositional elements. One by two inches is a good thumbnail-sketch size.

Bill Griffin, the creator of the *Zippy the Pinhead* cartoon, recently published a compendium of his travel sketches. His book, *Waiter Get Me a Table Without Flies,* is full of wonderful drawings, unique insights, and humorous situations. He has said that he uses a 3-by-5-inch spiral notepad, so people will refrain from coming up and asking him what he is doing because they think he is a detective.

When traveling it can be very helpful to carry a lightweight folding stool. Carrying an aluminum tripod stool with a shoulder strap will make it easier to stop and draw. I've found that when I'm not carrying my stool with me I will only stop and draw where there is a comfortable seat, thus limiting my subjects. With a portable seat, you can increase your opportunities for recording visual elements. It is also helpful to carry a couple of heavy rubberbands with you. Use these to secure the pages of your daybook from blowing in the wind.

These are just a few of the possible variations on the daybook format. You don't have to follow any one form, but should develop your own individual method.

FIGURE 2–18 *Eugène Delacroix.* Illustration from Travels Through Morocco Sketchbook. *1832. Pen and ink and watercolor. $7^{11}/_{16} \times 5^{1}/_{8}$. Delacroix's sketchbooks from his expedition to Morocco illustrate an excellent balance of small thumbnail sketches, gestures, and watercolors intermixed with written notes. The gesture of Delacroix's figures and landscapes is brilliant in capturing the mood and sense of place, color, and sensation. He used these information-packed studies as the basis for many paintings he did in his studio in Paris. (The Louvre Museum, Cabinet des Dessins, Paris)*

EXERCISE 2–4: *Draw Every Day*

Try to develop your own personal notation or visual language to record your environment and ideas. Your daybook should be an extension of your mind, a graphic indication of the struggles that are going on in your subconscious. It should illustrate your design process. Write down your impulses and thoughts, practice your composition, work on the interaction between text and image. View each page as a design element.

Draw and write in your daybook every day and carry it with you always. The daybook is one of the most important pieces in your design repertoire. It's a tool to help you indicate and test your ideas. Your book should be always at your side, your pen forever ready to jot down those fleeting ideas that will lead you on fantastic explorations. In 1948 when Matisse showed his sketch book to Francoise Gilot, a painter and Picasso's first wife, she said it was full of "rapid signlike notations, an intimate document of his inquisitive mind at work." (Gilot 1990, 90)

FIGURE 2–19 *Samuel Palmer. Landscape studies. 1824. Pen and ink and watercolor. 4¹/₂″ × 7⁷/₁₆″. This page contains imaginative contour drawings of foliage and beautiful land-scapes. (Victoria and Albert Museum, London)*

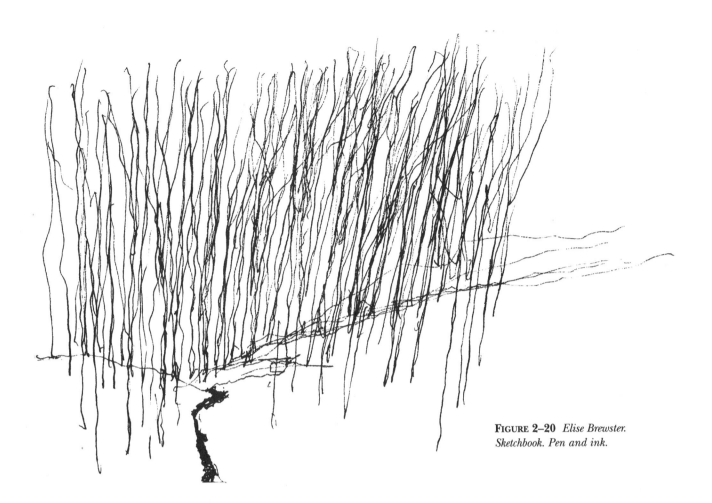

FIGURE 2–20 *Elise Brewster. Sketchbook. Pen and ink.*

The Creative Environment

*All those li'l finksters sittin' in the back of class in all the schools
around the world copyin' junk out of my catalog at the back
of class pumping out reams of worthless(?) trash as far as the
teachers and parents are concerned, but developin' their skills
and style of thinkin'. That's the important part. Keepin' them
hands busy and lettin' their imaginations soar!
Reality is a concept that we destroy their ability or desire
to fly with thoughts and ideas.*

ED "BIG DADDY" ROTH
Confessions of a Rat Fink

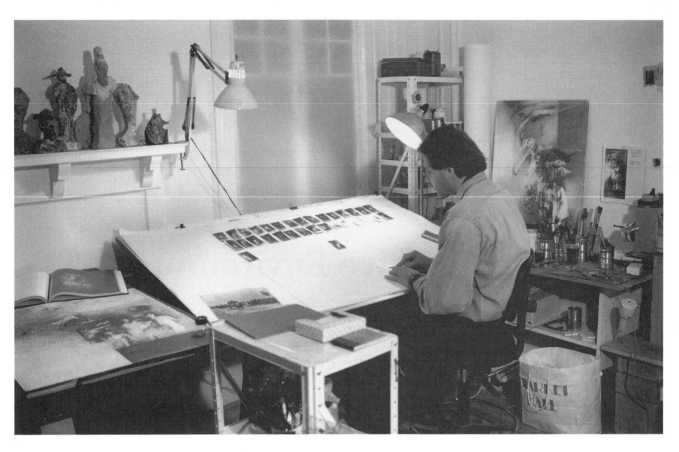

FIGURE 3–1 *Studio of Ireneusz Ciesiolkiewicz. (Photo: Kathryn Drinkhouse)*

The Studio

Ideally you will want to have your own space where you can draw, write, and think. Ultimately your studio will become inextricably connected to your creativity. It is much more than just a room; it is a space filled with your life. This room should be a refuge, a welcoming room, a very special location where you can study, learn, and develop your individuality. It doesn't have to be a huge artist's loft; it can be any size. Most important, it should be accessible and comfortable, quiet, receptive, and relaxing. It can be even a small corner of a room, as long as you are happy in it and can leave your tools, books, and drawings undisturbed.

The creative process cannot be separated from the environment in which the work is made. No one will give you a creative space in which to work; it is something you will have to make yourself. It should be a place that excites you. Every day when I get up, I really look forward to going to my studio; in the evenings before I go to bed, I usually can't wait to get back there the next morning.

Creative work spaces have many consistent features. One of the most common is access to natural light. A clear, uninterrupted flow of natural light is invaluable, and if you are lucky, a view is also nice. Da Vinci recommended that the painter have a window shade to raise or lower to control the natural light. He also said the light for drawing from nature should come from the north so it will not vary. Da Vinci felt that

Figure 3–2 *Ireneusz Ciesiolkiewicz. Desk in corner of kitchen designed for drawing while cooking or making coffee. (Photo: Kathryn Drinkhouse)*

if you have southern light exposure you should use an opaque cloth to cover the window to evenly disperse the sunlight.

The bigger the window the better, although Parisian garrets often have but one small opening. It is something simply elegant and wonderful when sunlight flows across your studio, illuminating your space with radiant light.

Some artists will use adjustable white canvas curtains to vary the intensity and provide an even cast of light. I prefer a southern exposure,

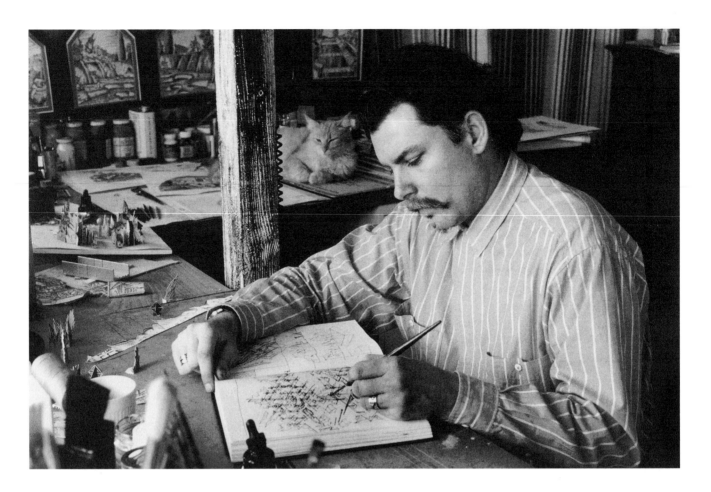

FIGURE 3–3 *The author drawing in natural light, with a cat as watchful critic. (Photo: Kathryn Drinkhouse)*

because I like to feel the sunlight on my back. However, I do have large canvas awnings to filter the light. Unfortunately, the new tinted and thermally insulated glass diminishes the quality of natural light by reducing the sun's glare.

Most artists place a sizable easel or drawing board near the light source. Nearby will be a small table for brushes, tools, and supplies. The artist must also have room to move away from the work in progress and to view it from a variety of distances. No matter what creative endeavor you are involved with, it's important to be able to move away from the work and reflect on it. Many artists place a comfortable chair at a distance from the easel for reflection and contemplation.

Studios often contain a smaller table for writing, making small sketches, or working in a daybook. This is a thinking spot, where you can gaze out the window (if you have one) and let your thoughts run free. It allows you to change easily from the large-scale drawing to much smaller more detailed sketches.

Another thing found in most studios is a comfortable place for reading or napping—perhaps a couch with a bookshelf nearby. Artists often look to books for inspiration; it's always interesting to ask them what they are reading. Among the cases or piles of books found in this area of the studio you will often find books lying about open to photos or paintings. I start the day by reading for a short period, then I work for

a long time; later I take another short reading break, alternating between working and reading throughout the day and night. Being able to read while you work is an incredible luxury, but it is part of the overall process.

Many artists take short naps in their studios. In addition to being refreshing, naps also connect you with your dreams. Rousseau would sleep in a chair right in front of his easel, alternating between painting and sleeping. Salvador Dali would sometimes fall asleep in his studio, then jump up and immediately paint what he was dreaming. I have found that napping in a slightly uncomfortable chair keeps me from sleeping too long—neck cramps limit me to fifteen or twenty minutes.

Each individual personalizes his or her studio in a unique way. It is fascinating to go to different studios and see what artists have put up for inspiration. The whole studio will sometimes develop the character of the artist. You'll find copies of the work of other artists, sheet music, train tickets photos, cut-outs from magazines, and all sorts of knick-knacks. The walls of Braque's studio looked almost like collages, hung with African masks, guitars, cut-outs, thumbnail sketches, and keys. You could almost see his thought process at work.

In a different vein, the English artist Glen Baxter has his drawing table set up in his living room in front of the television set. While he

FIGURE 3–4 *A small area for working out ideas for larger projects. (Photo: Kathryn Drinkhouse)*

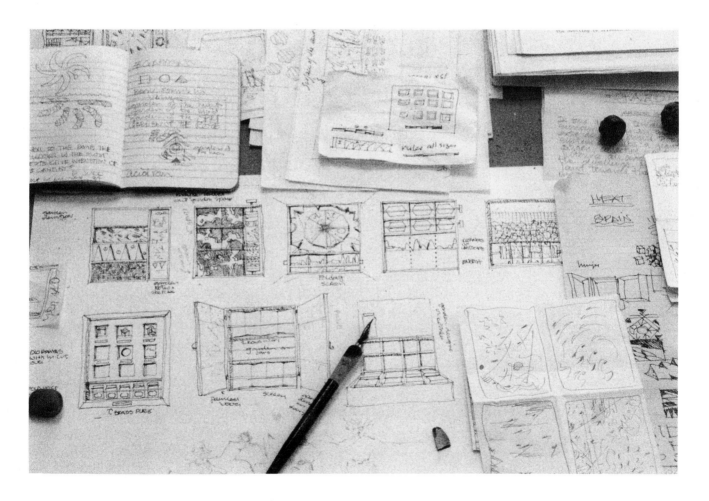

draws he also watches the television as a sort of meditation. This might explain the sardonic outlook of his work, which depicts unusual juxtapositions.

Artists usually like to be surrounded by their own work in addition to their tools and supplies. Your works become like family and friends: enjoyable to look at and comfortable to have around. If you get angry at or tired of a certain piece you can always take it down and hide it away until you cool off.

Some studios I've visited are so teeming with creative energy that I'll want to pick up a pencil and start drawing, and sometimes I do. Maria McVarish's studio is like that for me. Maria is a San Francisco artist who makes small constructions and assemblages in her tiny five-by-eight-foot

FIGURE 3–6 *Maria McVarish's studio. (Photo: Cheryl Fenton)*

studio. Her whole studio has become a collage. Everything is so well designed and well placed that the room is a chamber of energy and dynamism. This sort of dynamism is described by Musa Mayer; Philip Guston's daughter:

When I visited [Philip Guston] those last years, this big cinder block space with its tiny high windows seemed cavelike to me, like some underground chamber filled with treasure. You walked in, he turned on the

*lights and there they [the paintings] were. You were completely surround-
ed by amazing images, by legs and shoes, and ladders, by high red tides
and drowning heads. (1988, 241)*

...

EXERCISE 3–1: *Creating a Studio Space*

*Visit as many artists' studios and design offices as you can. Make mental notes
as to what features work and what elements you would like to incorporate into
your own space.*
*Work on obtaining and setting up your own studio space. Spend as much time
as necessary personalizing it and making it a comfortable refuge in which to
work undisturbed.*

...

The Artistic Community

Pablo Picasso once said he "never avoided the influences of others." Art
does not happen in a vacuum. It needs reinforcement, reassurance,
community, and criticism. Often, artists have only one another for
encouragement.

None of the great artistic movements of the past happened in the sub-
urbs. Most have grown in urban environments—Paris, New York, San
Francisco. It seems that at some point in their careers most poets, writ-

FIGURE 3–7 *The author's studio sur-
rounds him with his work. (Photo:
Kathryn Drinkhouse)*

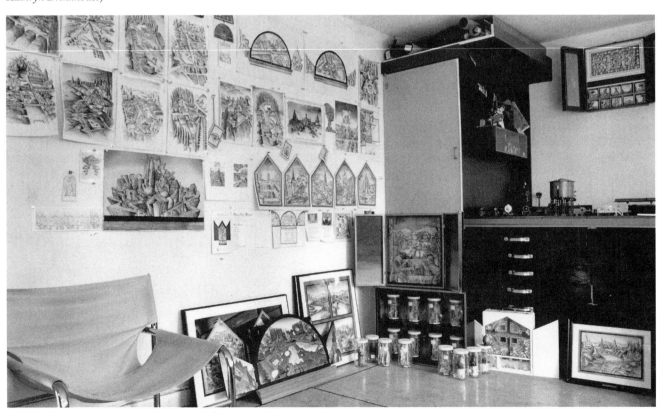

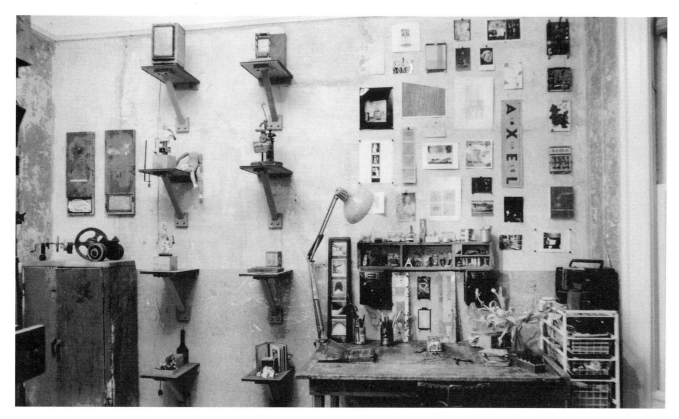

ers, painters, and designers find sources of inspiration in cities. Cities provide a variety of venues where people of similar interests can gather. In these centers you are surrounded by creative people who are passionate about their work. Through socialization and companionship, a strong bond develops among the arts. It is important for artists to be surrounded by others who are driven and motivated. In *Seeing with the Mind's Eye* the authors Mike and Nancy Samuels wrote that "Artists are nourished by each other more than by fame or by the public . . . To give one's work to the public is an experience of peculiar emptiness." (1975, 169) The type of social environment they spoke of can be infectious, generating an energy that often results in a movement.

A perfect example of this is the Paris salon of Gertrude Stein and Alice B. Toklas, which was a haven for writers, poets, and artists in the 1930s. Picasso, Braque, Hemingway, and other members of the "lost generation" were highly influenced by the ideas exchanged there.

The communication between Henri Matisse and Pablo Picasso developed a new style of painting. Picasso referred to their relationship as a marriage. In 1908 the two artists

> *initiated an unusual artistic dialogue which they pursued day after day until 1914. They worked in separate studios and met in the evening to evaluate works in progress and agree on further research. The ideas they developed and shared attracted other artists, who adapted them to suit their own needs. (Gilot 1990, 187)*

In New York City during the Abstract Expressionist movement of the 1940s and 1950s, artists, poets, and writers would gather at the Waldorf Cafeteria. The Waldorf was a well-heated, all-night cafeteria where you could talk for hours and not be thrown out. Joyce Johnson, a writer who was a college student at that time, recalls these days:

Ideas flashed by like silver freight trains that wouldn't stop at your station to unload but had to push on to a vanishing point in the distance.

FIGURE 3–9 *Maria McVarish. Small drawing desk next to window. (Photo: Cheryl Fenton)*

What was Jungian? Existentialist? Abstract Expressionism? . . . [Those who stopped by included] e. e. cummings, W. H. Auden, Maxwell Bodenheim, Delmore Schwartz. Painters like Hans Hofmann, Jackson Pollock, and Franz Kline. Obscure younger people too, like Allen Ginsberg, who moved downtown to the Lower East Side before he followed [Jack Kerouac's] route westward in pursuit of Neal Cassady. (1983, 42)

New York's Cedar Tavern was the favored drinking establishment for painters and writers of the period. There were generally lively discussions or fistfights going on about one ideology or another. Painters such as Willem de Kooning, Franz Kline, Larry Rivers, and Jackson Pollock were just a few of the regulars. Jack Kerouac also mingled with these artists, whose work was similar to his in style.

Like Picasso and Matisse, Robert Rauschenberg and Jasper Johns also had an important creative relationship. In the summer of 1953 Rauschenberg moved into a loft on Pearl Street in New York City where Johns lived. They would visit each other at the end of the day and look over what they had both worked on. Perhaps their union allowed them to break away from Abstract Expressionism, the major force in the art world at that time. They criticized and encouraged each other's work and shared long discussions. Their communion was important despite their different styles. Of it, Johns is quoted as saying:

FIGURE 3–10 *Gathering in SoHo after Clark Coolidge's poetry reading at a nearby gallery. 1986. (Photo: Kathryn Drinkhouse)*

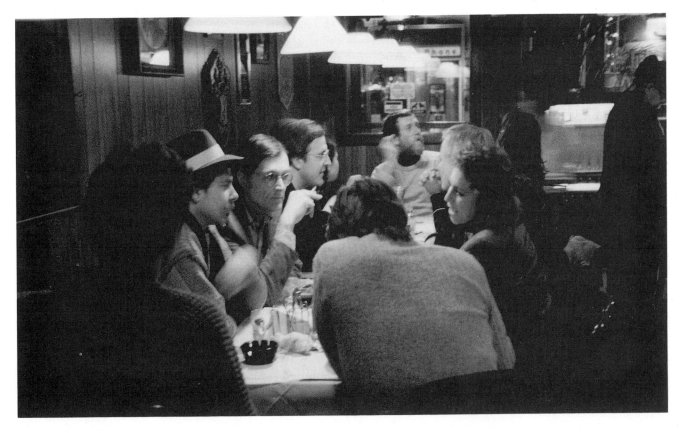

FIGURE 3–11 *A weekly gathering of the Breakfast Group in Berkeley, California. This group of artists meets every Friday morning at 7 a.m. for breakfast to discuss one another's work and talk about the art world in general. (Photo: Richard Sargent)*

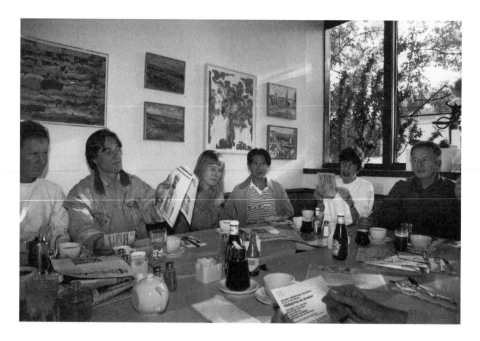

You get a lot by doing. It is very important for a young artist to see how things are done. This kind of exchange we had was stronger than talking. If you do something and I do something, it means more than what you say. It's nice to have verbal ideas about painting but better to express them through the medium itself. (Scharifman 1993, 204)

When I studied at the Art Students' League in the 1970s, New York saw an incredible explosion in creative energy. It was a tremendously inspiring environment that continues to influence my work. The Lower East Side was bursting with new galleries, poetry readings, performance art, and the punk rock scene. Participating in this opened my eyes to the potentials of interaction between the arts. Associating with artists who were so committed and passionate about their art that they were willing to fight about it was deeply moving.

I have found that same energy since moving to the San Francisco Bay Area. The Bay Area has always been a center for the literary arts, beginning with the Beats in the early 1950s and continuing today with the poetry renaissance and underground comic scene. San Francisco is a nucleus for performance art, installation art, and underground theater. The Bay Area is also a mecca for landscape architects and home to many of the profession's heroes: Halprin, Eckbo, and Walker. I am pleased to be among a group of artists, poets, writers, architects, and landscape architects that meets once a week to discuss current projects.

But throughout the United States, the profession of landscape architecture must become part of the larger creative community, participating and collaborating with artists from all fields.

Start a group or salon where you meet with colleagues once a week. Invite a variety of people from many disciplines; get together and discuss one another's work, and visit each other's studios. The main thing is that you make your meetings consistent, because once you break the

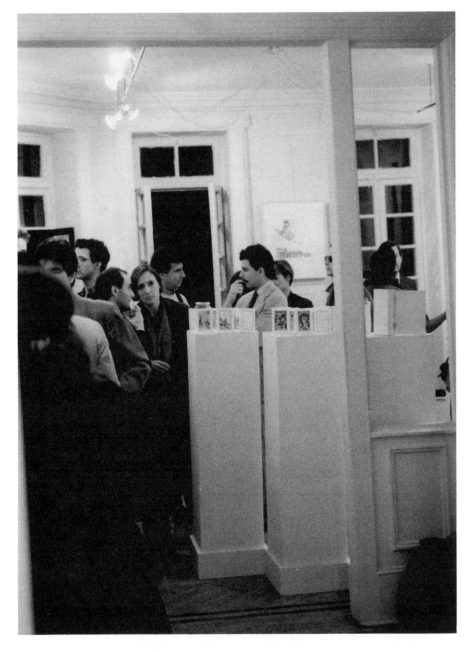

FIGURE 3–12 *Opening night of an exhibition of landscape drawings, paintings, and sculptures at Facade Gallery, N.Y.C. 1984. (Photo: Kathryn Drinkhouse)*

routine it becomes easier to not get together. Picking a topic to discuss beforehand is a good way to begin your meeting; many groups find shared reading a good way to get started.

You don't have to be in a large metropolitan area to find or start a reading group. Small reading groups have been forming throughout the country in connection with a monthly publication called the *Utne Reader,* which is an anthology of articles, book excerpts, and assigned articles on current topics. The publication even provides guidelines for starting local reading groups. Each person reads the issue and comes to the meeting prepared to discuss it. Depending on how each group is set up, the meeting is scheduled at the same place each month, or it revolves to each member's home. It's helpful to be a member of a sup-

THE SHIP CAME DOWN FROM SPACE. IT CAME DOWN FROM THE STARS AND THE SILENT GULFS OF SPACE. IT WAS A NEW SHIP, THE ONLY ONE OF ITS KIND. IT HAD FIRE IN ITS BELLY AND MEN IN ITS BODY, AND IT MOVED WITH CLEAN SILENCE, FIERY AND HOT. A CROWD HAD GATHERED AT ITS NEW YORK LAUNCHING SITE AND SHOUTED AND WAVED THEIR HANDS UP INTO THE SUNLIGHT...AND THE ROCKET HAD JERKED UP, BLOOMED OUT GREAT FLOWERS OF HEAT AND COLOR, AND RUN AWAY INTO SPACE ON THE *FIRST VOYAGE TO MARS!* AND NOW, IT WAS DECELERATING WITH METAL EFFICIENCY IN THE UPPER ZONES OF MARS'S ATMOSPHERE...

NAVIGATOR LUSTIG, ARCHAEOLOGIST HINKSTON, AND CAPTAIN JOHN BLACK WATCHED MARS SWING UP UNDER THEM...

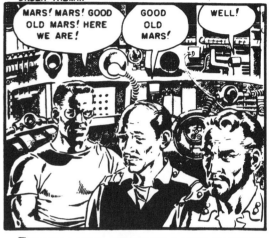

MARS! MARS! GOOD OLD MARS! HERE WE ARE!

GOOD OLD MARS!

WELL!

THE SHIP LANDED SOFTLY ON A LAWN OF GREEN GRASS. OUTSIDE, UPON THE LAWN, STOOD AN IRON DEER. FURTHER UP THE LAWN, A TALL BROWN VICTORIAN HOUSE SAT IN THE QUIET SUNLIGHT. AN OLD SWING WHICH WAS HOOKED INTO THE PORCH CEILING SWUNG BACK AND FORTH, BACK AND FORTH, IN A LITTLE BREEZE...

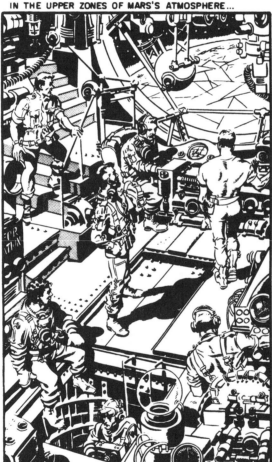

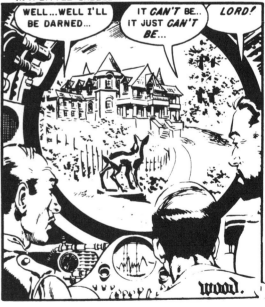

WELL...WELL I'LL BE DARNED...

IT *CAN'T* BE... IT JUST *CAN'T* BE...

LORD!

FIGURE 3–13 *Wally Wood. Pen and ink. Wally Wood/Weird Science #18. "Mars is Heaven," by Ray Bradbury © 1948 Copyright © 1952 Fables Publishing Co., Inc. re © 1980 William M. Gaines, Agent)*

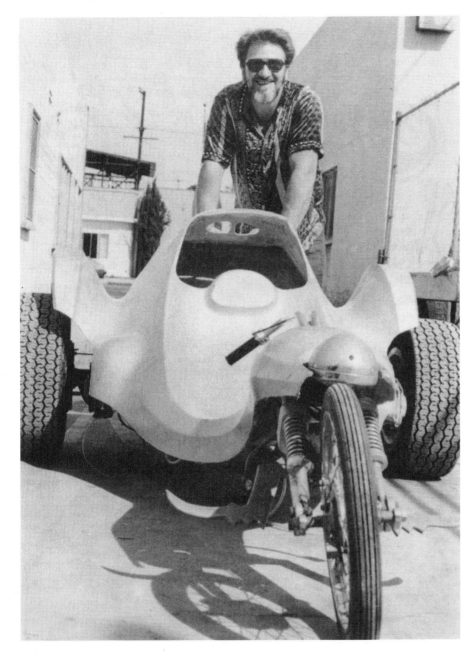

FIGURE 3–14 *Ed "Big Daddy" Roth with customized VW-powered "Secret Weapon." 1967. (Petersen Publishing Company, Photo Department. Courtesy Ed Roth)*

portive group that can offer positive feedback, even if you're not discussing art or landscape architecture per se.

Inspiration

"Examine all things intensely and relentlessly. Probe and search . . . follow it down until you see it in the mystery of its own strength." (Dillard 1989, 78)

How do you find your own source of ideas and locate your personal muse? Inspiration is integral to the drawing process, for one must be inspired to draw well. Art is the process of sifting through many inspi-

FIGURE 3–15 *Author. High school sketchbooks, 1963. Pen and ink.*

rational sources and bringing them into focus to produce your own singular vision. Finding your own muse is critical to sparking your imagination. First, you must love your work and love that which fires your imagination. No one will come up and whisper directions into your ear. You must be open-minded and simultaneously focused on your ideas. You must develop tricks to spur your imagination, and consistently court your muse, for it can be illusive and bewildering.

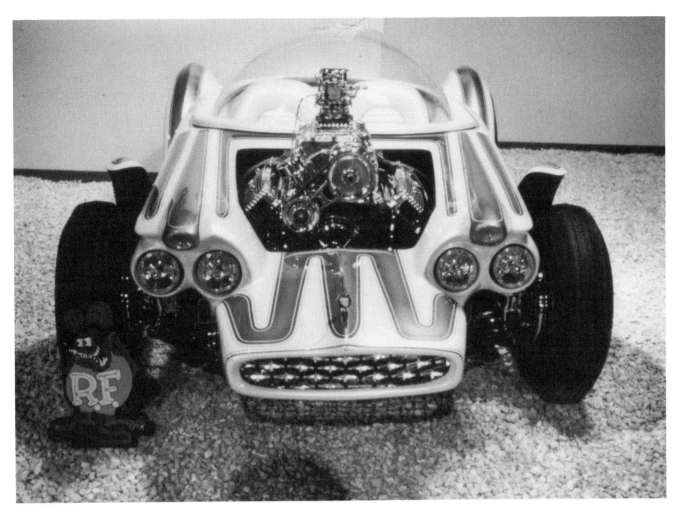

Figure 3–16 *Ed "Big Daddy" Roth's "Beatnik Bandit." 1962. (Photo: Kathryn Drinkhouse)*

Since I did not have a traditional art education, my personal sources of inspiration tend to be unusual. Sometimes you must look for unusual and nontraditional sources of inspiration if you are going to take innovative leaps. Inspiration and creativity are very closely linked.

My earliest inspiration came from the illustrations in 1950s *Mad* magazines; particularly the science-fiction landscapes of Wally Wood. Each of his highly detailed drawings could hold my attention for at least an hour. Unfortunately, that was the length of our high-school class periods. I would spend an entire class period losing myself in his drawings and exercising my imagination rather than memorizing math or Shakespeare. Luckily, I did not suffer much in the long-run. I learned primarily from copying Wood's marvelous ink lines, highlights, and shadows. Drawing his wild landscapes opened up my imagination while I developed my drawing skills. Today I judge the quality of a drawing by how long it holds my attention; the proper length of time is the length of a high-school class, about fifty minutes.

Later in high school I discovered the "monster" tee-shirts of Ed "Big Daddy" Roth, and sent away for his catalog. I would spend hours studying his drawing technique and the crazy, imaginative custom cars he designed, and copying his tee-shirt designs until I could draw them

from memory. Eventually I took all these images and reassembled them into surrealistic landscapes, which were my first forays into landscape architecture.

These images, together with the sculptural art of hot-rod cars, were my early muses. What I learned from these works was that art is a transformational process, something that you do for the love and passion of it, something that rarely pays for itself. Most people have to work other jobs in order to support their art, but it is the vision that counts.

As noted earlier, in addition to studying the visual arts, many illustrators, painters, and sculptors immerse themselves in literature or poetry. In college, I discovered the literature of the Beats, and was especially awed by Kerouac's *On the Road*. It was from his observations of the artistic community that I first realized the importance of being part of a community of like-minded beings. I was also impressed with the Beats' enthusiasm for life, and their explosive way of embracing their surroundings. Their work allowed me to begin to see landscapes in a nontraditional way and forever changed my perceptions of reality:

> *I wasn't frightened at all that night; it was perfectly legitimate to go 110 and talk and have all the Nebraska towns—Ogallala, Gothenburg, Kearney, Grand Island, Columbus—unreel with dream-like rapidity as we roared ahead and talked. It was a magnificent car; it could hold the road like a boat holds on water. Gradual curves were its singing ease. "Ah, man, what a dream boat," sighed Dean. "Think if you and I had a car like this what we could do. Do you know there's a road that goes down to Mexico and all the way to Panama?" (Kerouac 1955, 189)*

The Creative Process

> *When Matisse painted he tried to get closer and closer to his original sensation, to apprehend and comprehend the mood, the mode, and feeling that led him in a certain direction. He trusted his intuition; he concentrated until eventually he was able to conclude. (Gilot 1990, 156)*

Creativity is perhaps the most important step in the production of innovative and exciting drawings. There is a certain degree of magic and mystery to creativity, but if you understand the process it may come easier. First, you must be open and receptive to your imagination. Creativity is not one of those things that comes effortlessly; it is not instantaneous. It takes a lot of work, and artists work at it constantly. Creativity is 90 percent hard work and intense preparation. Ideas implanted in your mind linger for a long time; they're nurtured, then explode into a burst of creative energy. When Hemingway lived in Key West, he would get up early every morning and go out to his writing studio. He would sit at his typewriter until early afternoon even if nothing came to him; even if he could not write a single word. If nothing came by afternoon, he would then head down to Sloppy Joe's Bar. But when the ideas clicked and the energy flowed, he would sit for days typing. The creative flow is very much intertwined with perseverance.

In their book *Seeing with the Mind's Eye*, Mike and Nancy Samuels state that the creative process consists of four stages: preparation, incubation, illumination, and verification. In the first stage, preparation, the artist consciously and unconsciously searches for an idea; sometimes this idea remains unknown to the artist. As a result, he or she builds a storehouse of ideas, collecting data, reading, looking. Preparation is a state of anticipation and even anxiety.

FIGURE 3–18 *Charles Burchfield.* Falling Leaves, Maple Tree. *Crayon on paper. 21″ × 15″. (Courtesy Kennedy Galleries Inc., New York)*

FIGURE 3–19 *Author. Visionary Landscape. 1989. Pen and ink on paper.*

During the incubation stage, the ideas, thoughts, designs, and concepts gestate in the subconscious. Researchers theorize that this is the most important stage of creativity. The impulse lies dormant in the subconscious mind and deals primarily with images. Often in this stage, artists receive incomplete visions of images they are trying to resolve. As the Samuelses put it, "In the mind unconscious images join, rejoin, become interlocked, and form entirely new images." (1975, 241)

The third stage, illumination, is that unexpected moment when the vision takes on concrete form in the imagination. Images come forth freely and easily; the artist is connected with a stream of consciousness of images. This spontaneous moment of inspiration is combined with feelings of happiness and well-being. This is the state for which all artists strive, and it is perhaps the most exciting stage in the creative process. The Samuelses call the moment of illumination "a visualization experience—a dense, wordless, sensory experience symbolic of a highly complicated concept." (1975, 248)

Verification is the process of organizing and refining the work. The design begins to take form easily; you reshape the ideas, making minor adjustments, and complete the product. The artist can step away from his or her personal attachment to the work and view it with a critical eye. This is the point where skill to draw the images from stream of consciousness becomes valuable.

Of course, this is a very rational analysis of the process, and artists should not try to force their work into such an orderly system. However, you should try to be aware of how your own ideas originate, form, and become reality. Realize that there is no linear way to proceed and that the creative process shifts among these stages.

EXERCISE 3–2: *Finding a Comfortable Place to Work*

To facilitate the creative process, it is important that you have a place set up where you can work. This must be a personalized space, receptive and relaxing. Next, you must set aside a certain time each day when you will be at this place; this time should be sacrosanct. Sit there daily, drawing, writing, thinking, and daydreaming. The most important thing about arriving at the point of illumination is to be continually at work on solving problems. Without this persistence, the illumination will not come. Although illumination usually occurs during an activity totally unrelated to the problem, often when you are distracted, it will not happen unless you are continually working. Free yourself from ordinary fixed ideas, visualize your thoughts, and brainstorm for completely new solutions.

The most productive time of day varies with the individual. Some artists get up at four in the morning and work before they have to go to the office. Others find the late evening to be their best time. Some come home from work in the evening, take a short nap, get up and make a pot of coffee, then work late into the night. Find the best time for yourself to work and stick to it.

When Jack Kerouac had written his first complete draft of *On the Road,* he experienced an almost ecstatic state. After many false starts, beginning with his journal entries in 1948, Kerouac embarked on a new version of the novel in 1951. In early April he taped together twenty-foot strips of Japanese drawing paper so he would not have to interrupt his flow of words by having to put new sheets of paper into the typewriter. He then began.

> *For the next twenty days he typed almost non-stop. He slept rarely. . . . He was sweating so badly that he went through dozens of tee-shirts a day, wringing them out and hanging them all over the apartment. By April 9 he had written 34,000 words; by April 20, 86,000, nearly finishing the novel. The whole manuscript was a single paragraph with no commas and few periods. . . . He had finally found his own literary Road. (Nicosia 1983, 343)*

You have to work very hard to reach such an intense flow of creativity; if and when you find it, stay with it, you can work for long periods of time in this heightened state.

When the painter Phillip Guston was overcome by the creative state, the results were much the same:

> *I've been painting around the clock, 24 hours or more—sleep a bit and go back to it—it is totally uncontrollable now. . . . It is a new "Real" world now that I am making—and I can't stop. . . . This is a way of working not defined essentially by chronological age, but by certain attitudes: a newly discovered freedom, a belief in instinct, a sense of isolation, a feeling of holy rage. (Mayer 1988, 179)*

Charles Burchfield also spoke of reaching this point:

Ideas, memories and sensations are pouring in upon me. . . . I feel as if I ought to have four hands and 48 hours. . . . After I got into bed I had to get up again and again to jot down ideas. My hand seemed to work without any help from my mind. It was almost midnight before the tumult in my brain subsided. (Baur 1956, 76)

Understanding the steps that induce such a heightened condition is a good place to begin. The productive states just mentioned transmit and translate ideas from our minds into visual representation.

Visionary artists, able to discern what the rest of us still cannot, embrace and announce through their art the principles emanating from this 'spiritus mundi.' (Schlain 1991, 387)

Equipment and Drawing Instruments

*One thing is quite certain: in creative moments I have
the great privilege of feeling thoroughly calm, completely naked
before myself, not the self of a day but the whole sum of self,
totally a working instrument.*

PAUL KLEE
The Diaries of Paul Klee

FIGURE 4–1 *Author. Drawing equipment.*

Equipment

Now we take up the matter of equipment. Though drawing aids are best avoided for spontaneous freehand drawings, there are certain tools you will need. The quality and character of your drawings will be dictated to an extent by the equipment and materials you use. There are so many kinds of drawing tools to choose from that even an expert can be overwhelmed, so the best rule is to start out buying only a few tools of excellent quality and then slowly accumulate more. You can learn a lot about drawing tools and supplies by studying catalogs. Two excellent catalogs are *Daniel Smith Inc., A Catalog of Artists' Materials* (4130 First Avenue, South Seattle, Washington, 98134), and the *Charrette* catalog (31 Olympia Avenue, Woburn, Massachusetts, 01888). Browsing in your local art supply store can also be very informative.

A solid, smooth surface to work on is a necessity. A wooden drawing board, 23-by-31-inches, provides a good surface. For field sketching, a portable 18-by-24-inch drawing clipboard and large rubber bands to secure the paper in the wind is useful.

A heavy sheet of illustration board can provide a fine drawing surface. If you leave your work out on the drawing board for extended periods of time, use a cloth cover to protect it. To hold your work in place use low-tack drafting tape, available at art supply stores. Masking tape is much stronger and can easily rip paper. Thumb tacks and push-pins will also come in handy for holding your work down and for hanging it up to look at. An X-Acto knife with a #11 blade will be useful. Use a metal straightedge whenever you cut paper or cardboard.

Triangles and a T-square should be in every studio as well, to help you make straight lines. Standard triangle sizes are 30/60 degree and 45 degree; an adjustable 45 degree triangle can be quite useful because it can be adjusted to make angles from 0 to 90 degrees. The length of the T-square corresponds to the length of the drawing board. Test a variety of triangles and T-squares at the art supply store to find the ones that are right for you.

No studio should be without an architectural scale and an engineering scale. In representing objects that are larger than can be drawn to

FIGURE 4–2 *Clockwise from top left: Drafting-tape dispenser; tracing paper; Flexi-curve; circle templates; T-square; clear plastic triangles; X-Acto knife; adjustable triangle; heavy-duty matte knife; metal straightedge; compass; architects' and engineers' scales; a parallel glider. (Photo: Kathryn Drinkhouse)*

FIGURE 4–3 *Storage containers.*
(Photo: Kathryn Drinkhouse)

FIGURE 4–4 *Emily Stussi. Pencil and kneaded eraser.*

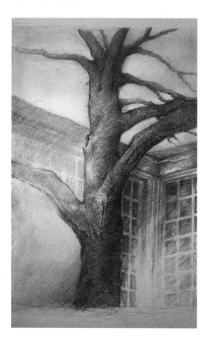

their full size, it is necessary to reduce dimensions on the drawing proportionately. Most often design ideas are drawn to a proportion of their true size so they can fit within the area of the drawing board. A scale can reduce or enlarge dimensions proportionally. Scales can come in two different types, either flat or triangular. Architectural scales are divided in $\frac{1}{8}$, $\frac{1}{4}$, $\frac{1}{2}$, $1\frac{1}{2}$, 3, $\frac{3}{32}$, and $\frac{3}{16}$ inches to the foot. Engineering scales are divided into 10, 20, 30, 40, 50, and 60 parts to the inch. These come in many varieties; pick one that suits your individual taste.

A variety of circle templates will also be necessary, particularly for drawing landscape plans. Obtain templates with both small and large circles. An adjustable compass with interchangeable ink and pencil points is an excellent tool for drafting circles of all sizes.

Empty tomato cans and large glass jars are great for holding drawing tools. Cigar boxes are not only beautiful objects, they are also utilitarian. If you don't smoke cigars, visit your local cigar store and buy empty boxes.

A large portfolio is necessary to protect and store your drawings; be sure to always lay your work flat. In the field, a large canvas carpenter's bag is ideal for holding all of your tools.

Finally, it is also a good idea to work in a well-ventilated place with a window, which you can open and get fresh air.

The Pencil

Even the experienced artist, accustomed to the everyday use of these accessories, can hardly gaze upon a new clean sheet of paper and pencils pointed and ready to use without itching to begin, a desire to seize a pencil and be at it. There is something about such materials that lures you on and urges you to do your best. (Guptill 1977, 15)

The pencil is a timeless instrument and perhaps one of the most versatile drawing tools you can own. The old-fashioned wooden pencil has an incredibly sensitive touch and feel. Wooden pencils are the best to use because of the warm feel of the wood. They also give off a wonderful wood smell when they are hand-sharpened with a knife. When used to their full potential, pencils can yield marvelous results, from quick studies to detailed works. Paul Klee became so attached to his pencils he gave them names such as Nero, Chrutti, and Rigoletto.

Graphite pencils range from very soft to very hard. The pencil grading system ranges from 9H, for hardest, to 9B, for softest, with HB and B in the medium range. Pencils are usually numbered in the following order: 9H, 6H, 5H, 4H, 3H, 2H, H, HB, B, 2B, 3B, 4B, 5B, 6B, 7B, 8B. The softer the pencil the more often you will have to sharpen it. Pencils are either hexagonal or round; you have to decide which type is the most comfortable to use. Often you will use a few different pencils in the same drawing in order to achieve a variety of marks. It is best to

FIGURE 4–5 *Pencils, clockwise from right: The classic Dison Ticonderoga #2; HB; 2B; 6B; Berol 314 Draughting; Ebony 6325; Pink Pearl eraser cut into special shapes; kneaded eraser pushed into small ball; erasing shield with bent corner for easy pickup; sanding block; single-edged razor blade; pencil extenders. (Photo: Kathryn Drinkhouse)*

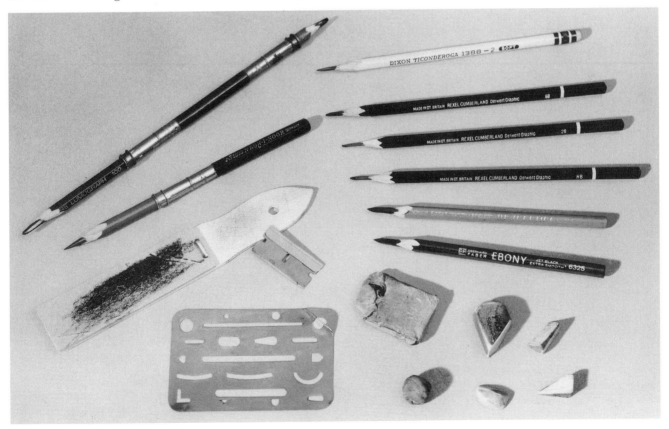

avoid the harder drafting pencils, except for specific tasks such as hard straight lines. When selecting a pencil look for one that will produce a consistent, solid line with lead that does not break easily. The Eberhard Faber Ebony 6325 is a classic pencil and produces a very smooth black line. Another classic is the Berol 314 Draughting pencil, which was developed for architectural sketching and drafting. Along with these, everyone's sketch box should contain a Dixon Ticonderoga #2, and an HB, a 2B, and a 6B.

Sharpening

For sharpening the pencil some artists use a hand-operated or electric pencil sharpener. The advantages of the electric sharpener are that it is quick and produces a consistent symmetrical point, but it wastes a lot of the pencil. The best way to sharpen a point is still by hand; this gives the most control over the type of point selected. To shape a point by hand, use a single-edged razor blade or an X-Acto knife. Cut the wood back three quarters of an inch, exposing a quarter-inch of lead. Use a sanding block to point it; if you've made a long taper the pencil can easily be repointed many times on the sanding block before recutting it. First, decide what type of point is needed: a standard tapered point, chisel point, or blunt point. The chisel point can be used to create a variety of very sharp to very broad lines. The blunt point can be used to make very broad, thick lines. Keep a rough piece of paper next to your drawing and rub the point on it to shape it between sandings. Keep a soft cloth nearby to wipe excess graphite from the point. I've made a special box for sharpening my pencils that holds the cuttings and has a built-in sanding block and cloth. When doing a lot of pencil work it is a good

FIGURE 4–6 *To sharpen the pencil, cut back the wood to a long taper, exposing about a quarter-inch of lead. (Photo: Kathryn Drinkhouse)*

idea to start the day by sharpening a number of them. When the drawing is going well you won't have to waste time sharpening your pencil. This ritual is something that should be enjoyable and savored.

The pencil holder or lengthener is a great device that prolongs the life of a pencil, which is especially important if you become attached to your pencils. Some artists like them for the balance they give the pencil. When doing a lot of pencil drawing, put a cloth or piece of paper under your hand to keep from smudging the lines. Better yet, use a drawing bridge so your hand floats above the paper. A drawing bridge is a slightly elevated resting surface for your drawing hand to prevent smudging. They can be purchased at most art stores. After completing a drawing, varnish-like effects can be achieved by coating it with either acrylic matte medium or acrylic gloss medium.

EXERCISE 4-1: *Pencil Practice*

After selecting your pencils, practice drawing with them on a variety of surfaces. Look for the different reactions of each pencil. Practice filling up a large piece of paper with random, wandering doodles; see what kinds of lines the different pencils produce. Use a sanding block to make different points and see what they can do. Push the limits of each pencil.

Erasing

The all-around best tool for erasing pencil work is the soft, pliable kneaded rubber eraser. The kneaded eraser can be used in several ways: you can press it down and lift off the graphite to lighten up lines or tones; it can be pinched together to erase small areas; and with firm

FIGURE 4–8 *When drawing, put a cloth, a piece of paper, or a drawing bridge under your hand. (Photo: Kathryn Drinkhouse)*

rubbing it can totally remove pencil marks. Pink Pearl or gum erasers are ideal for erasing graphite not easily removed with a kneaded eraser. With a knife they can be trimmed into small shapes for tiny erasures. Keep a soft brush nearby to wipe the erasures off the paper so they will not get smudged into the drawing. A flexible stainless-steel erasing shield can be used as a guide to accurately remove a limited area of pencil work without disturbing the surrounding drawing.

Drawing Paper

There is an enormous variety of papers available today; find the types that are most receptive to your work. Take time to learn about the unique characteristics of each type of paper. When you find the right paper it can be an inspiration. There is no substitute for feeling and seeing the

paper to learn about its qualities. You should always use an acid-free paper with a neutral pH. The *tooth* of the paper is its surface roughness and will affect line quality. For example, a smooth, glossy paper requires a much softer pencil, whereas rough paper takes a harder pencil.

For general sketching practice, the 18-by-24-inch Biggy Jumbo Sketch Pad is fine. It is acid-free and provides an excellent surface for drawing in all media, including wash. Strathmore 500 Series Bristol Drawing Paper is outstanding for drawing. It is 100 percent cotton, acid-free, and can take repeated erasures and reworking. It comes in a vellum finish, which is slightly toothy, and a plate finish, which is smooth. Lightweight yellow tracing paper has many fine qualities for drawing with pencil: it has a wonderful tooth, it can be used for overlays, and it is inexpensive. Its yellow tint makes it pleasing to the eye and a good background for pencil. Drafting vellum has a fine surface for pencil drawing and drafting, along with excellent tooth and good erasability. It is transparent and can be used for overlays. Because of their transparency, both yellow trace and vellum have long been the standard papers for blueprinting and *diazo,* which is a copying process. When used in diazo, yellow trace will produce a slightly gray background, but many designers like this effect. Vellum will usually reproduce fairly clearly.

Soft Media

Soft media like charcoal and pastel are not often used in landscape architectural drawings, but they can be employed for special effects. The red chalk landscape drawings of Leonardo da Vinci illustrate the potential of soft media. He was able to produce atmosphere and detail with a simple piece of chalk.

Charcoal

Charcoal is an indispensable tool for the artist and has been used for centuries. It comes in a variety of hardnesses. It is easy to use and is excellent for atmospheric techniques or quick drawings. For landscape drawing it can be rubbed into a smooth rich surface to produce dense areas. To smooth it you can use your fingers, a kneaded eraser, a stump, or a *tortillon* (rolled papers for smoothing soft media). A kneaded eraser can also be used to lighten dark areas. The best type of charcoal to use is a 4B Conté compressed stick. The Bistre (brown umber) and the Sanquine Watteau (red) Conté crayons are also classic drawing tools and can be used in the same manner as charcoal.

Pastels

An advantage of pastel is that it is immediate and convenient, and comes in a wide range of brilliant colors. It can be very difficult, however, to get fine details, and because of its powdery nature, it must be set with a fixative. Pastels are effective for transparent washes of brilliant

FIGURE 4–9 *Leonardo da Vinci.* Storm Over a Valley in the Foothills of the Alps. *Red chalk. c. 1500. 198 × 150 mm. (The Royal Collection © 1993 Her Majesty Queen Elizabeth II)*

color over ink or pencil drawings. The basic primary colors are all that is needed to begin. For skies, water, or ground planes, they are ideal. Take a razor blade or an X-acto knife and shave off a fine powder of pigment onto a sheet of paper. Use a cotton ball or cotton swab to pick up the pigment and lightly rub it down on the drawing. Repeat this process until the designated area is covered. Use your fingers, a stump—a cigar-shaped implement to blend or smudge soft drawing mediums—or a soft cloth to smooth it out. A kneaded eraser can also be used for blending or lifting off the pigment.

Oil Pastels

Oil pastels are very expressive media and difficult to use. They can be used for creating bold, abstract, and impressionistic landscapes. They cannot be sharpened, so they're not very accurate; also, you cannot erase them. Oil pastels are more resistant to rubbing than pastels and do not need to be fixed. They are best used over an ink or pencil drawing for broad areas of color. Oil pastels produce unusual depth when you use them to color the underside of drawings on transparent paper. You can blend them with linseed oil and a cotton swab, and use a knife to scrape away color, creating sharp lines. You can also use oil pastels to color photocopies.

..

EXERCISE 4–2: *Soft Media*

Take you all your soft media and play with them in your Biggy Jumbo tablet. See what they can do. Practice blending, rubbing, lifting, and erasing them. Use your fingers to push them around.

..

FIGURE 4–10 *Clockwise from top right: Conté crayons; 4B Conté compressed charcoal stick; kneaded eraser; tortillon; pastels; oil pastels; stump. (Photo: Kathryn Drinkhouse)*

FIGURE 4–11 *Walter Hood. Landscape. Oil pastel. 1994.*

Pen and Ink

Pen and ink was used for writing and drawing as early as 2500 B.C. From the Renaissance through the nineteenth century, artists and draftsmen developed the pen-and-ink technique to the point where, today, it holds an important position among the artistic media. Drawing with pen and ink has distinct advantages. It is a very inexpensive medium that allows you to make crisp, delicate, accurate drawings with absolutely black lines. Ink line drawings will not fade, and can be effectively and economically reproduced as high-quality images. There is probably no other medium that allows for such a high degree of development of personal style.

The Steel Quill Pen

The steel quill pen is an exquisite instrument; nothing can quite equal its undulating swiftness. It is one of the most vigorous and expressive of all the available drawing instruments. There are innumerable styles of pen points from which to chose. For a good, versatile beginning set, choose the #102 Hunt Crow Quill for very detailed, fine-line work; the #99 Hunt drawing point has a very flexible point that produces some very expressive lines; and the #512 Hunt Extra Fine Bowl-Point has a rounded point for making large, bold lines. A holder with a

good feel is the Koh-I-Nor #127 with a cork handle. Write down the style and number of your pen points before they become caked with ink and you cannot read them.

India ink is the best to use in your pens. Get a bottle with a wide bottom so it will not spill easily, and a rubber dropper to fill the pen point. Always shake and stir the ink before using it. A small wide-mouth jar with a lid can be used as an ink well and is faster than using the ink stopper. Placing the ink in a small cardboard box makes it next to impossible to spill. Next to the ink source, tape down a small piece of paper to test the ink flow before drawing. Next to the test strip have a soft cloth and wipe your pen clean every so often.

Technical Pens

Technical pens are a great advancement for architectural drafting; they produce even lines and can't be beaten for drafting work that needs consistent line quality. This uniformity of line is also one of the major drawbacks of technical pens; they don't allow the dynamic texture and spontaneous line of a flexible steel quill.

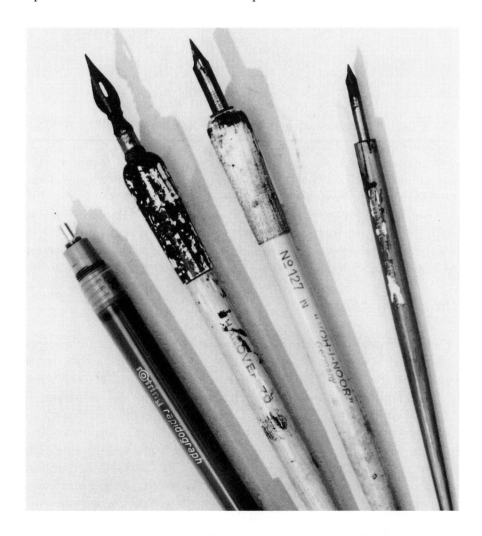

FIGURE 4–12 *Left to right: the technical pen; #512 Hunt extra fine bowl; #99 Hunt drawing point; #102 Hunt crow quill. (Photo: Kathryn Drinkhouse)*

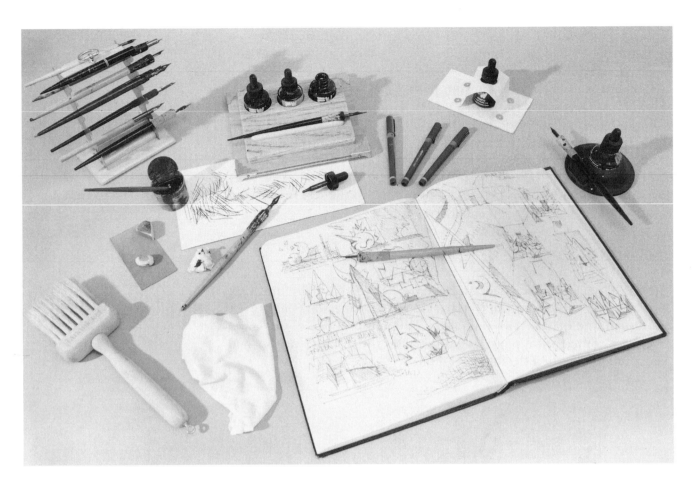

FIGURE 4–13 *Setting up for ink drawing. Clockwise from top left: holder for steel quill pens; metal school inkwell; wood holder for ink bottles and paper for testing pens; technical pens; cardboard holder for inkwell; rubber Higgins ink bottle holder; sketchbook with #99 Hunt drawing point; soft cloth for wiping pens; brush; #512 Hunt extra fine bowl; tissue; Castell MagicRub erasers. (Photo: Kathryn Drinkhouse)*

Technical pens come in a variety of widths from very fine to quite wide. Another disadvantage of these pens is that it can be difficult to keep them working, because they clog easily, although there are now several on the market that are trouble-free, including the Rotring and the Rapidograph. Point sizes 00, 1, and 3 provide the basic line weights for most drawing requirements. For special effects you can use quill and technical pen together. A specially formulated nonclogging ink is designed for these pens and you should use it. It is a dense, free-flowing ink that produces high-quality lines and comes in a variety of colors.

The Drawing Surface

Steel quill pens and technical pens work best on smooth, hard paper. If the paper is soft and rough, the finer pens will catch on the surface and break the flow of the line. The more porous papers will cause bleeding and will produce unusual lines. Sometimes this effect can be used to your advantage, but if you want control, don't use porous paper. Likewise, tracing paper is difficult because it wrinkles under ink. Drafting vellum is excellent for ink as well as for pencil drawing. The three-ply Strathmore 500 Series is great; both the plate and vellum respond well to ink. You can also get some interesting effects with watercolor papers. Try a variety of papers to see which kinds work best for

FIGURE 4–14 *Author. Quill pen and ink on Strathmore board. 1989.*

you. Before using the paper rub it with Pounce, a powdery preparation that keeps the ink from smudging and keeps oil from your hand off the page. Brush off any remaining Pounce so that the pen does not pick it up. As you are drawing, periodically Pounce the paper to remove any dirt or grease that might have accumulated.

Inexpensive tracing paper can be used to work out your rough preparation sketches. The drawing sequence can evolve by tracing the original drawing onto a series of tracing paper overlays where the drawing is refined on each successive overlay. When you begin your final ink drawing you can use a light table to trace the study drawing onto the final paper. Be careful not to drag your hand through the wet ink.

Nonreproducable blue pencils can be used for the underdrawing for the finished ink drawing. When subjected to printing or photocopying the blue underdrawing will disappear, leaving only the ink lines. The advantage of this process is that you do not have to erase the pencil lines. If you use the standard pencil for the underdrawing make sure the ink has dried thoroughly before you erase. To erase the pencil use a plastic Faber Castell Magic Rub or a gum eraser. With a sharp single-edge razor blade, scrape off small mistakes. An old fashioned typewriter eraser can be handy for removing mistakes or lightening up the ink

lines. An electric erasing machine can rapidly remove ink lines. These are excellent for removing large areas of ink but they should always be used with an erasing shield. Be careful not to damage the drawing surfaces.

EXERCISE 4–3: *Ink Practice*

With all your ink pens, make thousands of lines in your Biggy Jumbo tablet. Learn the limitations and possibilities of your pens, but most of all, become comfortable with them. Because ink is permanent, many people are afraid to use it. Make random lines until you gain confidence.

Colored Pencils

Through the use of colored pencils you can rapidly produce colorful three-dimensional drawings. Colored pencils come in a variety of brands. When you select your palette, look for colors that are easy to blend. Two of the best colored pencils on the market are the Berol Prismacolor and the Rexel Derwent Studio Pencil. Prismacolor has a

FIGURE 4–15 *Colored pencils left to right: Berol Verithin; Faber-Castel Col-Erase, Rexel Derwent Studio pencil; Prismacolor; Prismacolor sticks. (Photo: Kathryn Drinkhouse)*

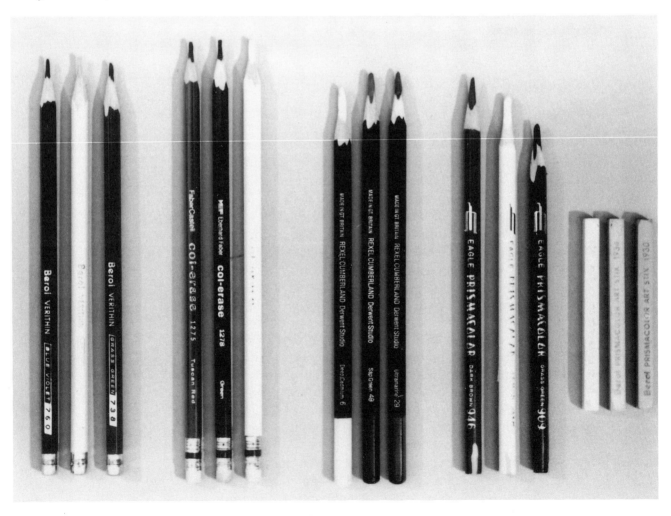

large-diameter lead, which gives soft, smooth lines that are very easy to blend. Derwents are a little harder to blend, but they hold a fine point. Both brands have a wide selection of colors. The Berol Verithin have very hard, fine leads that can be sharpened to hold a fine point for drafted lines. They do not blend easily and are good for detail work and for emphasis over previously applied color. Faber-Castel Col-Erase Pencils also have hard, fine leads that hold their point and do not blend well. They do have the advantage of being erasable, however, and have a special eraser on their tip.

Prismacolor also comes in stick form, which allows broad washes of color when laid on its side, and broad flat lines using its ends. Try out a few brands of colored pencils to see which ones you like, then gradually build up your supply.

Sharpening

Because the lead in colored pencils is so soft and breakable, it is not a good idea to sharpen them in a handcrank pencil sharpener. It is also not wise to use an electric pencil sharpener, because the wax from the pencil will eventually clog up its mechanics. Even a small hand-held pencil sharpener will sometimes break the lead. Therefore, it is best to

FIGURE 4–16 *Setting up the palette. Clockwise from top left: library of color combinations; sharpening box to hold shavings with sandpaper for pointing pencils; cloth for wiping point; pencil extender; sanding block; single-edge razor blade; pencil holder made from sheet of cardboard. (Photo: Kathryn Drinkhouse)*

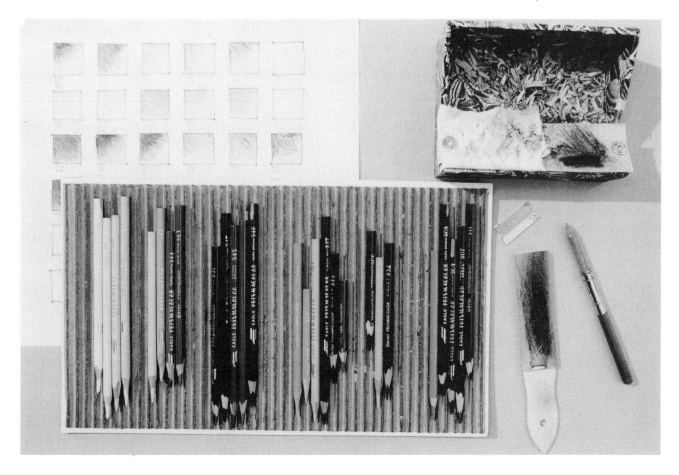

sharpen a colored pencil by hand, the same way you would a wood pencil. You can also use a sanding block to give the pencil a chisel point, which can be used for shading and blending.

Setting Up Your Palette

It is important to develop a system for setting up your palette. Lay out your pencils according to color family, from light to dark. Corrugated cardboard or a cigar box is handy to keep pencils from rolling around, or you can buy a set that comes with a special tray. Some suggested colors to start your palette are: Crimson Red, Tuscan Red, Canary Yellow, Yellow Ochre, Ultramarine, Indigo Blue, Grass Green, Dark Green, Raw Umber, Sienna Brown, Burnt Ochre, and Sand.

EXERCISE 4–5: *The Basic Stroke*

Lay out a page of four-inch squares in your Biggy Jumbo sketch pad. Use a sanding block to smooth the tip of a pencil to a slight angle; use any color. Hold the pencil lightly, and, starting in one corner of the square, lay down smooth, even, diagonal lines that barely overlap. There should be no perceivable lines. Keep your stroke moving across the page at an even speed. See what happens when you speed up or slow down.

EXERCISE 4–6: *Overlaying Colors*

Practice overlaying different colors on top of one another. Make a series of four-inch boxes and experiment mixing different colors. Lay down smooth even tones and overlay a variety of colors to see what happens. Mix several colors on top of one another to get deep overlays until no white paper shows through. See how the line changes when you grip the pencil harder.

Make sure the drawing surface is free of any cuts or pieces of tape or small paper, because your coloring will pick up shadow images of anything on the surface below. When using colored pencils, work on a smooth, clean surface. The smoother and harder the surface, the smoother your color blending. Glass is an excellent surface to color on. Different surfaces can be used to achieve unusual textures. For instance, coloring your drawing on a wooden wall will pick up the grain of the wood. Lay your drawing down on a sidewalk and color it to pick up unusual textures. It is fun to experiment with different surfaces.

Coloring Your Drawing

Before starting a final rendering, make a page of one-inch squares and fill them with the colors you will be using. Note the colors used under each box. Test the colors you want to use on a separate piece of paper to study the mood you want to achieve. Determine the time of

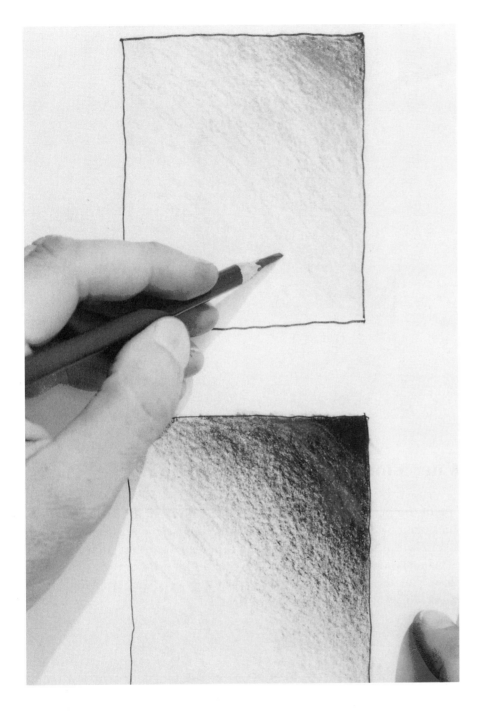

FIGURE 4–17 *The basic stroke, laying down smooth diagonal lines. (Photo: Kathryn Drinkhouse)*

year you want to portray; decide where the sun is coming from, and keep the light source consistent. Always start with the lightest colors, laying down smooth, even lines and building up color with a series of light washes. Use a diagonal stroke and move very slowly. Start off with light pressure and grip the pencil harder as you gradually move toward completion. Add details and textures. After you have finished all the coloring and added highlights, put down shadows. Shadows should always be added last since then can be effective for adding depth to the elements of the drawing.

Watercolor

One of the beauties of watercolor is its innate flexibility: you can make quick sketches in transparent wash and finely detailed finished paintings in luminous colors. Perhaps no other medium has such an ability to make landscape drawings come alive. Once mastered, watercolor allows you to complete landscape drawings very quickly. Working in watercolor is also relatively inexpensive.

Brushes

The brush should be considered an extension of your arm. For watercolor it is very important that you use good brushes. The best type of brush to use is the sable round—the traditional watercolor brush shape. These extremely soft and flexible brushes hold an excellent point and are capable of making thick broad areas and very thin lines. The Winsor & Newton Series 7 brushes, made with Kolinsky sable hair, are just about the best watercolor brushes you can buy. The synthetic watercolor brushes now on the market also handle well. The Winsor & Newton Scepter Gold, a mixture of sable and synthetic fiber, is much less expensive than an all-sable brush and works about as well. The blend of natural and synthetic hairs holds water well and has a springy point. For a beginning set I recommend three basic brushes: a number 7 for detail

work; a number 12 for general work; and a number 24 for large washes. Test all brushes before buying them. Look for a brush's balance point and check its springiness by bouncing it in the palm of your hand. Brush it along your cheek to see if it has any scratchy hairs; it should feel smooth and silky. Good art stores will usually have a jar of water and some paper for brush-testing. Dip the brush in the water and see if it holds its point. A good brush can last a lifetime.

Another good brush to have is the French-made Isabely Squirrel Mop. The number 8 holds a lot of color and is great for laying down large washes for skies, water, or ground planes. Another important brush is the one-inch sable flat. When this brush is loaded with paint it forms a broad chisel edge, which can be used for a lot of unusual effects, from broad sweeping washes to thin lines.

A couple of natural sponges are ideal for dampening areas, laving down washes, and removing color, and blotting paper can remove

FIGURE 4–19 *Basic watercolor brush set. Left to right: number 7 round; number 12 round; number 24 round; Isabey squirrel mop number 6; 1-inch flat. (Photo: Kathryn Drinkhouse)*

excessive water or color from the painting. Never clean your brushes with soap or hot water. After use, rinse them in cold water and store them upright. Never leave them on their ends in water. Use watercolor brushes only for watercolor.

Colors

There are two basic packages for watercolors: pans and tubes. Tubes are handy for mixing large amounts of paint for broad washes; pans are portable and useful for traveling or outdoor sketching. The paints come in a variety of qualities, from cheaper student brands to expensive, high-quality colors. The quality and brilliance of the better brands is so superior that there is no comparison. There is some variation in color from one manufacturer to another, so it is a good idea to study the manufacturer's color charts before buying paint. Winsor & Newton Artists' Watercolors are the most widely used colors in the world and are

FIGURE 4–20 *Watercolor types. Clockwise from top left: 15 ml tubes; watercolor field box, with pans for travel; half pans; 5 ml tube. (Photo: Kathryn Drinkhouse*

highly recommended for landscape painting. Before buying any colors open the end of the tube and see if any of the binder (the cementing ingredient in paint) oozes out or if the paint is dried out. Though the high-end may seem expensive, the paints will last a very long time.

For mixing colors I recommend two palettes: the Winsor & Newton China Slant Tile and the Windsor Newton China Cabinet Saucers. The slant tile is made out of porcelain, has five wells, measures 4-by-7½ inches, and can be used for laying out and mixing tube colors. When not using the slant, keep it covered with a piece of cardboard. The porcelain cabinet saucers with a diameter of 2⅝ inches come in a stack of five; you can use them individually for mixing large amounts of colors for washes. The saucers stack to cover and protect your mixes. A porcelain dinner plate bought at a second-hand store can also make a good, inexpensive palette. Just lay out your colors along the rim and mix them in the middle.

The basic colors needed for landscape painting are Burnt Umber, Raw Umber, Raw Sienna, Burnt Sienna, Cadmium Red-Deep, Cadmium Yellow-Deep, Hooker's Green, Cobalt Blue, French Ultramarine, and Payne's Gray.

FIGURE 4–21 *Setting up for watercolor. Clockwise from top left: jar for holding brushes; wide mouth glass jars for water; sponge; china cabinet stacking saucers for mixing colors; paint tubes; holder for setting out brushes; blotter paper; drawing; test strip; sponges; paper towel; china slant tile for mixing colors. (Photo: Kathryn Drinkhouse)*

Paper

Watercolor paper comes in three types: hot press (smooth), cold press (mildly textured), and rough (highly textured). Hot press is very smooth and is a fine surface for drawing in ink or pencil, but it absorbs watercolor washes very fast. It is difficult to work the color for any length of time on this paper, which is better suited for quick, light washes. Cold-press paper takes both pencil and ink work and watercolor washes well. Because of the slight roughness of the paper, the color floats on the surface before being absorbed into the paper; therefore it allows you to work your washes longer. It is harder to draw smooth, even lines on rough watercolor paper, but it is excellent for washes. The rougher the surface of the watercolor paper the darker the color will appear. The roughness of the surface will also affect the look of the transparent washes by allowing the paper to reflect light from the surface.

The thickness of the paper is measured by its weight; the higher the weight, the thicker the paper. Generally, watercolor paper comes in three weights: 90 lb., 140 lb., and 300 lb. Lighter papers tend to buckle. Always use acid-free, 100 percent rag paper, which is made from fibers of nonwood origin, including actual cotton rags, cotton linters, and cotton or linen pulp. The standard size for individual watercolor sheets is 22-by-30-inches. Watercolor blocks are precut, prestretched sheets bound at all four edges in stacks of twenty. They come in a variety of dimensions and weights, and are quite convenient for field work. Arches Watercolor Paper is one of the most popular papers in the world. It is very versatile, handles watercolor wonderfully, and is good for working in mixed media. Any top-of-the-line watercolor paper, such as Fabriano or Waterford, is excellent; each has its advantages and disadvantages. Experiment to find the one that works best for your style.

Stretching the Paper

When working with watercolors you can either use unstretched or stretched paper. The disadvantage of using unstretched paper is that it buckles when it gets wet, and your paint follows the buckles. As a result you do not have total control of the wash, though some artists prefer that spontaneity. Stretched paper allows for much greater control. To stretch paper you need a drawing board at least a half-inch thick and several inches larger than your paper. Thoroughly wet the paper with a sponge or soak it under a cold faucet. Lay the paper on the board, smoothing out wrinkles. Cut two-inch strips of gummed kraft tape about one inch longer than each side of the paper. Wet the tape and apply it first to the longer sides of the paper, making sure that half is attached to the board. Then tape the remaining sides. Lay the board flat until the paper dries completely. Some artists stretch several boards at once so that they can work on more than one drawing at a time.

FIGURE 4–22 *Author. Laying a wash. With a slow, even stroke move the brush across the paper, overlapping the previous stroke by ¼ inch while keeping the leading edge of the wash wet.*

Setting Up

Set up your painting supplies beside the stretched paper. Some water-colorists work on a slight incline to aid the flow of their washes. The jar or can that holds your brushes should be placed for easy access. Your palette, along with two wide-mouth jars filled with water, should be right next to the painting. Use one jar for cleaning brushes and one for mixing colors. Keep your coffee cup away from these jars or you will soon be dipping your brush into it or drinking from your water jars. To the right of the palette, tape down a scrap piece of watercolor paper for testing the amount and intensity of color in the brush before using it. It is also a good idea to put a piece of blotting paper or a heavy paper towel alongside the palette to blot out excess water in the brush.

EXERCISE 4–6: *Laying Washes*

Learning to lay washes is one of the most important steps in watercolor painting. Skill in laying washes is acquired only by practice. Before you even attempt a painting you must master the graded wash, which is a wash that is gradated from dark to light. On a sheet of watercolor paper draw several four-inch squares. Load the brush with pigment and place it at the top of the square at about a 45 degree angle. Very carefully, and with a slow, even stroke, move the brush across the paper. Repeat the strokes, alternating back and forth. Every few strokes, dip the brush in clean water so that by the time the wash reaches the bottom of the square it is almost clear. Always keep the brush moving; if you hesitate it will leave a line. Always keep the leading edge of the wash wet with a film of color. Never go over the previous stroke, because it will leave a mark. Keep practicing until you can make perfectly graded washes. Practice laying washes with all your colors. When you master the four-inch square wash move up to twelve-inch square washes.

EXERCISE 4–7: *Transparent Glazes*

One of the beauties of watercolor is that you can create luminous transparent glazes. After your practice sheets for the last exercise have dried, practice overlaying another color wash on top. Let them dry and add a third color. Watch what happens. The wash should be as light as possible so that each layer of color can shine through.

Painting Over a Drawing

You can transfer a drawing to watercolor paper by using transfer paper, which is a type of carbon paper, or by tracing your drawing on a light-table. You can also lay out the drawing directly onto the watercolor paper in a soft pencil such as a Berol 314, then ink in the pencil lines. After the ink has completely dried, erase the pencil with a plastic eras-

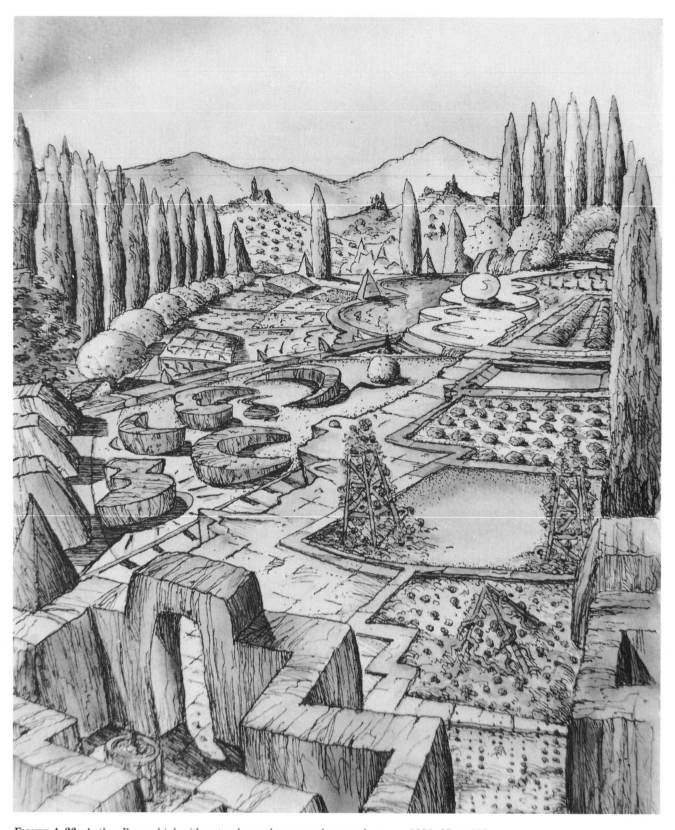

FIGURE 4–23 *Author. Pen and ink with watercolor washes on rough watercolor paper. 1990. 9" × 12".*

er, taking care to do this away from the area where you will be watercoloring. Otherwise, no matter how hard you try, one of these erasure crumbs will land right on one of your washes and ruin it. You can watercolor over an ink or pencil drawing. It depends on the effect you're after; a pencil drawing will be much more subtle than an ink drawing. After you've inked the drawing, lightly rub the ink with a wet sponge to reduce its intensity.

With watercolor, always work from light to dark, from the background to the foreground, and from broad areas to details. Working wet-to-wet, or laying down wet washes and adding color directly into them, gives you less control. The color bleeds and is diluted; this is a great technique for expressive skies and bodies of water. You can control the perimeter of the washes by painting a mask to form a temporary coating; use Winsor & Newton Art Masking Fluid or rubber cement. When the wash has dried, remove the mask. You can also use an X-Acto knife to cut straight lines into (not through) the paper so that when you lay down a wash the color will accumulate in the channel, making a fine line. Each successive wash added to the drawing should be slightly darker. Remember that it is difficult to correct your mistakes in watercolor, so you must plan ahead and move deliberately. After you have laid out the areas of color, add the detail using a dry brush and a lot of pigment; this way you can almost draw the details. Add shadows last.

In a tool box there are many different tools for different tasks. Preferably, you do not tighten a nut with a hammer! (Bernt Nilsson, Magnus Troedsson, Jesper Magnusson, and Boris Kildetoft—International Laboratory of Architecture and Urban Design)

Preliminary Drawing Exercises

*Lines may now give the idea of being two shooting stars
which move with speed through the universe.
Your empty paper has been transformed by
the simplest graphic means to a universe in action.
This is real magic.*

HANS HOFMANN
Search for the Real

FIGURE 5–1 *Author. Quick gesture travel sketch from daybook.*

Holding the Drawing Instrument

The drawing instrument is not a hammer, it is not a coffee cup or a cigar; it is a delicate, expressive instrument. Learn to see the drawing tool as connected to your hand, eye, and mind, and it can be a pathway to freedom.

Grip it lightly, move freely, achieve looseness. Hold the instrument like a chopstick and push it forward; feel its movement on the surface of the paper, feel it caress the paper. See what happens when you vary the pressure as you glide across the page. Francoise Gilot remembered Picasso describing line drawing as "the most demanding form of expression and also the purest, since each stroke had to define itself and the positive and negative space on each side." (Gilot 1990, 90)

Developing hand-eye coordination is one of the major objectives of the exercises in this chapter. It is important to first establish your relationship to the line and learn to judge distances. Begin by placing your hand on the environment of the page. Think of it as an object in space. Be conscious of the relationship between your eye and the tip of your drawing instrument. There should be an intimate connection between your eye and hand. You are taking your eye on an adventure. You direct the action.

Through the drawing of lines you produce a language that determines how the environments you create will be perceived. A line is like a letter in the alphabet; it has calligraphic meaning. A series of lines can be like a literary passage. You should make each line mean something; it should have its own character. A true artist can make a single line read like a total composition. Hemingway tried to write one true sentence. Likewise, you should try to draw one true line.

> In drawing there are lines which travel fast, which carry the eye over space with surprising rapidity and land you at a nodal point, where you are forced to rest, and then take new departure at the same or quite a different speed. There are lines that are heavy, dragging, lines that have pain, and lines that laugh. (Henri 1923, 114)

As you work through the following exercises, try these variations:
1. Begin the exercise with your natural writing hand using a Berol 314 Draughting pencil or Ebony pencil. After completing the exercises go back and use your opposite hand, then draw with both hands at once.
2. Repeat all of the exercises as slowly as possible.
3. Put your pencil in your mouth and do the exercises.
4. Get a stick, cut it to a drawing point, dip it in ink, and repeat the exercises.
5. Dip your forefinger in ink and complete the exercises.
6. Some Japanese Zen masters would, when drunk, soak their hair in ink and draw with their heads. Try this.

FIGURE 5–2 *Holding the pencil.*
(Photo: Kathryn Drinkhouse)

7. Gather up several different kinds of paper. Put your nose right next to the page, and smell the differences between each type of paper. Now draw invisible lines with your nose.

8. As a final activity, go back and do each one of these exercises with your eyes closed.

EXERCISE 5–1: *The Palmer Handwriting Method*

The Palmer beginning handwriting exercises are a very good introduction to hand-eye coordination. On an 8½-by-11-inch sheet of yellow ruled paper at quarter-inch intervals, do five pages each of slants, the letter m, spirals, and continuous circles. Let your wrist glide above the page and use your whole arm. Work on your accuracy and speed. As a last exercise in this series draw a page of loops and on each successive page progressively widen the loops. Keep widening the loops to the longest loop that you can draw with accuracy and speed.

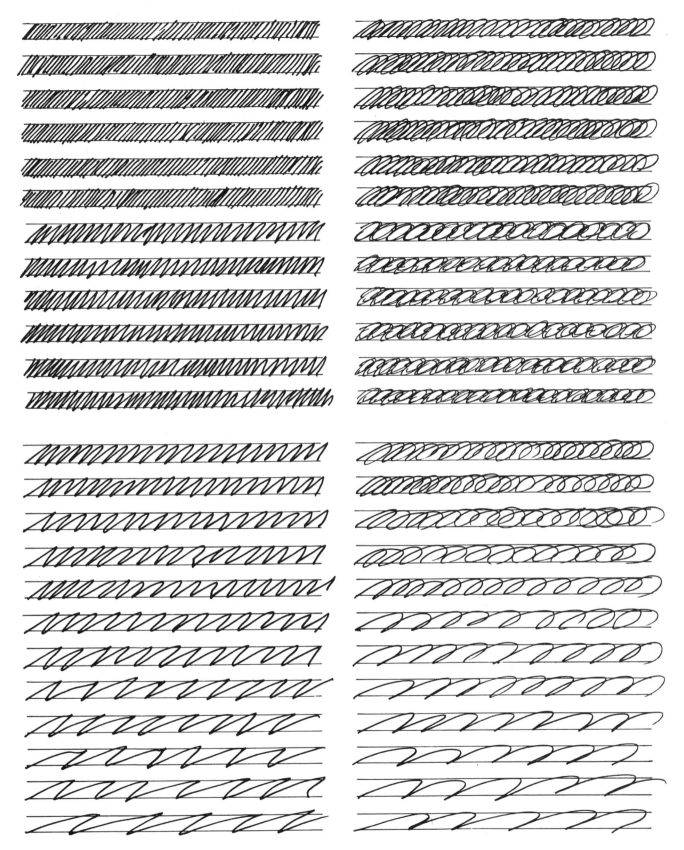

FIGURE 5–3 *Palmer handwriting exercises.*

FIGURE 5–4 *Line exercises.*

EXERCISE 5–2: *Line Exercises*

This exercise is a method to gain a feeling for line control and the relationship between the pencil and the eye. On the long side of an 18-by-24-inch sheet of smooth Bristol paper, draw a series of parallel lines a quarter-inch apart. Start and stop your lines on the sheet and leave a half-inch border around the edge of the page. Make a complete line from beginning to end, trying to achieve authority in your line movement. Draw one page of lines with equal line weight and another page varying the line weight by altering the pressure of your hand on the pencil. Try to draw one true line. Observe how the lines react to different pressures from your grip, and notice how the white spaces between the lines react to the varying line weights.

EXERCISE 5–3: *The Basic Line Weights*

Drawing can be broken down into three basic line weights: light, medium, and heavy. Practice these three line types by drawing them vertically on an 18-by-24-inch sheet. Start by drawing one long, very light line; a quarter-inch from it draw a medium-width line by gripping the pencil slightly harder. Parallel to this line draw another one, but this time use an even firmer grip and make a very dark and heavy line. Repeat this procedure over and over until you fill the page.

FIGURE 5–5 *The basic line weights.*

EXERCISE 5–4: *The Exclamation*

On an 18-by-24-inch page, practice a series of lines spaced a quarter-inch apart in which you start and stop with a strong accent. Concentrate on starting and stopping with a dark mark; this will give your line work a sense of authority and confidence. Between the accents, vary your line weight. This is a very important exercise for learning control.

EXERCISE 5–5. *Fades*

Practice creating lines that fade from very dark to very light. Alternate between dark-to-light and light-to-dark lines. Also at the beginning and end of each line practice the exclamations learned in Exercise 5–4.

EXERCISE 5–6: *Dots*

Learning to draw and accurately place dots might seem simplistic, but can add a very lively dimension to your drawing. They can be used for a variety of beautiful effects. The Japanese wood-block artists were masters of the dotted line. Draw a series of horizontal rows of dots. Work on developing a rhythm in your rows, then vary the sequences. Work on different spacing. Draw slowly, then faster; notice how this will affect the appearance of the dotted lines. This is a good exercise to do while playing music. Notice that different types of music affect your dots.

FIGURE 5–6 *The exclamation.*

FIGURE 5–7 *Fades.*

FIGURE 5–8 *Dots.*

EXERCISE 5–7: *Fades to Dots*

Practice drawing from right to left dark lines that fade to faint lines then to a series of dots, and dots that build to light and then dark lines. Observe the white space between the lines.

Exercise 5–8. The Wiggly Wiggly Line

On a good sheet of Bristol paper, practice making straight lines a quarter-inch apart as slowly and wiggly as possible. Vary the pressure as much as possible and leave occasional breaks in the line. This type of line tends to have a lot of character, and the appearance of reflected light. Many years ago artists would bang a wooden rule against the edge of a table many times, then use it to easily draw this type of line.

Exercise 5–9: Connect the Dots

Randomly place a series of dots on a large sheet of paper and then connect them with continuous lines. Use straight lines, fades, wiggly wigglies, and slightly curving lines. Notice the development of the white space between the lines.

FIGURE 5–9 *Fades to dots.*

FIGURE 5–10 *Wiggly wiggly line.*

FIGURE 5–11 *Connect the dots.*

Exercise 5–10: Spirals

Do a sheet of random lines that spiral forward and backward. Think about proportion and form when drawing them; note what looks good to your eye and what does not. Use the exclamation at the beginning and end of each spiral. Vary the spiral from tight to loose.

Exercise 5–11: Spiral Variations

Draw circular spirals in horizontal rows, varying the size from very small to as large as you can accurately draw with ease. Do more horizontal rows, slanting the axis and varying the spacing. Practice this exercise until it becomes second nature.

FIGURE 5–12 *Spirals.*

FIGURE 5–13 *Spiral variations.*

Exercise 5–12: The Scallop

The scallop has a lot of application to landscape drawing. Frank James, artist and landscape architect, uses this form as a basic line in his repertoire and as a foundation for his drawings.

When drawing this form, develop a freedom of movement in your wrist; let the marks fly out of your hand. Start the bottom of the scallop by marking a point in space with the exclamation, then draw a downward arc with two serrations. Next draw the upper scallop, connecting it to the top of the lower scallop. Try to match the upper serrations and lower serrations. Vary the sizes and the angles of the scallops; fill pages and pages with them, watching the white space. Work on making the scallops progressively longer. Finally, make one continuous scalloped line all the way across the page, then fill a page with these. Work on accuracy. On your own, develop as many variations as possible.

FIGURE 5–14 *The scallop.*

FIGURE 5–15 *The expressive line.*

Exercise 5–13: The Expressive Line

Charles Burchfield used expressive lines to abstract his visual experiences into calligraphic patterns and forms. He attempted to translate the hidden moods of nature through his experimental line work. Develop for yourself expressive lines that abstract your feelings about nature. Begin by trying some quick loosening-up exercises, and draw lines that express shortness, height, and confidence. Next, invent lines that have meaning to you. Draw as fast as possible, with a loose wrist, while trying to capture emotion. Be sure to always use one continuous line as you try to capture feeling with quick shorthand-like strokes.

Try this exercise out in the field while looking at the landscape, and then draw an emotional impression as one quick movement. Do this exercise a little bit every day. When composing all of these shorthand impressions on your page think of them as a symphony of lines.

Exercise 5–14: Drawing the Sphere

This warm-up exercise for drawing was developed by the artist and teacher Joseph Slusky while teaching at the College of Environmental Design at the University of California at Berkeley. This is one of the most important exercise in this chapter, and a good introduction to the next chapter. Always use the sphere as a warm-up exercise.

Use a sheet of good 18-by-24-inch paper. Do this exercise standing with your weight on the balls of your feet. Get centered by balancing yourself and concentrating on the page. Start by drawing a large circle the full size of the page. Set up your relationship to the circle; discover its roundness. Begin to shift its center point, varying the line width. Loosen up your wrist and put your whole body into it; your fingers, hand, arm, shoulder, torso, and mind. Keep drawing the sphere as a nonstop, continuous line. Continue to move the axis while building up its form with backward and forward motions. See how the sphere begins to build up volume. Bring out the lights and darks by varying the pressure of your pencil. Feel the width of the sphere as it begins to take shape, becoming heavy and occupying space. Feel the drawing come into being as an object full of dynamism, vitality, movement, and rhythm. You should end up not with a ball of string, but with an object with depth and energy. Stand back and look at it; it should occupy space and carry weight. Draw another sphere using your other hand. Then draw two more spheres, this time using both hands at once. You can also add variety by changing media while drawing the sphere.

Exercise 5–15: Ray, Spike, and Sphere

The ray, spike, and sphere are simple forms that can help you create flowing gestures. Practice drawing them very quickly, repeating these exercises on several large sheets of paper working in a series. After you've learned to draw them with ease, combine them into compositions. Again draw these compositions very rapidly on a 18-by-24-inch sheet of paper, spending 5 to 10 minutes on each sheet.

FIGURE 5–16 *Drawing the sphere: The Joseph Slusky technique. 18" × 24".*

A. Draw the ray as a series of continuous radiant lines from a variety of points.

B. The spike should be drawn with deft strokes producing definitive quick accents. The spike is used to create points of tension and counterpoints in the composition.

C. After practicing the ray and spike begin to draw spheres of different sizes. Try to get them to relate to one another in scale, large and small, and orbiting around one another. Orchestrate how the spheres fill the space of the page and how they react to one another.

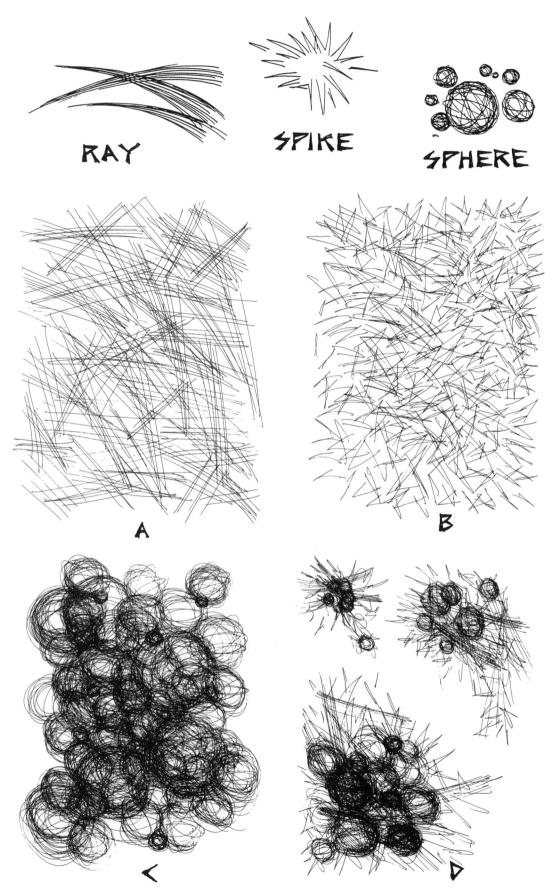

FIGURE 5–17 *José Parral. Practice drawing the ray, spike, and sphere quickly to develop flowing gestures.*

FIGURE 5–18 *José Parral. Have fun when you draw your loosening-up exercises, fill the page with similar images.*

FIGURE 5–19 *Joseph Slusky. Mixed media. 1984. 8" × 10".*

D. Practice your compositions by rapidly drwing the ray, spike, and sphere together in spontaneous masses. Draw these as a series of small compositions on an 18-by-24-inch sheet.

Exercize 5–16: Loosening-Up

Loosening-up exercises are intended to be fun, spontaneous, and humorous. Don't be worried about the final results. On an 18-by-24-inch sheet, quickly draw anything that comes into your mind: spaceships, coffee cups, knives, balls, desserts, and so forth. Fill the page with these objects flying through the air. Fill up many sheets of paper. Be repetitive. Have someone read poetry or a story or play music to occupy your left brain and help free your right brain to wander.

Exercize 5–17: Imagining Sound

Find a comfortable, relaxing place to sit. Use a 10-by-12-inch sheet of paper and a pen or soft pencil such as a 6B. Close your eyes and listen to the sounds

you hear for a few minutes. Try to imagine what these sounds may look like if you could see them. When you can visualize a particular sound, abstract it into a gesture that expresses it. Do this with your eyes closed. Fill the page with a variety of sounds. Do this exercize as a one-hour meditation. To draw sounds you have to imagine; you have to stop and listen. This exercize helps you observe the environment.

I managed to have a peek at the series of line drawings piled high in a corner . . . Matisse's lines were so spontaneous and so dynamic, their impetus had such vitality, that it seemed as if they were about to collide with one another. Instead the masterful strokes stopped suddenly before any fatal encounters allowing the passage of light, giving ample breathing space. His hand obviously knew exactly when to lift away from the paper. (Gilot 1990, 24)

Tone and Texture

*By "chiaroscuro of nature" English painter John Constable
also meant that some drama of light and shade must
underline all landscape compositions,
and give the keynote of feeling in which the scene was painted.*

KENNETH CLARK
Landscape Into Art

FIGURE 6–1 *Ireneusz Ciesiolkiewicz. Landscapes on Tone. 1993. Pencil on paper.*

Light, Shade, and Shadow

If lines give structure and context to a drawing, then it is light, shade, and shadow that make a drawing come alive. Da Vinci advised: "You who draw from nature, look carefully at the extent, the degree and the form of the lights and shadows." (Richter, 1976, 132) Tone and shadow breathe life into a landscape drawing while giving it depth and atmosphere. Landscape drawings are usually a combination of line and tone. The potential mood or tone in a drawing can be quite exciting:

> *Within tonal art the most extraordinary variety of effects is possible—the psychological studies of Leonardo da Vinci, the crass "tremebroso" realism of Caravaggio, the classic serenity of Poussin, the pulsation of lights in El Greco's mystic vision. . . . (Taylor 1964, 154)*

I first learned the significance of tone, shade, and shadow while working in the office of Sasaki Associates in Boston. I had a huge landscape perspective spread out on a table when Frank James walked over and pulled the pencil right out of my hand as I was finishing the vegetation,

yelling, "You're doing this all wrong!" He rolled out a large sheet of tracing paper and proceeded to show me how to render shadows and texture to the plants. Since then I've always savored that moment when the drawing begins to take on depth and the psychological dimensions of tone.

Tone and Value

"Tone and value are synonymous, but ambiguous terms in the visual arts, both refer to the gradations of gray—between white and black." (Hill 1966, 45) Simply put, tone and value are measures of light and dark in a drawing. Through the integration of light and dark, a range of graded tones is created; a smooth modulation from white to black. To produce tone with a soft medium such as pencil or charcoal, you place the strokes closely together to create subtle, smooth, even gradations. With pen and ink, tone is built up with lightly applied parallel and cross-hatched lines. Used correctly, tone will help to render landscape forms realistically and enrich the drawing.

Tone will aid in the articulation of form by establishing volume and giving weight to the elements in your pictorial space. Also, by contrasting tones one can create emphasis, and in a landscape drawing this will help the viewer to see shapes. When drawing the landscape begin by building up an equal distribution of tonal volumes gradually to obtain unity. You must understand how to distribute tones in order to produce depth in your drawing. Remember, the direction of light will always affect the graded tones of the landscape.

..

EXERCISE 6–1: *Learning to Observe Tone*

Learn to judge tone by always looking around you. Develop your powers of observation by studying innate natural tones and their effects on your sur-

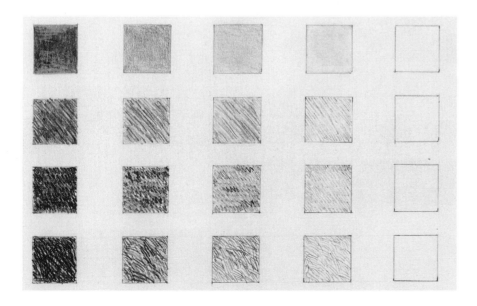

FIGURE 6–2 *Creating graduated tones from black to white in pencil.*

roundings. Before you begin a drawing, first learn the tones and values of your subject. Squinting when looking at a subject will help you to see tones. Practice drawing vegetation in the landscape as objects shaded with graded tones.

EXERCISE 6–2: *Tone Studies*

This is a standard but basic exercise for creating a series of tones. On an 18-by-24-inch sheet of good paper draw five two-inch square boxes across the top of the page, and repeat the rows all the way down the page. In each row use different shading methods to create a series of tones in gradations from black, in the first box, to white, in the last box on the right. Be inventive!

Do one page each with 6B pencil, soft charcoal, and pen and ink. When practicing these exercises in pen and ink, use separate strokes rather than a continuous smooth tone.

EXERCISE 6–3: *Smooth Tones*

The object of this exercise is to practice making smooth, even tones from light to dark. On a sheet of paper draw 2-by-14-inch rectangles. In each rectangle lay down your tone as smoothly as possible with closely spaced parallel strokes, working from light to dark. Use a kneaded eraser and a paper stump to rub down the lines so that they become smooth and almost imperceptible. Alternate light-to-dark rectangles with dark-to-light ones. Do one sheet in 6B pencil and another in charcoal.

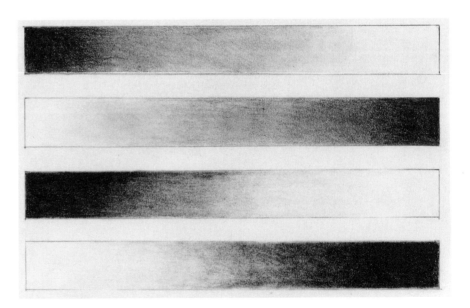

FIGURE 6–3 *Practice making smooth tones from dark to light and vice versa in pencil and charcoal.*

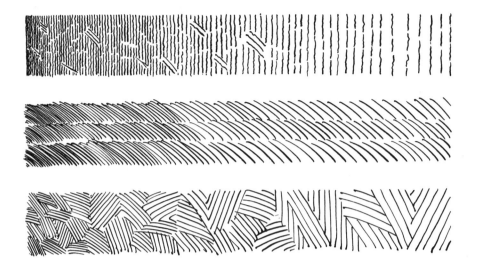

FIGURE 6–4 *Hatching to create tone in pen and ink.*

Hatching

Hatching is a simple drawing convention that can give the effect of tone and value with pen and ink. It is a classic method for producing beautiful drawings. Da Vinci's pen and ink drawings are marvelous examples. Hatching can also increase the expressive quality of line and produce texture. Hatched lines, or *hatchures,* are short parallel strokes repeated in patterns. By controlling the variety and intensity of the hatching, tones will appear dark or pale. The parallel lines can be spaced loosely or tightly to control the tone. For added character, hatchures can be slightly curved or placed at different angles.

EXERCISE 6–4: *Hatching*

On a sheet of smooth 18-by-24-inch Bristol board, draw in pen and ink a series of 2-by-16-inch rectangular boxes. Within these boxes, experiment in tone with short hatched lines, starting with loosely spaced parallel lines then gradually increasing their density until they become almost black. Use a different type of line in each box.

Cross-Hatching

Cross-hatching is a variation of hatching, but can produce a wider range of tonalities. To create cross-hatching draw a series of short parallel lines. At right angles draw a series of overlapping parallel lines. Keep repeating this process by overlapping the hatched lines at a slightly different angle each time until you produce almost total blackness.

FIGURE 6–5 *Cross-hatching to create tone in pen and ink.*

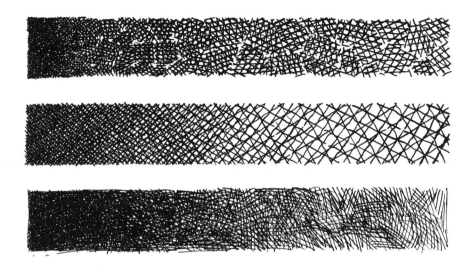

..

EXERCISE 6–5: *Cross-Hatching*

On a sheet of 18-by-24-inch smooth Bristol board, draw in pen and ink a series of 2-by-16-inch rectangular boxes. Within these boxes practice cross-hatching from light tones to black. Vary the type of strokes you use, including slightly curving and arching strokes, and strokes in different directions.

..

Chiaroscuro

Renaissance artists perfected this technique, which is essentially the use of very subtle transitions in tone with almost no lines. Chiaroscuro fuses the range of values of the drawing, giving the artist a broad range of expression. In this method, always work your preliminary sketch creating depth by keeping in mind the light and how it can be brought out most effectively by use of shadow. To build up chiaroscuro, first identify the lightest portions of the subject, and plan to allow the white of the paper to show through. Gradually build up layers of light tones, finally drawing the darkest shades of the shadowed edge. The cumulative effect is of atmosphere around the element occupying space in the composition.

Light

Before beginning a drawing always note where the light is coming from. Determine its point of origin, and place yourself in reference to the light. Exploiting the light will illuminate your landscape drawing and bring out the third dimension. Through the careful distribution of light you can achieve the feeling of emotion in your drawing.

Work out the composition of your drawing using light construction lines, starting with the light areas and then adding the shade. The

source and the quality of the light will effect your gray tones. Through the manipulation of bright light, you can create divine and miraculous situations; with diminished, murky light you can represent deep thoughts or introspection.

EXERCISE 6–6: *Observing the Changing Light*

To understand light quality try this experiment. On a clear day get up before dawn, and from a fixed, comfortable viewing station such as a large window, back porch, or hillside, spend the day until twilight observing how the landscape is affected by the changing light. Develop an awareness of how the mood changes as the light passes. Follow the angle of the shadows and the glint of light, and the juxtaposition of light and shadows. Record your thoughts and observations in your daybook.

With the proper use of light and shadow a drawing will become fuller. Light can be used to create highlights that lead the eye to certain points, or as a focus, to create areas of emphasis. When light is used in combination with tone it can produce a sense of volume.

Shadow

The opposite of light is shadow; shadow cannot happen without light. Leonardo da Vinci said, "Shadow is the obstruction of light. Shadows appear to me to be of supreme importance in perspective, because without them, opaque and solid bodies will be ill defined." (Richter 1970, 69)

Through the interplay of light and shadow a drawing will become fuller and give the illusion of relief. Rembrandt brought drama to his paintings by manipulating shadow on a level reached by few artists. Observe the use of shadow in his etchings, the strong contrasts of light and dark. We can look at shadow as a material that can be painted, mak-

FIGURE 6–6 *Using tone to create chiaroscuro.*

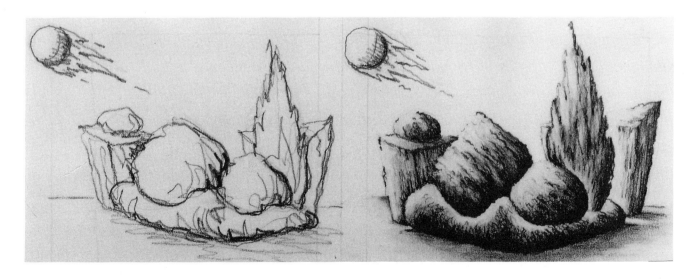

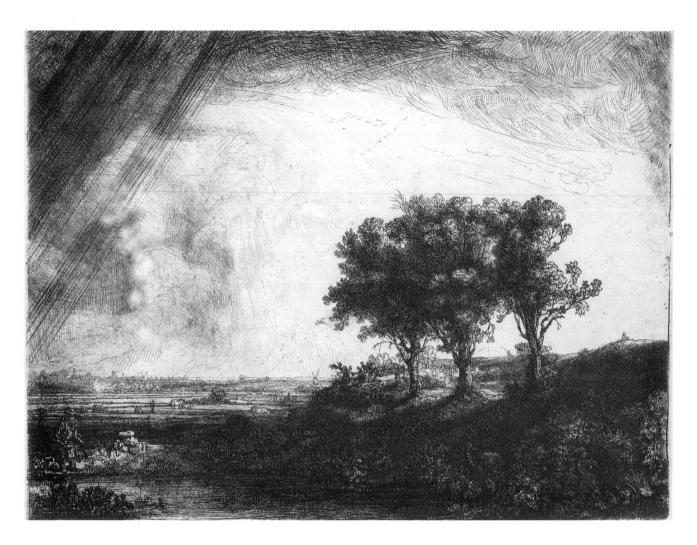

FIGURE 6–7 *Rembrandt van Rijn.*
The Three Trees. *1643. Etching with
dry point and burin. 8⅝″ × 11″.
(National Gallery of Art, Washington
Rosenwald Collection)*

ing surfaces and planes stand out. Shadow is not something one
depicts; it is something *with which* one depicts. That is, you create light
on white paper by creating shadow. Shadows are cast by objects in a
landscape through the interception of light on the ground plane or
background. In full sunlight shadows are sharper and more distinct; on
overcast days their edges are softer. According to da Vinci, "the shadows
of plants are never black, for where the atmosphere penetrates there
can never be utter darkness." (Richter 1970, 277)

Light projected on an object will cast a shadow on the plane on which
the object rests. The area of the object opposite the light source is shad-
ed. The cast shadow generally appears darker than the shaded side of
the object, and the shadow is darkest along its leading edge. The
boundary between shade and shadow is called the *shaded edge.* The shad-
ow will also reflect the form of the object that is casting the shadow, and
will always follow the contours of the ground plane. In drawing compo-
sition, shade and shadow can be used in many possible combinations:
as a silhouette, as a frame for different shapes, or to define the picture
plane.

FIGURE 6–8 *Shadowed edge.*

FIGURE 6–9 *Shade used to create a silhouette.*

FIGURE 6–10 *Drawing a sphere in tone with A) highlights, B) shadow, C) shaded edge, and D) cast shadow.*

..

EXERCISE 6–7: *Drawing the Sphere in Chiaroscuro*

Place a white sphere under strong light in the evening; this primary shape is one of the dominant forms in the landscape. Look very carefully at the object before you begin to draw. Observe how the light source hits the object; look for the highlights, the shadow, and the shaded edge, and notice how the shadow hits the surface. Draw the sphere in the traditional chiaroscuro method using 6B pencil then charcoal. To facilitate the building up of smooth tone, sharpen an eraser to a point or pinch a kneaded eraser into a line, and as you lay down your parallel lines, gently smooth them together. You may also want to use a paper stump. Keep repeating this method until the desired volume and weight is achieved. This process is called sfumato—the creation of imperceptible gradations of tone in light and shadow.

..

Basic Solids in Tone

Understanding how to draw the basic geometric solids is important because everything in nature, and especially in landscape drawing, is modeled according to them. The basic building blocks are the sphere,

FIGURE 6–11 *Observe the basic geometrical forms in nature and draw them in tone.*

cone, cylinder, and square. Before you can go on to draw the landscape you must first master these forms in tone. These simple objects are combined to produce more complicated shapes.

EXERCISE 6–8: *Drawing the Basic Solids in Tone*

On a good sheet of 18-by-24-inch paper draw the sphere, cone, cylinder, and square in full tone across the top of the page in pencil. Repeat these forms below in pen and ink. On another sheet of paper draw the same basic solids with shade and cast shadow. Ideally it is helpful to make these objects out of cardboard or wood, paint them white and draw them at night with a bright light on them. On another sheet of paper draw the solids defined with shadow and tonal background. This is an exercise in how to use shadow and background to make forms appear as if they are occupying space. It is an important step in learning to create a landscape. In placing these objects on your page, think of your composition. Do each of these projects in 6B pencil, soft charcoal, and pen and ink.

EXERCISE 6–9: *Drawing Common Objects in Tone*

Collect a bunch of common objects such as wine bottles, cups, pitchers, and so on. Try to find objects with character; no plastic, please. Paint them white and arrange them into a still life, taking care to overlap them. When you are setting them up, think of them as a landscape design. This exercise is an introduction to the drawing of landscape. Turn a bright light on the objects and draw them in charcoal with shadowed backgrounds. Use your kneaded eraser and paper stump. When drawing, think about the positive and negative space and try to see the relationships between them.

EXERCISE 6–10: *Contrasting Forms*

This exercise is about learning to draw forms to contrast with one another. Cut abstract shapes out of cardboard and set them up as a still life. Work on the arrangement of positive and negative spaces and overlapping shapes. Under a bright light, render them in tone with shadow and shadowed background. Use charcoal, kneaded eraser, and a paper stump.

EXERCISE 6–11: *Rendering Values*

Paper is an excellent medium for studying and rendering values. Take a paper bag and crumple it up over and over again, until it is very pliable. Scrunch it up and draw it under a bright light in pencil. Try to depict its full range of tone. When drawing, imagine it as the ground plane of a landscape. Draw it from a variety of angles using 6B pencil, kneaded eraser, and a paper stump.

FIGURE 6–12 *The sphere, cone, cylinder, and square: A) in tone in pencil, B) in pen, C) with shade and cast shadow, D) with tonal background.*

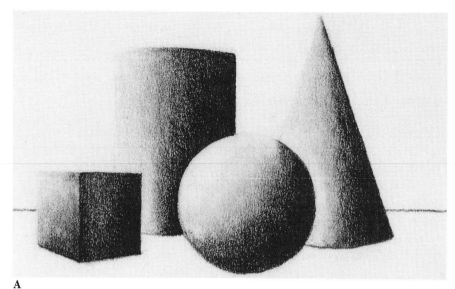

A

B

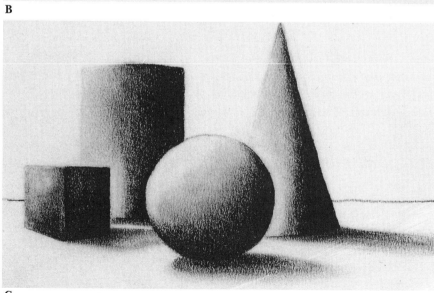

C

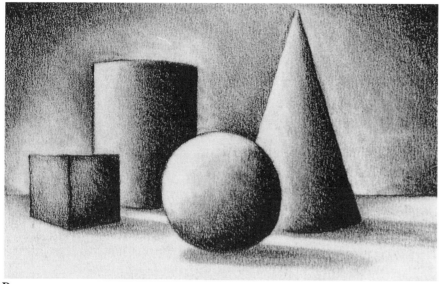

D

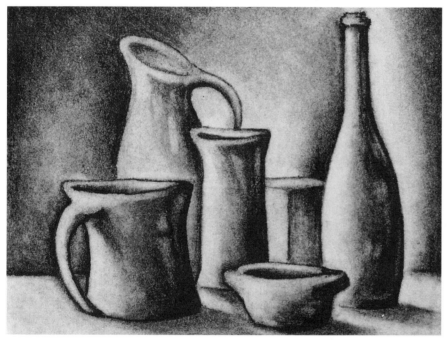

FIGURE 6–13 *Common objects in full tone with shadowed backgrounds.*

Texture

Texture combined with tone creates pictorial space. The landscape contains an endless variety of textures; this is one of the characteristics that defines a landscape. Every element in the landscape has some amount of texture, and these textures must be reflected in the drawing.

In his book, *A Guide to Drawing,* Daniel M. Mendelowitz writes that texture and its representation are "fundamental to the aesthetic strength of any drawing.' (1967, 109) Texture is also about touch. Unless we can touch the texture we are rendering, we must rely on our eyes to inter-

FIGURE **6–14** *Abstract shapes in full tone with shadowed backgrounds.*

pret it for us. A drawing should express the emotion of tactile experience.

The artist may mix the media of strongly textured materials with drawn representations of textures. The cubist painters Braque, Picasso, and Gris were some of the first artists to incorporate newspaper ads, wallpaper samples, stamps, and so on in their work to evoke textural interest in the flat surface of the canvas. Georges Braque's "Musical Forms" and Kurt Schwitters's "De Stijl" are good examples of how real textures are incorporated into a work.

Our perceptions of texture influence our landscape drawings. Many landscape textures are taken for granted by the casual observer. Look carefully at the textures of the landscape before you begin to draw them. In *Rendering in Pencil,* Arthur Guptil talked about developing a "textural consciousness" to insure a constant awareness of the textures

FIGURE 6–16 *Elise Brewster.*
Landscape in texture. From travel
sketchbook.

that surround you. Learn to recognize textures that are shiny or
smooth, dull or sharp, hard or soft. Observe the effects of different tex-
tural combinations and develop a perception of surfaces.

In landscape drawing it is best to abstract the textures of your vision.
If you look at maps and plan views you will notice that abstracted tex-
tural symbols are used to represent different landscape forms. First,
interpret the texture, then abstract it into simple descriptive represen-

FIGURE 6–17 *Frank James, Sasaki*
Associates. Abstract landscape textures.

FIGURE 6–18 *Vincent van Gogh. View of Arles. 1888. Reed pen. 17¹⁄₁₆″ × 21⅝″ (Museum of Art, Rhode Island School of Design. Gift of Mrs. Murray S. Danforth)*

tation. You must interpret the textures of the subject, giving each a separate identity, and at the same time develop a textural style that unifies the picture. Van Gogh's landscape drawings contain an amazing array of textures and are charged with emotion. Avoid using many types and styles of textural representation, since this will only make the drawing chaotic. Texture is more than just pattern; it is lively interwoven lines that remind the viewer of the sense of touch and stimulate the imagination. Shadows reflect the various textures of the landscape upon which they are cast.

These beginning texture exercises build on the preliminary loosening-up exercises discussed earlier. By overlapping and building up the lines you've already practiced you can create texture. As American painter and teacher Robert Henri said, "Texture is a tactile quality, fabricated from the use of lines and tonal value. It is not just a by-product but part of the larger context and function the drawing is to serve." (1923, 196)

EXERCISE 6–12: *Varying Textures*

Lay out 2-by-16-inch rectangles on an 18-by-24-inch sheet. The boxes will give you the chance to really see the effects you can achieve by drawing textures. Work on varying the texture from light to dark, considering it a compositional element. This gradation will become important when we begin to draw actual landscapes. The trick here is to develop consistency in your lines and create a pattern through the repetition of line. Explore and invent your own textures. Do practice sheets in 6B pencil and pen and ink.

FIGURE 6–19 *Varying texture from light to dark with repetition of line.*

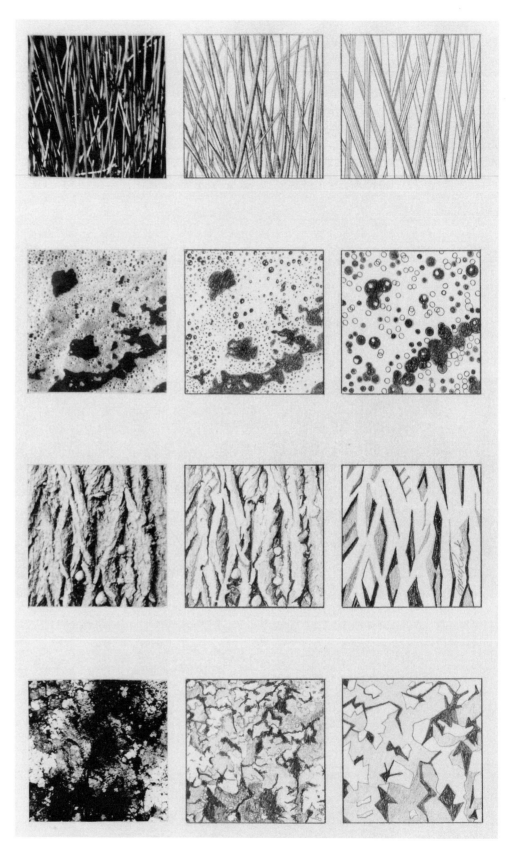

FIGURE 6–20 *Grace Kwak. Texture abstracted. 1993.*

EXERCISE 6–13: *Learning to Feel Texture*

In order to draw textures it is important to first feel them. Collect a variety of manufactured objects, such as tin foil, wax paper, bottle caps, sand paper, etc. And natural objects, such as tree barks, leaves, sticks, rocks, bricks, gravel, and so on. Find enough objects to fill a table top and set them out randomly. Sit down at the table and blindfold yourself with a bandana. Run both your hands over the objects to feel the different textures. Notice with which hand you best feel the texture. While feeling these objects with the blindfold still on, interpret them by drawing what you feel on a pad of paper with 6B pencil.

EXERCISE 6–14: *Abstracting Textures*

In order to draw textures it is important to learn to abstract them. Find five contrasting flat textures; cut them into two-inch squares and glue them onto a sheet of paper. Mount them on one side of the page. Now construct two two-inch squares beside each texture. In the first empty square draw a simulation of the texture. In the second create an abstraction of the actual texture. Be inventive. Repeat this exercise with other actual textures. Use a 6B pencil.

FIGURE 6–21 *Sponges in a variety of textures can produce some unusual images.*

EXERCISE 6–15: *Accenting Texture*

*Get several types of sponges; take a toothbrush soaked in India ink and splatter
the sponges with the ink. This will accent the different textures of the sponges.
Draw these with tone and texture using your 6B pencil and kneaded eraser.
Repeat this exercise with different types of bark or leaves or anything else you
can find that has interesting texture.*

EXERCISE 6–16: *Observing Contrasting Texture*

Cut 1-by-16-inch strips from newspapers, magazines, or other printed media, staying with black and white because this will enhance the textures. Glue them down parallel to one another, and observe the effect of the contrasting textures.

In summary, a refined use of texture can describe the individual landscape elements, create tactile responses, enrich the pictorial space, and control or reinforce the spatial composition.

> . . . *natural objects, leaves and stones are rendered precisely, and in Giorgione's "Trial of Moses" there is Giovanni Bellini's sense of precious light. . . . Only in Italy all natural things are as it were woven through and through with gold thread, even the cypress revealing it among the folds of its blackness. It is the golden light and flowing rhythm line of trees and contours which make Giorgione's earliest landscapes poetical. (Clark 1976, 114)*

Drawing Techniques for Trees and Plants

Know your trees, their nature, their growth,
their movement; understand that they are conscious,
living things, with tribulations and desires not
totally disassociated with your own.

JOHN F. CARLSON
Carlson's Guide to Landscape Painting

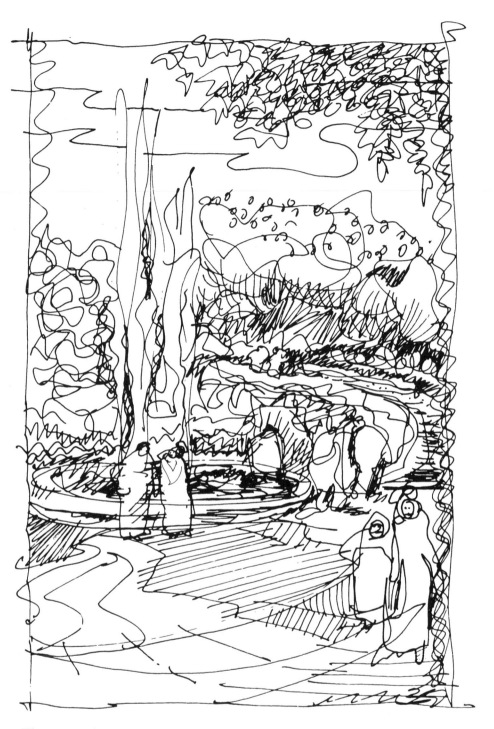

The art student must first learn to *observe*. Nature is the raw material of the artist and one should spend much time making contact with actual objects.

Trees and vegetation form the essence of landscape drawing. In order to be able to conceptualize, draw, and design landscapes in perspective, plan, and elevation, you must first gain an understanding of the organic structures of individual trees and masses of landscape forms. In this chapter we will work on developing a visual shorthand for trees and plants based on drawing techniques described in chapters 4 and 5.

FIGURE 7–2 *Frank James, Sasaki Associates. Trees in gesture. Pen and ink.*

Contour Drawing

"When executed by the sensitive artist, a contour drawing of even the simplest forms acquires great distinction and elegance through disciplined purity of line." (Mendelowitz 1976, 93) To draw vegetation we must first learn to draw in contour. Contour drawing improves your power of observation and comprehension of shape. It is also an exercise in interpreting form. Contours are lines that delineate the edge of a form and distinguish one shape from another. Typically, a contour line does not vary in width.

Contour drawings are composed of pure line independent of tone, texture, and shadow. When you engage in contour drawing you draw with control, slowly and decisively, as da Vinci instructs:

Consider with the greatest care the form of the outlines of every object, and the character of their undulations. And these undulations must be separate studies, as to whether the curves are of arched convexities or angular concavities. (Richter 1970, 29)

When drawing in contour don't look at the page. Instead, concentrate on following the edge of the shape with your eye. The contour line should follow the movement of your eye. Look at the outside edge of your subject very carefully; note every indentation, every little movement of the edge. Does it move in or out, up or down, forward or backward? What you interpret in line should be based on exact observation. Before beginning, squint at the subject; by blurring your vision you may better understand its form.

Figure 7–3 *Lisa Micheli. Hand and shoe in contour. Pen and ink on paper.*

FIGURE 7–4 *Author. Landscape form observed and interpreted in contour. Pen and ink.*

EXERCISE 7–1: *Feeling the Contour*

Start with a common object such as an apple, hat, or twig. Close your eyes and feel the edge of the object with your hand. With a 6B pencil draw a contour of the subject. Draw extremely slowly, as if in slow motion, while looking at the edge of the object very carefully. Begin by focusing on one part. Imagine that your pencil is touching the object rather than the paper. Avoid the temptation of looking at the page until you are done. Move your pencil slowly as you follow the edge of your subject. Concentrate and don't draw too fast.

Next draw your hand as a large contour on an 18-by-24-inch sheet of paper. Fill the whole page. Again, work on your observation; look, and draw every nook and cranny on the edge of your hand. Hold your hand up close to your eye in order to see its detail. On another single sheet draw three hands in contrasting poses.

Get an old well-worn shoe, such as a tennis shoe, and draw a contour of it. While you are drawing try to understand it, and capture its folds. Again, feel the shoe before beginning. Next, do a single page with two shoes, and create a composition with them.

EXERCISE 7–2: *Contours of Plant Forms*

"What outlines are seen in trees at a distance against the sky which serves as their backgrounds?" asks da Vinci. (Richter 1970, 227) For this exercise, go outside and observe a variety of plant forms. Observe as many trees as possible before beginning to draw. Find ten distinctive types of vegetation; draw several on a large sheet of paper. Look for the distinguishing shapes and silhouettes. Follow the edge with your eye; work toward developing a sensitivity to the edge. Touch the edges of the plants before you draw them. Concentrate on the tree, not the drawing. Don't look at your page. Observe carefully the outline of the plant. Be economical with line. If your drawing is out of proportion, don't worry about it. After you complete each plant form, below it draw its contour in plan view, as if you're flying above and looking down at its shape. Walk around the plants to grasp their plan view—are they perfect circles?

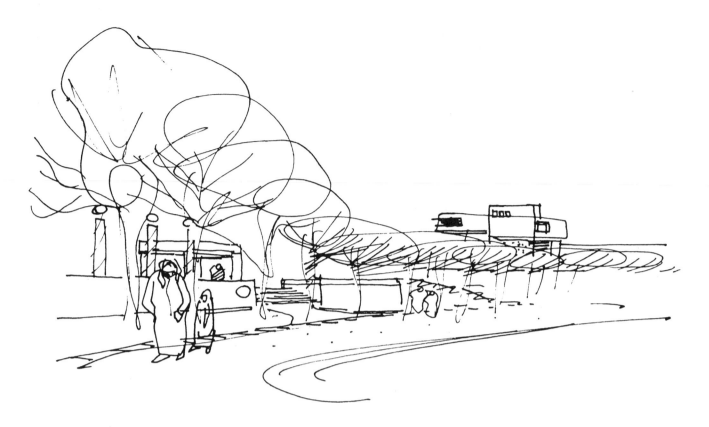

Gesture

A work of art in itself is a gesture.
ROBERT HENRI
The Art Spirit

Learning to draw with gesture is the key to creating landscape drawings of elegance, force, and character. Gesture is a response to your initial observations. It is lacking in contemporary landscape drawing; as a result, many landscape drawings lack spontaneity and drama. Gesture is access to the inner form of the landscape.

Your ability to convey gesture depends on your powers of observation. A gesture is a way to project meaning onto inanimate objects. It is about the activity of drawing and the ability to correlate individual lines to produce a compositional effect. The successful gesture captures a moment through a few quick motions. It expresses the artist's attitude. To draw gesturally one must be able to abstract. Great artists do not reproduce nature, but extract the intense sensation it has made upon them.

Gesture drawing relies on speed, movement and a feeling for volume and light. In his book, *The Natural Way to Draw*, Kimon Nicolaides provides one of the best descriptions of how to correctly draw the gesture:

> *You are to draw, letting your pencil swing around the paper almost at will, being compelled by the sense of action you feel, draw rapidly and*

continuously in a ceaseless line, from top to bottom, around and around, without taking your pencil off the paper. Let the pencil roam, reporting the gesture. You should draw not what the thing looks like, not even what it is, but what it is doing. Feel how the figure lifts or droops, pushes forward here, droops down easily there. (1941, 10)

EXERCISE 7–3: *The Gesture*

Start with a warm-up sphere that fills the page. Transfer that same energy to the following exercises. Draw a large gesture of your hand on a large sheet of paper. Then draw three hands on a page, thinking of them as a composition. Never draw a line twice; make your linear statement and then leave it alone. Your gesture should be clear and concise, with no excess lines. Your pencil should roam around the page as if you were drawing the sphere. Move the pencil in and out, up and down. Penetrate the subject to its very core. Do not make scratchy lines; draw one complete flowing line. Don't lift your pencil from the page; express the gesture with one line from start to finish, while varying the pressure of your stroke.

After the hands, draw one large shoe on a single page, using a two-thirds view. Then draw several shoes on a page.

EXERCISE 7–4: *Drawing Plant Forms in Gesture*

"The most vital things in the look of a face or of a landscape endure for only a moment." (Henri 1923, 27) This exercise should be done in the field. Find ten plants with unusual characteristics. Draw them large on 18-by-24-inch paper. As you draw, seize the vital impulse that registered during the first moment of observation. Remember the Zen koan, "first thought, best thought;' and consider the gesture a way to capture "first impression, best impression." Work toward proportion, rhythm, speed, and creating a sense of volume. Your motive should be to capture the essence and vitality of each plant; each one should tell a story. When drawing plants try to feel them using the gesture as a guide. Before drawing, feel your hand and arm loosening up. Get the full swing of your body into it. Let your hand move freely, as if by impulse. Work with great speed. Capture the flow of energy. Do not change the course of the line until you have to. Before drawing each plant try to empathize with it: How does it feel? What is its attitude? Seek the impulse or energy of what the plant is trying to do. Use intuition in your approach. For instance, a tree does not grow from the crown down to the trunk. It starts from within the earth and pushes up toward the sky, its leaves branching out, reaching to the sunlight, forming a dome.

Start your gesture of the plant at the ground plane. Push it up from the trunk, swinging it outward along the branching structure, following the movement through to the leaves. Keep the pencil moving, working it in and out until you create a volume out of the cacophony of line. Try to avoid making superfluous lines. Make every line descriptive. Stop only when you are satisfied with the form and it feels complete to you.

Below each plant form draw the plan view; with a quick gesture, capture its shape and habit in plan. Work from the center out, keeping the pencil moving

FIGURE 7-6 *Lisa Micheli. Hand and
shoe in gesture. Pen and ink.*

*all the time. Don't stop drawing. Work outward along the branching form to the
cloak of leaves and their edge. Penetrate through the center and outward again
until the image begins to carry weight. Stop when you feel the performance is com-
plete. Keep working on this exercise until you develop rapid, accurate, rhythmic
lines that capture the soul of the living form. This is a good exercise to repeat with
your opposite hand.*

Plant Forms

After acquiring skill in contour and gesture, work to develop a graphic
vocabulary that can describe the character of plant forms. Look at vari-
ous plants to grasp their individual gestures. Without drawing, look at
the plant forms you pass every day and visualize their major gesture and
outline. Observe many kinds of plants under as many different light
conditions and situations as possible. Observe the seasonal changes
throughout the year. Discipline yourself to continually observe plants
and analyze their conditions.

Plant Structure

When you begin studying plants, imagine the dominant line of growth as it moves through the plant. To visualize the trunk, first draw the silhouette of the plant, then draw a light line through its center. The trunk should follow this central line, which will also express the trunk's dominant movement. From the trunk all of the features of the plant originate. Beginners will typically draw trees as if they were perfectly symmetrical; this does not reflect their true form in nature. Trees are

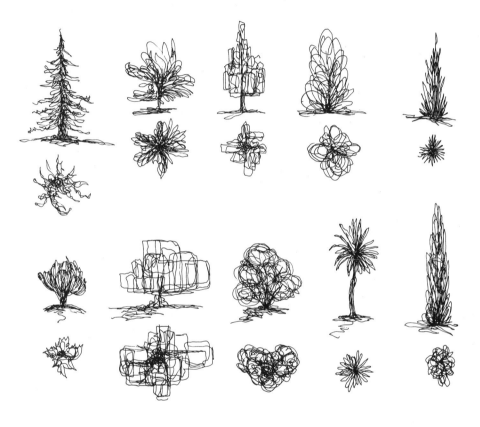

FIGURE 7–7 *(left) Author. Plant forms in gesture.*

FIGURE 7–8 *(below) Author. A gestural vocabulary to describe the character of plant forms.*

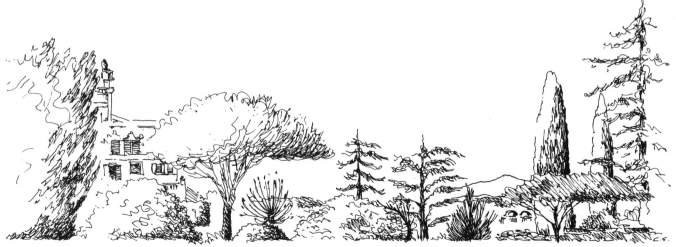

FIGURE 7–9 *Finding the dominant line of growth.*

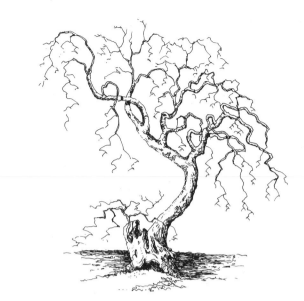

FIGURE 7–10 *A) Ground plane, silhouette, and center line. B) Branching structure. C) Adding foliage.*

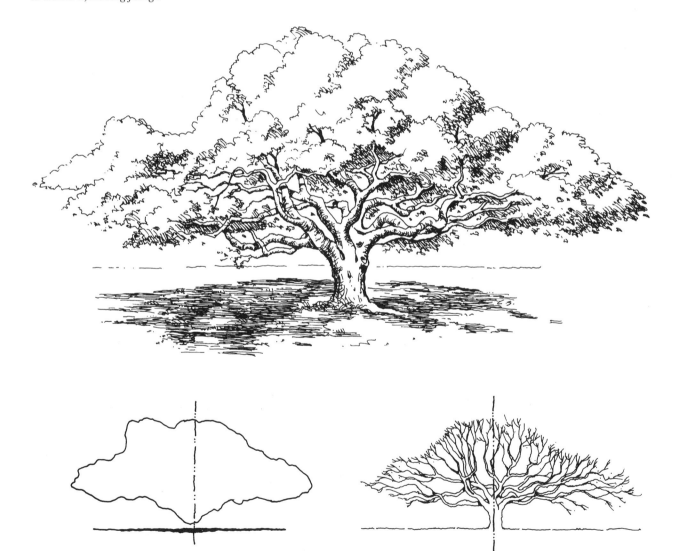

not cotton balls. They have a strong central spine that is usually a smooth curving line. As the branching moves away from the trunk each segment becomes proportionally smaller. There is a proportional harmony to the growth of the branching. In other words, a tree is like the body of a person who is standing with arms stretched outward toward the sun. The appendages become smaller the further they get from the trunk of the body.

There is a whole complex trunk and root system underneath the earth that has the same proportional harmony. Usually this anatomy is more extensive than the canopy structure above ground, flaring gracefully outward into small roots that disappear into the earth. To help you imagine this, picture the canopy flipped upside down and under the earth.

To draw the branching structure, first draw the ground plane and the silhouette, then locate the center line. On either side of the center line, add the flare of the trunk in construction lines. From the main trunk, sketch the branching structure all the way out to the edge of the silhouette, where the twigs taper to hair lines. Use smooth lines that follow the general form of growth, and end the hair-line twigs with exclamation points. Thoroughly work out the branching structure before you draw the leaves. This will be the outline of the tree's structure, to which you may add foliage and apertures. After you have drawn all your construction lines, determine the light source. The shadowed edge of the branches can be expressed by darkening the construction lines. This will help give volume to the branching.

EXERCISE 7–5: *Branching Practice*

To gain an understanding of plant structure draw at least ten trees without their foliage. Winter is the best time to practice this exercise. Otherwise, look closely at the branching and use your imagination. Start with a silhouette of the plant, add the center line, then lightly draw in the branching structure.

Foliage

Once you have analyzed the silhouette, structure, and branching, observe the character of the individual leaves. The most critical element about drawing leaves is being able to abstract them. Look closely at the leaves and twigs on a sunny day and abstract them in your mind. When trying to draw plants, most beginners attempt to reproduce every single leaf. It is always a temptation to draw the foliage as a pattern. To abstract the leaf forms you must first understand the individual leaf. After deciding on a leaf form you will want to repeat it consistently as a gesture. You do not want twenty-five different kinds of leaves on one tree. Indicate the foliage with just enough gesture to give it a minimal amount of form.

FIGURE 7–11 *Analyze the branching structure before attempting to draw the foliage.*

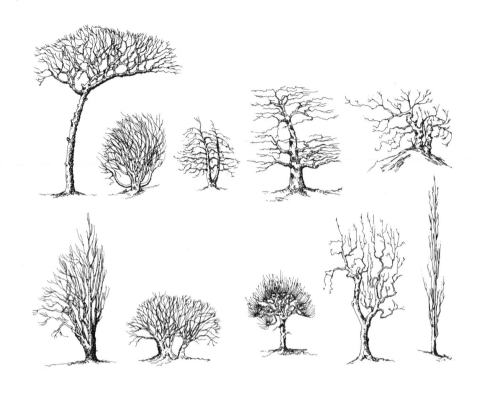

FIGURE 7–12 *Observe the individual character of each leaf, then abstract it.*

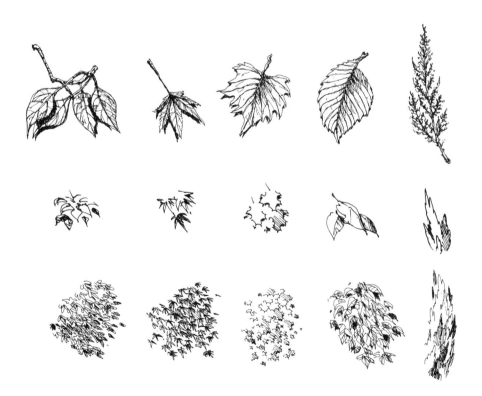

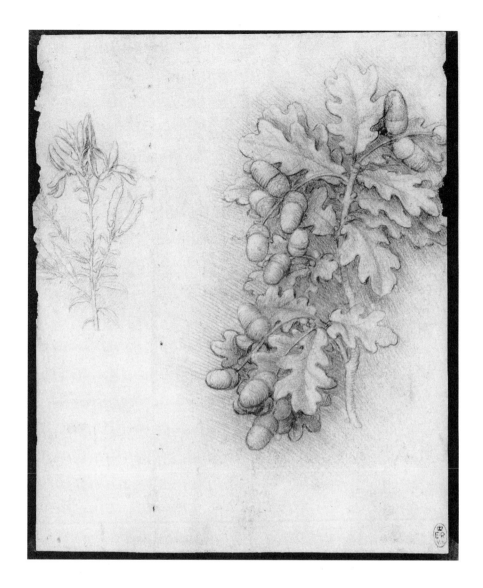

EXERCISE 7–6: *Leaves and Twigs in Tone*

Take a twig with a few leaves and carefully do a tone drawing with a 6B pencil. Draw five types of twigs and leaves organized on an 18-by-24-inch sheet. As an example, look at da Vinci's Sprays of Oak Leaves and Dyer's Greenweed. *This was a study for the painting* Leda. *The red chalk lines of the shading are beautiful, but what is most interesting is the degree of study that Leonardo put into the individual leaves. Look at his use of parallel lines to produce a background for the leaves and twigs, and the sensitivity of his linework.*

The foliage of a tree is like its clothing. The individual abstract gesture of the leaf form will be repeated over and over in your plant drawing to create a feeling of volume in the foliage. You want to capture the essence of the leaf in a simple line movement that can be repeated in a single sweeping stroke. The stroke should not be an exact copy of the

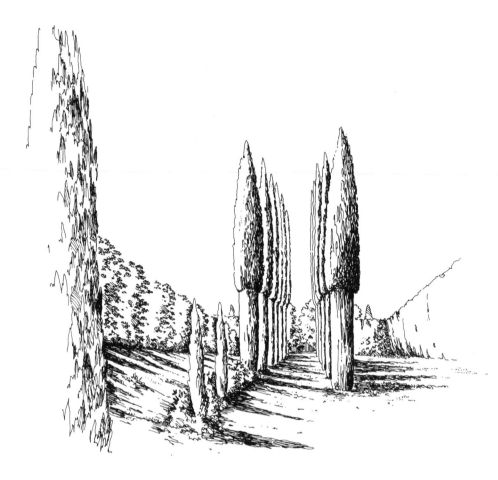

FIGURE 7–14 *Author. Line and texture combined to illustrate foliage.*

FIGURE 7–15 *Author. To draw palm trees, start with thumbnail sketches, then draw the center line of each frond. Abstract the form.*

plant's leaf. The best way to draw foliage is with a combination of the line and texture exercises in chapters 4 and 5. The *M*s, *W*s, wandering lines, scallops, and dots are very good basic lines to use for inventing your own shapes. Determine the scale of your foliage, based on your viewing distance from the plant. This will affect the intensity of your leaf gestures; the closer you are the more detail you will see.

Most trees have apertures, or openings in the foliage where you can see through to the branching structure, and sometimes completely through to the sky beyond. Careful rendering of apertures adds a third dimension to your volume and helps to animate your plants with light and shade. To construct the sky aperture draw an outline lightly around the opening, then sketch in the leaf gestures around the opening. Capture the shape and essence of the opening. Don't overemphasize the placement of these apertures—that is, don't punch the tree full of holes. Carefully place them to add interest with a consideration of the overall composition.

The Renaissance painters Titian and Girolamo Muziano drew beautiful and evocative foliage in their pen-and-ink landscapes. They abstracted the boughs of foliage into delicate scalloped strokes. With this technique they were able to achieve amazing depth with full tonal contrast and atmospheric effects. Rembrandt was a master of rendering landscapes in gesture. Much faster and looser than the Renaissance artists, he captured the essence of foliage with spontaneous compound lines repeated rapidly to produce texture. In his pen and bister (umber) wash drawing *A Thatched Cottage Among Trees,* one can easily see the vigorous strokes he used to produce the unique characteristics of each tree. The impressionistic quality of Van Gogh's vegetative gestures are a dynamic wonder. Van Gogh was able to capture the life forces of plant growth. His reed-pen drawings are an encyclopedia of linear gesture, exhibiting passionate and frenzied line work. Van Gogh's *Cypresses* is a fantasy of swirling lines that seem to push up out of the earth. His pen

FIGURE 7–16 *Author. Use apertures to add volume to vegetation.*

FIGURE 7–17 *Titian.* Landscape with Castle. *Pen and brown ink on paper. 217 × 347 mm. (M. Agnese Chiari Moretto Wiel, Rizzoli*

FIGURE 7–18 *Girolamo Muziano.* Forest Landscape. *Sixteenth century. Gabinetto Disegni e Stampe degli Uffizi)*

FIGURE 7–19 *Rembrandt van Rijn.* A Thatched Cottage Among Trees. *c. 1650. Pen and bister wash. 172 × 271 mm. (Courtesy: Dover Publications)*

FIGURE 7–20 *Vincent van Gogh. Cypresses, Saint-Remy. 1889. Reed and pen bister, 623 × 468 mm. (The Brooklyn Museum Frank L. Babbott and Augustus A. Healy Fund*

Drawing Techniques for Trees and Plants

FIGURE 7–21 *Charles Burchfield.* Pine Tree. *1955. Conté crayon. 19¼″ × 13″. (Private collection. Drawing courtesy Archives of the Burchfield Society)*

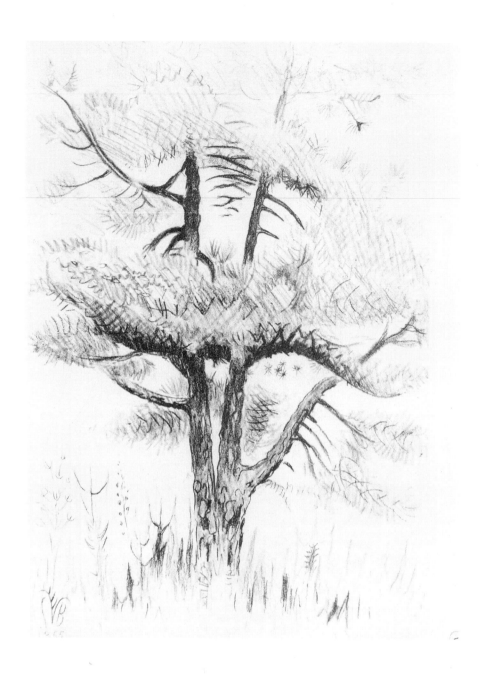

strokes animate the cypresses; the trees seem as if they are on fire. Charles Burchfield developed a calligraphic style in which he could capture his mental association of the vegetation he drew in the field. When he began to feel that his work lacked impulse, he would spend some time working spontaneously from nature.

"I need to paint right in front of the objects," he said, "feel it, experience that emotional state that actual presence produces in us." (Baur 1956, 53)

Shadow

When you draw, work to discriminate between the brightness of the lights and the extent of the darkness of the shadows. Drawing shadows is critical to producing realistic landscapes with depth and atmosphere. The most straightforward method to shade your vegetation is to use three values; light, medium, and dark, in combination with a shadowed edge. When vegetation is in the foreground or middle-ground you can usually see these three tones clearly. The background often requires only two tones, and the most distant portions may be implied with broken or dotted lines.

After you have lightly sketched in your silhouette and branching construction lines, you can add the foliage. Along the leading edge your line weight should be a very faint, almost broken line, because this is where the sun is brightest and the eye will not discern a solid line. On the opposite side, draw the shadowed edge as a dark line. Then repeat your abstracted leaf gesture to build up tone.

Always work from light to dark; lay down the medium tone, then slowly work back to the darkest tone, gradually building up volume. With your line work you should try to produce an even graduation from light to dark, keeping your stroke consistent. Make the shadowed edge as dark as possible. Finally, draw the shadow on the ground plane, which will be darkest next to shadowed edge. The edges of shadow will be

FIGURE 7–22 *Author. To create volume use abstracted leaf gesture to build up tone. Use the shadowed edge and shade for realism. Use the same process to shade the branching structure.*

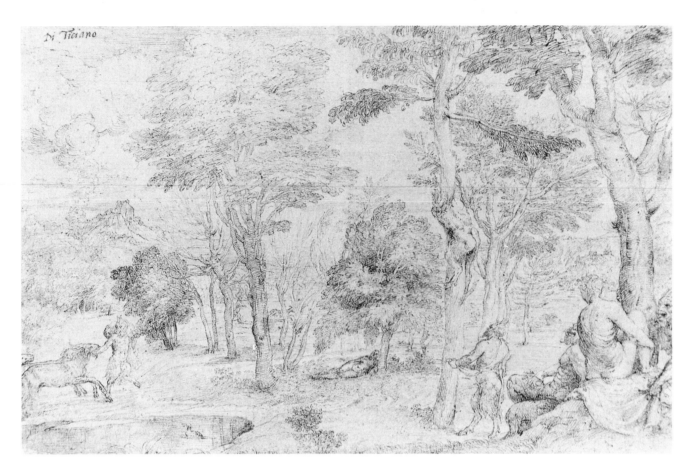

FIGURE 7–23 *Titian.* Landscape with Nymphs and Satyrs. *c. 1560. Pen and brown ink. 265 × 405 mm. (M. Agnese Chiari Moretto Wiel, Rizzoli*

lighter than the center, and some flickers of light will show through. Remember too that your shadow will pick up the texture on which it lies.

When shadowing the branching structure use the same process: keep the edge nearest the sun as light as possible (using a broken line); on the opposite side draw a heavy dark line and add the medium tones. To add further realism darken the tree crotches, and where a branch passes over another, add a shadow on the lower branch. Use the exclamation point throughout your drawing; you will be surprised at what a dynamic quality it can add.

Cross-contours are an excellent way to add detail and volume to the branching structure. Feel the bark. Look at its scale and texture. On the side away from the sunlight draw parallel lines following the upward growth of the tree. These lines lighten as they get further from the shadowed edge. Abstract the quality of the bark with your line. To add further detail to the branches use cross-contour lines at right angles to the parallel lines of the bark. The cross-contours should be slightly circular to express the volume and growth of the plant. Branches that come forward are usually darker. In *Landscape with Nymphs and Satyrs*, see how Titian's cross-contours give a feeling of volume and description to the bark. His line work gives each tree's structure a unique individuality.

EXERCISE 7–7: *The Leaf Gesture*

As a preliminary exercise to drawing the finished plant, practice graded tone with a variety of gestures. Begin by lightly drawing a series of two-inch circles freehand with a 6B pencil. Indicate the direction of the sunlight with an arrow. Start on the sunlit edge with a broken line that gets progressively darker as it reaches the shadowed edge. On each circle use a different leaf gesture. Work on building tone, making spheres from the circles. Develop consistency with your leaf gesture to build up a smooth graded volume. This is also a good time to work on inventing new gestures.

After completing one whole page of circles in pencil, do another page with a bamboo pen. The bamboo pen is made from a bamboo stem and has a stiff, thick, fibrous nib and can make harsh, angular, bold lines. You will not get the same consistency or the same amount of control as with the pencil, so allow for experimentation and accident. Work quickly when using the bamboo pen; keep drawing circles in gesture until you get used to the pen.

EXERCISE 7–8. *Silhouette Studies in Wash*

This exercise should be done in the field, to help you to discern and communicate the shape and form of vegetation. You will need an 18-by-24-inch tablet of newsprint, a large Japanese bamboo brush, three small wide-mouth jars, and India ink. Mix three gradations of black in the jars, from very light grey to dark. First, experiment with the brush. With this type of brush you can get a wide variety of effects, from fine lines to broad washes.

Select a tree with interesting form, and squint to see the silhouette and edge of the form. Remember that when using water-based techniques, always work from light to dark. First lay down the ground plane along the bottom of the page. Note the direction of the sun. With your lightest tone quickly paint the silhouette of the tree, trying to capture its unified pattern, or the gestalt of its form. Pay particular attention to the edges. It should almost look like a large, light blot. With your medium tone paint in the branching structure capturing its gesture. Take your second tone and paint in the shadowed edge, working back to the center of the plant form adding the shape. Use the same tone to paint the shadow. With your darkest tone put in the areas of shade and shadow, adding details to the branching and the leaves. Finally, add accents by using ink right from the bottle.

You can also experiment with a dry brush to produce unusual details. Blot out all of the excess water from the brush and drag or stipple it lightly across the surface of the paper.

After you become familiar with painting in wash, keep speeding up until you can do a wash gesture in five to ten minutes. Do ten different types of trees and shrubs, one to a page.

EXERCISE 7–9: *The Thumbnail Sketch*

The thumbnail sketch is handy for quick preliminary studies. It can be used as a warm-up exercise for the larger drawing. The thumbnail is different from the

FIGURE 7–24 *Regan McDonald.*
Silhouette Study in Wash. *1991.*
Japanese bamboo brush and ink on
newsprint. (Courtesy of Department of
Landscape Architecture, University of
California, Berkeley)

gesture in that you are working out the details and getting acquainted with the subject and its scale.

Draw a series of two-inch square boxes on a 18-by-24-inch sheet. In each box do a five-minute study of a variety of plant forms, illustrating all their major elements. Switch back and forth between 6B pencil and pen and ink.

EXERCISE 7–10: *The Sustained Gesture*

This exercise will combine all the previous ones, and should be done in the field. Do a full page sphere to warm up. Select a plant form that has an interesting shape and unique character. On an 18-by-24-inch sheet of newsprint, do a wash study. Look for the silhouette, shape, edge, and branching structure. Capture the gestalt of its form.

On an 18-by-24-inch sheet of two-ply Bristol board, draw a two-inch square thumbnail sketch of the plant. Just above it draw a quick gesture. Touch the plant and observe its form close up. In the upper left-hand of the sheet, do a tone

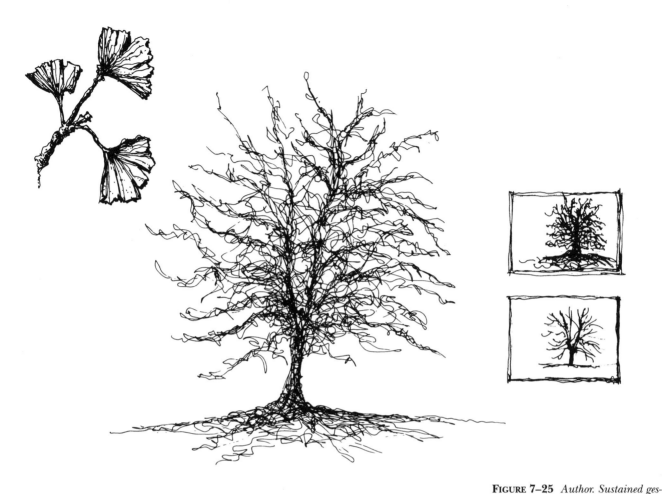

drawing of a twig with leaves; study its form and segmentation. As the central focus of your page, rough out your plant with light construction lines. Begin with the ground plane, then lightly gesture in the silhouette. Always work with your light construction lines first, getting slightly darker with each step. Draw your main center line, then lightly sketch the branching structure. Determine the light source, abstract the leaf form, and slowly build up the tones and textures, giving the tree volume. Add the darkest accents and the shadowed edges of the foliage and branching. As the last step draw the cast shadow and dark accents. Do at least ten types of plants.

EXERCISE 7–11: *Drawing Around the Tree*

Pick out a specimen tree. On a large sheet of newsprint draw the tree in 6B pencil from every angle as you move around it.

EXERCISE 7–12: *Ten Trees*

Divide an 18-by-24-inch sheet horizontally. Along the upper portion of the page draw ten species of trees from life, in gesture, with tone and texture. Below each, draw the trees in plan view in gesture with shadow.

FIGURE 7–26 *Author. Select a specimen tree and draw it from a variety of angles.*

EXERCISE 7–13: *The Day-Long Sustained Gesture*

On a nice day select a specimen tree; start in the morning and observe it all day. As you are watching the tree do a continual series of drawings that express the changes during the day. Use all the media you have been practicing with.

EXERCISE 7–14: *The Year-Long Tree Study*

Observe and study a single tree in your yard or next to your home for one year. Notice and record the effects of the changing seasons on the shadows, textures, colors, and flowers. Draw the tree once a week in varying media to capture its seasonal variations.

FIGURE 7–27 *Frank James, Sasaki Associates. Tree gestures.*

Tree and Plant Massing

Your object, as a painter, is to know in what manner one tree differs from another in its growth, so as to recognize a type and to be able to distinguish the varieties of individuals by their departure from that type. (Cole 1965, 147)

When drawing masses of trees, first find the direction of the sunlight and do a few thumbnail sketches. The trees in the foreground have more visible texture and sharper detail than those in the middle distance and background. The cross-hatching in the foreground is dark, and becomes lighter as it moves off into the distance. Discern the outlines of the plants against the sky and against one another. Look for the positive and negative shapes, and be particularly aware of the negative space around each plant. Begin by roughing in the silhouettes with construction lines. To create depth, contrast the textures of one plant against another to create the illusion that one is in front of another. By alternating the shadows of each plant from dark to light as they go off into the distance, you will reinforce the feeling of depth. Also, diminish your line weight as the plants move into the background. You can observe many of these techniques in the landscapes of the master cartoonists. The early Prince Valiant comics by Harold R. Foster had excellently rendered forest masses.

Exercise 7–15: Plants in Masses

For this exercise locate a series of three to five trees and shrubs in something of a line. Place yourself at a three-quarter view with the sun coming from the side. Begin with a thumbnail sketch of the composition in the lower-right corner of the page. On the full page lightly outline in 6B pencil the plant masses and

THE GLADE IS A BOWL FILLED WITH GOLDEN SUN-LIGHT. IN THE DIM FOREST BEYOND PEACE LIES SLEEPING. THE ONLY SOUNDS ARE THE CHEERY SCOLDING OF THE BIRDS AND THE SAD, SWEET MUSIC OF THE RUSHING WIND AMONG THE TREE TOPS. "THEY SAY HEAVEN IS BEAUTIFUL," MURMURS HUGH. "IT MUST BE JUST LIKE THIS."

FIGURE 7–28 *Harold R. Foster.* Prince Valiant. *1946. Creating depth within forest masses. (Reprinted with special permission of King Features Syndicate)*

their branching structures. Sketch in the leaf textures, building up the volume. Concentrate on making each receding volume alternate from dark to light. Let your line weight become gradually lighter as it recedes. Use a dotted line for the volumes in the background.

Exercise 7–16: High-Contrast Rapid Sketches

Select a plant mass and start with very light construction lines, quickly roughing in the composition. Always work from light to dark. Where light hits the edges, use a faint or dotted line. Draw the deep shadows with your darkest lines, using cross-hatching to build up tone and shadow, with which you can get incredible depth very rapidly. As the plant masses recede into the distance, use lighter line weights. Use a dotted line for the background. This exercise should be done in less than five minutes. Try to bring out the individual characteristics of each plant. Eliminate any unnecessary line work, using the most economical line to describe your images. In this exercise the shadows and shadowed edges should describe the plant forms.

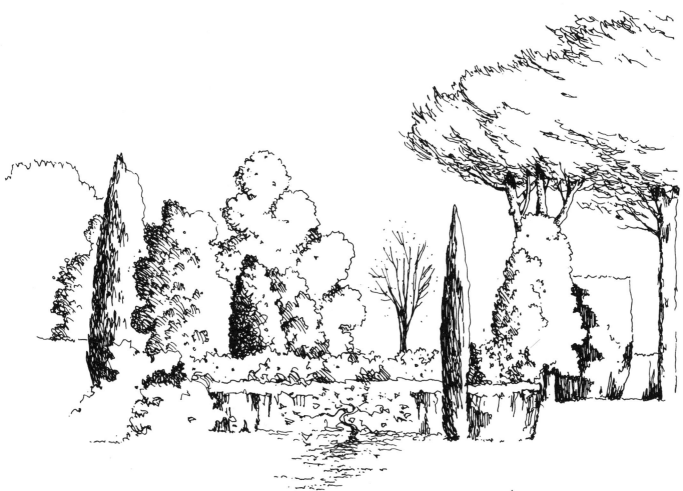

FIGURE 7–29 *Author. Plant masses with thumbnail sketches.*

Drawing vegetation can be one of the most difficult elements in the process of learning to draw the landscape. But the most important thing is to go through these exercises slowly, repeating them until you can do each one proficiently before going onto the next one. Once you learn the basics you will advance quickly. Be encouraged by the words of da Vinci:

> *And when you have thus schooled your hand and your judgment by such diligence, you will acquire rapidity before you are aware. (Richter 1970, 247)*

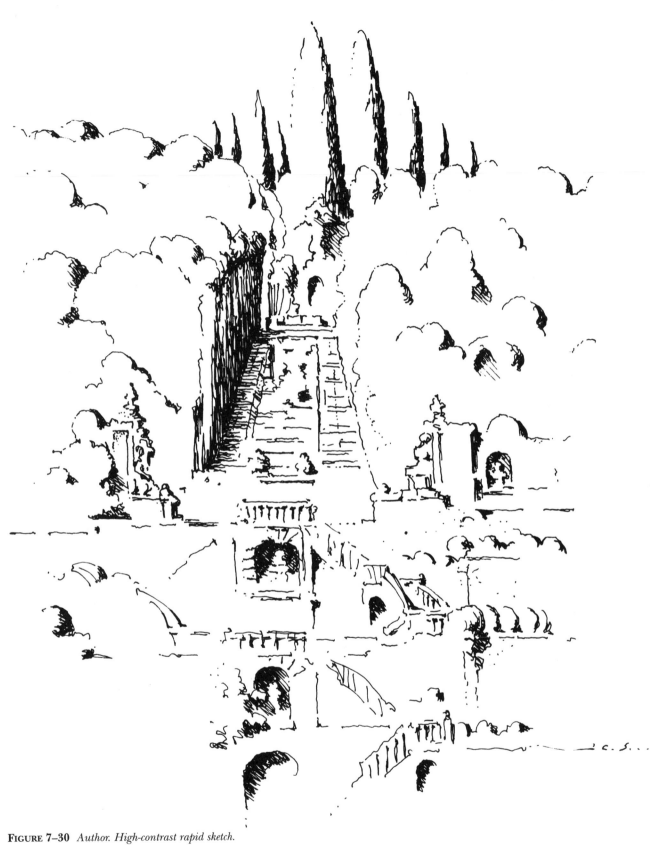

Figure 7-30 *Author. High-contrast rapid sketch.*

FIGURE 7–31 *Carol V. Deering*. Big Tree. *"Pencil on paper. 1993.*

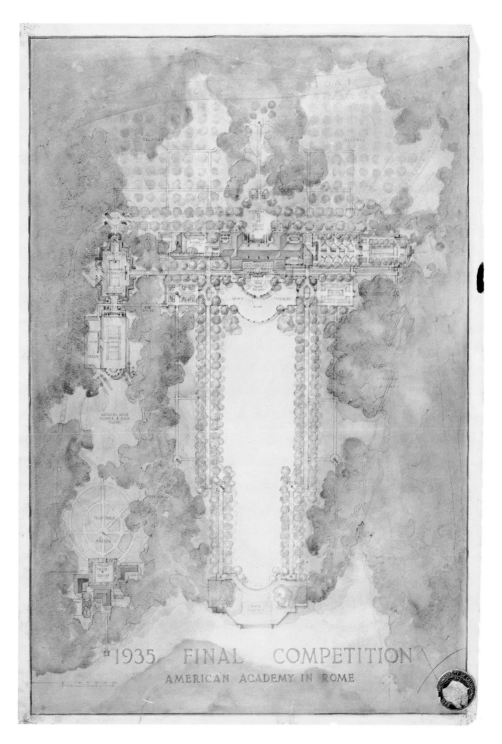

FIGURE C–1 *Student Project, 1935. Pencil and watercolor. 27″ × 40″. Courtesy of the collection of the Department of Landscape Architecture, University of California at Berkeley.*

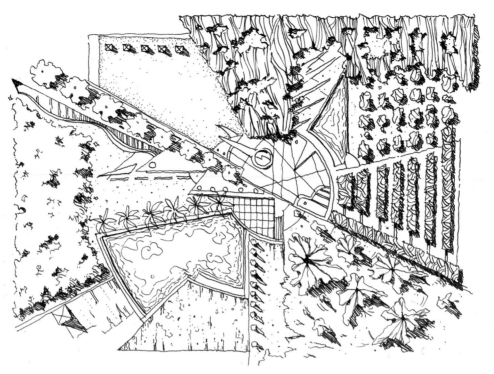

FIGURE C–2 *Start with an ink drawing on smooth 9-by-12-inch Bristol paper. (Photo: Catherine Harris)*

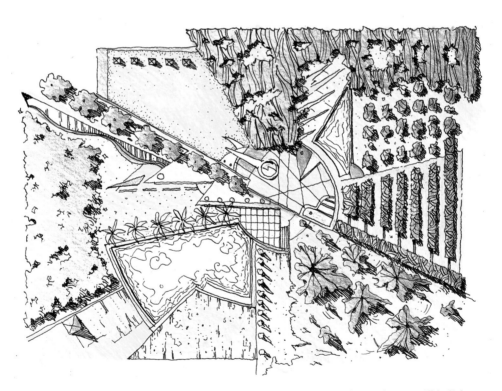

FIGURE C–3 *Begin by first determining the location of the sun; the areas facing the sun will be lighter and brighter. Start by using your brightest colors, filling in the large areas throughout the whole composition. Grip the colored pencil lightly, a couple inches from the point, and move it in parallel, even strokes. It is important to lay down a smooth, even base to be able to blend the succeeding layers of color. If you start too dark, it will be very difficult to lighten up your colors later. It is often tempting for the beginner to start with dark, heavy coloring, but if you start light, you can always add more color later. (Photo: Catherine Harris)*

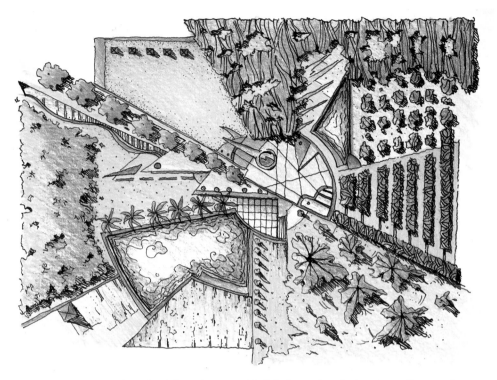

FIGURE C–4 *Once you've colored the entire page with light base colors, begin to intensify your colors, making your layers heavier. These layers should be large, smooth areas of color made with light strokes, lightly blended together. At this stage you will begin to mix other colors into the base colors. You should also begin to emphasize dark areas and create accents. (Photo: Catherine Harris)*

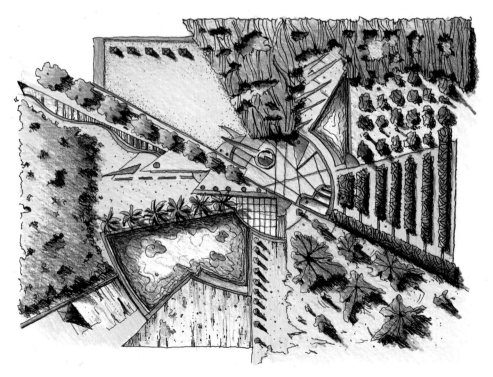

FIGURE C–5 *In the final stage you will work much more slowly and deliberately, holding the pencil tighter and closer to the point. You can also use the pencil to draw textures and details, and go back over your washes with bright colors to blend in the preceding layers and create highlights. Conclude your drawing by adding the shadows and emphasizing their edges. (Photo: Catherine Harris)*

FIGURE C–6 *Before beginning your color pencil drawing, begin by making a series of 1-inch square boxes and create a color pallet. Note which pencils you use so that you can re-create the color blends.*

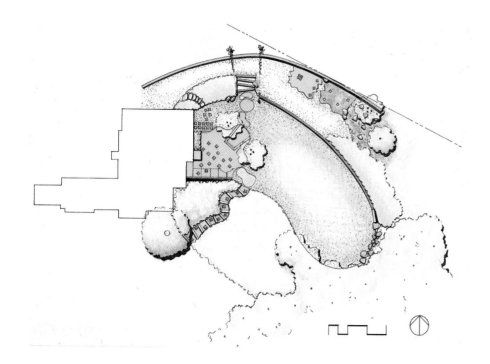

FIGURE C–7 *Andie Cochran, Delany & Cochran. Randell Denney Garden. 11" × 14". Ink on Mylar with Prisma color pencils. Coloring on the back of Mylar creates softer, more even tones and emphasizes the brighter colors on the front.*

FIGURE C–8 *Topher Delaney, Delaney & Cochran. Hatch Garden. 22" × 30". Oil stix™ and crayons hand-rubbed on watercolor paper.*

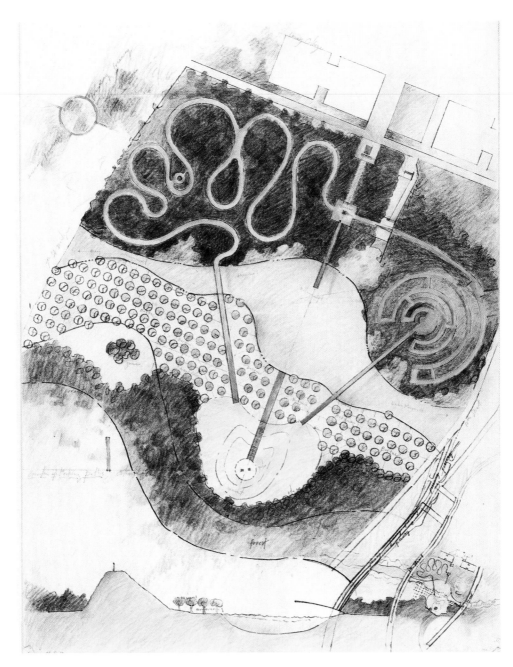

FIGURE C–9 *Catherine Chang. Garden of the Forking Paths. Prisma color pencils. 18" × 24".*

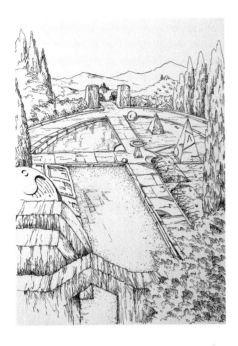

FIGURE C–10 *To begin, rough out a light pencil sketch, then trace it in indelible ink on 9-by-12-inch, 120-pound rough watercolor paper. After the ink has dried, erase the pencil layout sketch with a soft plastic eraser. (Photo: Catherine Harris)*

FIGURE C–11 *Determine the direction of the sun for shadows, then lay down light watercolor washes with a number 12 watercolor brush. Start with the sky. Using a lot of water in your wash gives you enough time while the washes are drying to drop in other colors to create brilliant transparent hues. After the sky has dried, work downward, filling in the large areas of the background, middle ground, and, finally, the foreground. Be sure each area has dried before moving forward, so that the washes will not bleed together. (Photo: Catherine Harris)*

FIGURE C–12 *Now begin to fill in the smaller areas with color and add details. Work the whole page rather than focusing on specific areas, so that you can determine the color balance of the page. Now all of your base washes should be finished. (Photo: Catherine Harris)*

FIGURE C–13 *For the final layer, slowly add the details and fine points. You should be drawing with your brush and using a lot of pigment with small amounts of water. If you need to you can also add transparent washes to increase the brilliance of your colors. To complete your painting add shadows and use them to define edges. This is a very important step; the shadows add dimension and can illustrate the relative heights and create detail in your painting. Well-defined shadows will increase the illusion of depth, and are the final creative touch. (Photo: Catherine Harris)*

Figure C–14 *Sally Anne Neal.*
Collage with color photos. Zip-A-Tone
and ink on Bristol board. 9" × 12".

Figure C–15 *Chisel. Collage. Mixed media. 8" × 10".*

FIGURE C–16 *Ken Smith. Mixed media. 30" × 40". Petrosino Park Competition, 1996; selected entry for exhibit at the Store Front for Art and Architecture, New York City. The original image was pen and ink on vellum with text pasted up and copied as a large format print on KP5 paper. The section and plan were rendered with color plastic film. The photographic images were shot from a model and copied using a laser color copier, and the circle details were also laser copies in black.*

FIGURE C–17 *Ken Smith. Mixed media. 30" × 40". Public Space in the New American City, 1995; honorable mention. The laser prints were shot from color photos as large copies worked over with extensive color plastic film. The model images are also color laser copies from photographed slides. The circle "call out" details were done with images instead of words.*

FIGURE C–18 *Maria McVarish*. The Real Story About. *Mixed media, including illustrations from* The Real Story About the Weather, *by Frank H. Forrester.*

FIGURE C–19 *Maria McVarish. Untitled. Mixed media.*

FIGURE C–20 *Author*. Garden of Linneaus. *Mixed media installation. Painted plywood, box constructions with watercolored diaramas, glass specimen jars, and glass glazing globe on pedestal. (Photo: Brit Bunkley)*

FIGURE C–21 *Catherine Chang. Axonometric drawing.*

FIGURE C–22 *Catherine Harris.
Panorama done in the field. Watercolor
in travel sketchbook. 5" ×14".*

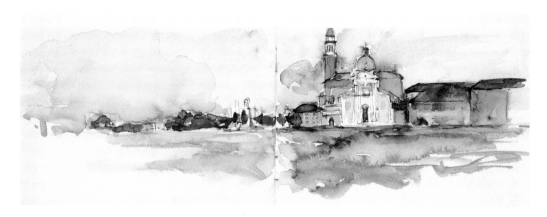

FIGURE C–23 *Annie Amundsen.*
Panorama of Venice. *Watercolor in
travel sketchbook. 5" × 12½".*

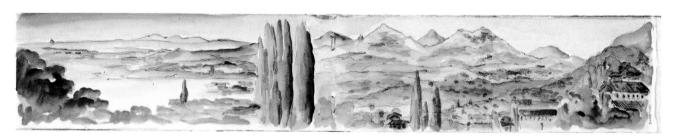

FIGURE C–24 *Author.* View from
the Villa d'Este, Tivoli, Italy,
*Watercolor in field sketchbook, 5" ×
24".*

Figure C–25 *Falcon & Bueno. Michael Seroka, renderer. Raskin House and Gardens. Axonometric drawing in color pencil on vellum.*

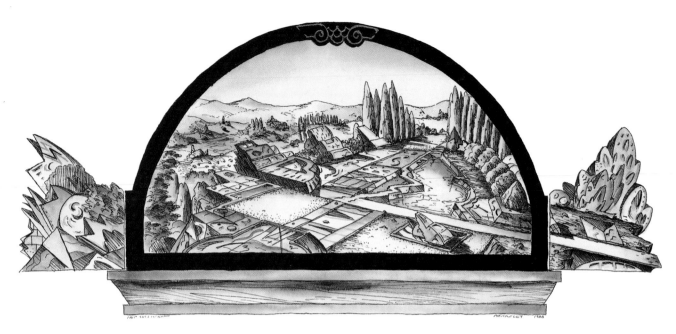

FIGURE C–26 *Author.* The Botanic
Garden. *Lunette, pen and ink with
watercolor, 18″ × 24″.*

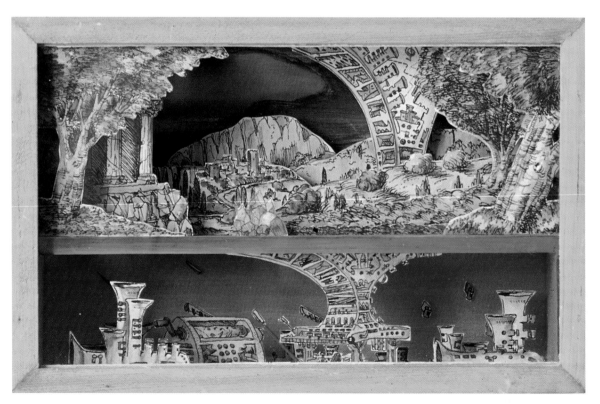

FIGURE C–27 *Author.* Classical
Landscape with Instrumentation.
*Box construction, diorama with painted
cutouts.*

FIGURE C–28 *Amy Wynn.* Dream House. *Stained burlap, gessoed with oil and ink, 1993.*

FIGURE C–29 *Amy Wynn.* Woman. *Oil on cotton (Oxford shirt), 1996.*

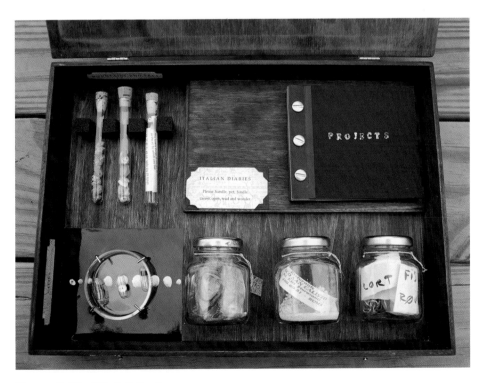

FIGURE C–30 *Elizabeth Boults.* Portfolio. *Mixed Media with objects, 1996, 10″ × 15″ × 2″.*

FIGURE C–31 *Joesph Slusky. Mindscape Series. Pen and Ink with watercolor.*

Composing the Landscape Drawing

*[Rembrandt] was one of the most sensitive and accurate
observers of fact who ever lived, and one who, as time went on,
could immediately find a graphic equivalent for
everything he saw. In his landscape drawings of the 1650s,
every dot and scribble contributes to an effect of space and light . . .
The white paper between three strokes of the pen seems to be full of air.*

KENNETH CLARK
Landscape Into Art

FIGURE 8–1 *Author.* Tuscan Landscape. *Pen and ink on paper. 1989.*

To create landscapes of interest and excitement, one must be able to create dynamic compositions, whether in perspective, plan, or elevation. The process of composition cannot begin without facility in drawing gesture. The gesture is the foundation upon which the composition is built. Think of composing the landscape drawing as if you were designing a movie or theater set.

Good landscape drawing does not just happen; it is grounded in many studies and a strong plan. John Constable had a lengthy process of observation, drawing, and design before beginning a final oil painting. He did this series of observations separately and in distinct stages. He would begin by doing small pencil sketches in tiny notebooks. Then he would do small oil sketches, working out the theme of light and shade. Next, using pencil, he would study the definition of form. After that he would do detailed drawings from nature of the various landscape ele-

FIGURE 8–2 *Author.* Lost Alchemy. *1990. Pen and ink on paper. Designing the landscape drawing.*

ments that eventually would be arranged into the painting. After this stage he would paint the larger oil sketches, studying the composition. The last step was the development of full-sized sketches at the same scale as the painting. Finally, after thoroughly acquainting himself with his subject, he would begin to paint his full-scale oil canvas.

Behind Claude Lorrain's landscape paintings was an incredible amount of preparation. Every element placed in his landscapes was the result of considerable thought and imagination. He would first do many sketches of landscapes in the field. These studies would often become parts of settings in larger oils. These field sketches were done for the pure enjoyment of drawing from nature. He would also make sketches of his ideas for landscape compositions, which would later become the bases for paintings. Finally he would work on the actual studies of the final composition for the painting. Only after this process of observa-

FIGURE 8–3 *Author. Use thumbnail sketches to compose the drawing.*

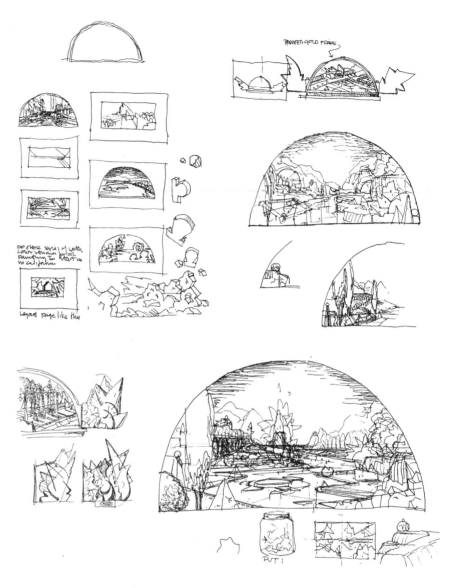

tion and study would he begin the oil painting. As a result of this lengthy study he produced paintings in which a harmony of elements formed a whole.

Though I don't advocate such an exacting process, I think it illustrates the importance of preparation. Through their lengthy design processes, Constable and Lorrain familiarized themselves thoroughly with all the compositional elements before beginning. Thus they organized the landscape form into a logical unity.

To create compositions you must train your hand and pencil to do what your eye does naturally when you observe a landscape. Artists edit the environment. They take from it what they deem pertinent, leave out what they consider confusing, and sum up scattered details into comprehensive images to create a pictorial fiction. No two artists portray the same landscape identically.

Not only should the landscape be well-composed, it should express an idea and a mood. During the Renaissance it was believed that the land-

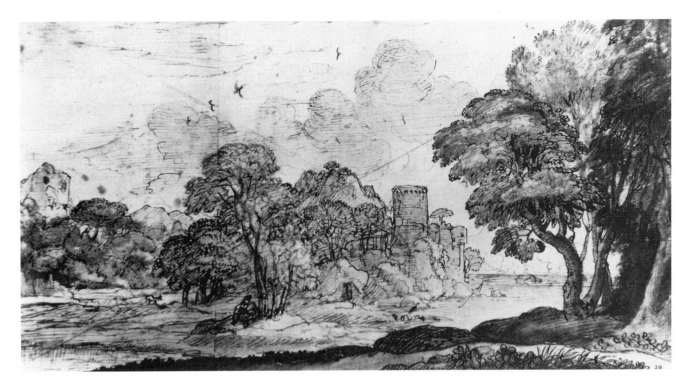

FIGURE 8–4 *Claude Lorrain.*
Landscape with Psyche. *1663. Pen,
various shades of brown wash, diagnosis in red chalk. 180 × 345 mm.
(Staatliche Kunsthalle Karlsruhe)*

scape could give rise to inspiration and activate the imagination. Centuries later Robert Henri reinforced this idea:

> *The various details in a landscape painting mean nothing to us if they
> do not express some mood of nature felt by the artist. It isn't sufficient
> that the spacing and arrangement of the composition be correct in formula. The true artist in viewing the landscape renders it upon his canvas as a living thing. (1923, 118)*

Charles Burchfield also felt that a picture must have a strong structure wherein all parts coordinate. He believed that this inner structure could come about only after a close study of nature's laws. His chief aim in painting was to capture a personal mood derived from the *genius loci,* or spirit of the place. Burchfield approached his landscapes not with ready-made formulas but with a humble reverence to learn from nature.

Landscape drawing provides a forum for the viewer to gain an understanding of his or her relationship to the order of nature. Not only is the landscape composition a place for ideas, it is also a place for imagination. According to Clark, for Rembrandt "landscape painting was the creation of an imaginary world, vaster, more dramatic and more fraught with associations than that which we can perceive for ourselves." (Clark 1979, 61)

It is important not only to draw from nature, but to develop methods to imagine landscape compositions. Da Vinci developed a marvelous technique for landscape imagination:

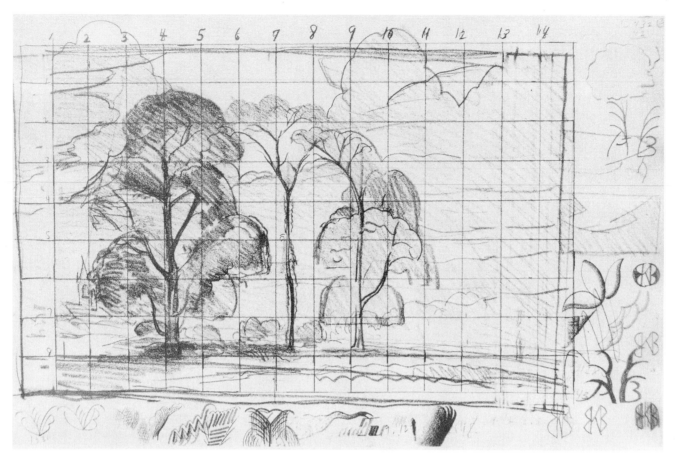

FIGURE 8–5 *Charles Burchfield.* Study for the Three Trees. *1931. Charcoal. 12" × 18". With study notes in the margins. (Collection of Kennedy Galleries, Inc. New York)*

I cannot forbear to mention among these precepts a new device for study which, although it may seem but trivial and almost ludicrous, is nevertheless extremely useful in arousing the mind to various inventions. And this is, when you look at a wall spotted with stains, or with a mixture of stones, if you have to devise some scene, you may discover a resemblance to various landscapes, beautified with mountains, rivers, rocks, trees, plains, wide valleys and hills in varied arrangements; or again you may see battles and figures in action; or strange faces and costumes, and endless variety of objects, which you could reduce to complete and well-drawn forms. And these appear on such walls confusedly, like the sound of bells in whose jangle you may find any name or word you chose to imagine. (Richter 1970, 254)

Da Vinci later returns to this concept in a slightly different manner in his notebooks, suggesting that the painter study not only walls but also "the embers of the fire, or clouds, or wind, or other similar objects from which you will find most admirable ideas. . . . Because from a confusion of shapes the spirit is quickened to new inventions. . . . But first be sure to know all the members of animals and the members of landscapes, that is to say, rocks, plants and so forth." (Clark 1976, 90)

Thus the design of landscapes is an interplay of the conscious and unconscious mind, evolving out of a chaos of form.

EXERCISE 8–1: *Imagining Landscapes*

*Follow da Vinci's example. Find a well-worn wall with lots of texture and inter-
esting surfaces. Sit in front of it until you begin to imagine landscapes either
in plan or perspective. Imagine it as a landscape drawing. In your daybook,
with your fountain pen, sketch out what you see. Keep doing this until you eas-
ily see the landscapes in a wall (or until you start to gather a crowd).*

...

The Picture Plane

In the fifteenth century Leon Battista Alberti described the picture
plane as "an open window through which the subject is to be seen."
(Frayling 1992, 4) To begin your landscape drawing you must first estab-
lish the picture plane. After you have determined the subject, the pic-
ture plane will frame the pictorial field so that you can penetrate the
space with your drawing. Being able to penetrate space is one of the
essential elements of landscape drawing. You can also imagine the pic-
ture plane as an aperture that allows you to view the composition.
Through this imaginary pane of glass passes your line of vision, and the
pictorial elements of the landscape drawing are composed. Thus it
becomes a frame of reference for the drawing similar to an *ecotone,* or
the boundary between two ecosystems. Since the physical surface of the
plane is flat, it will be transformed into the third dimension through the
act of drawing.

FIGURE 8–6 *Author. The picture plane.*

EXERCISE 8–2: *The Viewfinder*

Using a viewfinder is an excellent way to put yourself into the picture plane, and helps you to see how the frame creates the space of the drawing. You can easily make a viewfinder by cutting a 2½-by-3-inch rectangular frame from a piece of cardboard. It helps to attach to the opening a sheet of clear plastic with a half-inch grid on it. This device is also called an Alberti's veil, though his was constructed out of a wooden frame and thread. Take your viewfinder out into the landscape and hold it up. As you move it around, you will see an incredible array of good compositions. It is similar to looking through a camera. Rotate the frame from a horizontal to a vertical position and notice how the composition changes. Carry your viewfinder with you and use it whenever you see a landscape that catches your eye. You can also make a viewfinder out of an empty slide frame and keep it in your daybook.

EXERCISE 8–3: *Activating the Picture Plane*

It is important to see how the placement of a mark on the page can activate the picture plane. Start by drawing a heavy dot in the center of an 18-by-24-inch sheet of paper. Draw a series of two-inch squares on the page, and in each square draw the same size dot in a different location. Observe the effect of this

FIGURE 8–7 *Author. Using the viewfinder.*

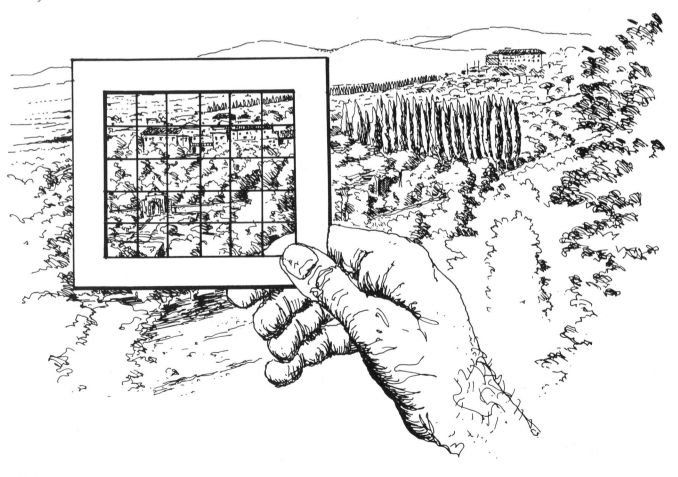

FIGURE 8–8 *Michael Laurie. Thumbnail landscape studies. Pencil with watercolor wash.*

simple dot as it moves around the picture plane. How does its placement effect the tension within the frame? On another sheet of paper draw another series of two-inch squares and place two quarter-inch lines in different relationships to each other in each box. How do the two lines react to each other and to the space of the frame?

Drawing Paper

Drawing paper is generally rectangular, with a three-to-two ratio. The longer side is roughly $1\frac{1}{2}$ times the length of the shorter side, which allows you to use the sheet horizontally or vertically. Usually landscape drawings are placed on the horizontal, and hardly ever in a square format. However, you should determine the layout of the page according to your specific subject and individual requirements.

EXERCISE 8–4: *On-Site Sketching*

Charles Burchfield felt that you could not experience a landscape until

> *you have known all of its discomforts. . . . You have to curse, fight mosquitoes, be slapped by stinging branches, fall over rocks and skin your knees, be stung by nettles, scratched by grasshopper grass, pricked by brambles . . . before you have really experienced the world of nature.*
> *(Baur 1956, 56)*

While this is a little extreme, it is important to draw directly from nature. For this exercise you should spend as much time as possible in the field making sketches from the landscape to later take back to the studio and work into ideas for designs or finished landscape drawings. Make yourself comfortable by taking a

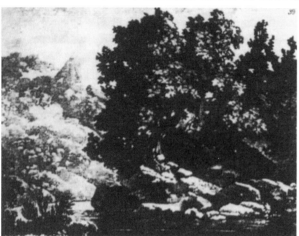

FIGURE 8–9 *The three stages of a landscape blot by Alexander Cozens. Catherine Harris completed landscape blot.*

folding stool, a drawing board, and a bag of art supplies. Draw everything from the smallest detail to broad horizontal compositions. While Burchfield was drawing in the field, he would sometimes throw himself down on the ground and embrace the earth with the hot sun glaring down on his back. You might try laying on the ground to feel the earth and watch the clouds move by for inspiration.

Make a habit of drawing in the field and collecting sketches and idea notes for later compositions or designs.

EXERCISE 8–5: *Observation and Drawing*

Select a view you want to draw. Look at the view for a few moments and try to remember it. Quickly turn around and draw everything that you remember. Turn around and face the view and see what you left out, then correct the original. Keep repeating this process until you can complete the view.

EXERCISE 8–6: *All-Day Landscape Sketches*

This is another one of Burchfield's drawing conventions. One evening while out drawing he had an idea:

Within the image, handwritten annotations read:

Santa Rosa mountains

date gardens

grapevines

Coachella Valley, near Thermal
20 April 91 10 Am 0 elevation.

FIGURE 8–10 *Michael Laurie. Field landscape composition in pencil and watercolor wash.*

He would paint, in continuity, transitions of weather and seasons, such as the development of a thunderstorm from a clear day, followed by a brilliant moon rise. Each phase would be a separate picture, but the pictures would be so designed that they could be united in a single composition. Hundreds of drawings were made, which he called "all-day sketches." (Baur 1956, 32)

If you can spend a full day sketching the changing moods of the landscape, do a series of drawings in a scale and drawing medium that feels comfortable to you. This is an exercise you should do throughout your career. Use all of your drawing equipment.

EXERCISE 8–7: *The Cozens Landscape Blot*

This exercise is a variation of the ones put forth in Alexander Cozens' book, A New Method of Assisting the Invention in Drawing Original Compositions of Landscape, first published in the late 1700s. This method is a variation on da Vinci's system of visualizing landscapes from wall surfaces. Rather than the imagination being sparked by stationary elements, Cozens' method can be done at any time, but still relies on accident and discovery. He states that:

Composing landscapes by invention is not the art of imitating individ-
ual nature; it is more; it is forming artificial representations of land-
scape on the general principles of nature, founded in unity of character,
which is true simplicity; concentrating in each individual composition
the beauties, which judicious imitation would select from those which are
dispersed in nature. (1954, 166)

In this exercize you will work from nonspecific abstract shapes, lines, and blots, to imagining these forms into a landscape drawing (see Figure 8–9).

First, lay down a diluted wash of India ink on an 18-by-24-inch sheet of newsprint. Rapidly move your bamboo brush all over the page so that forms develop by chance. Next, work on abstract shapes with no preconceived images in mind. This type of random blotting can give you an incredibly free beginning for creating compositions. Now lay down secondary forms and blots using a dry brush in as many inventive ways as you can think of.

The presence of an initial idea is the most important concept in this process. When doing this exercise one must be agile in the creation of the landscape composition. Cozens called the blot technique a "spirited sketch"; he believed the blot to be nearer to nature because the forms in the landscape are not distinguished by lines but by shade and contour.

To start this exercise use the Japanese bamboo brush and India ink. Dilute the ink into a medium-tone wash. Use an 18-by-24-inch sheet of newsprint. You want to work very quickly to create an assemblage out of accidental shapes. First lay down the diluted wash, rapidly moving the brush all over the page so that the forms come about by chance. Work on blocking out positive and negative shapes, concentrating on the empty spaces. This type of blotting can give you an incredible amount of freedom in creating compositions. Now, lay down secondary forms and blots using a dry brush in as many inventive ways as you can think of. As a final step, use the ink directly out of the bottle and begin to define landscape shapes by outlining them in contour. Use the brush to add detail and delineate the landscape forms.

After the paper has dried, tape a sheet of tracing paper over the blot. Take an ink pen and draw a fine-tuned landscape drawing from the wash underneath. You will be surprised by the unique landscape you come up with. Do at least ten blot-washes and overlays.

Figure 8–11 *Author. Diorama of the planes of a classical landscape composition. Pen and ink on Bristol board.*

Author. Side view of diorama illustrating actual division of space. (Photos: Catherine Harris)

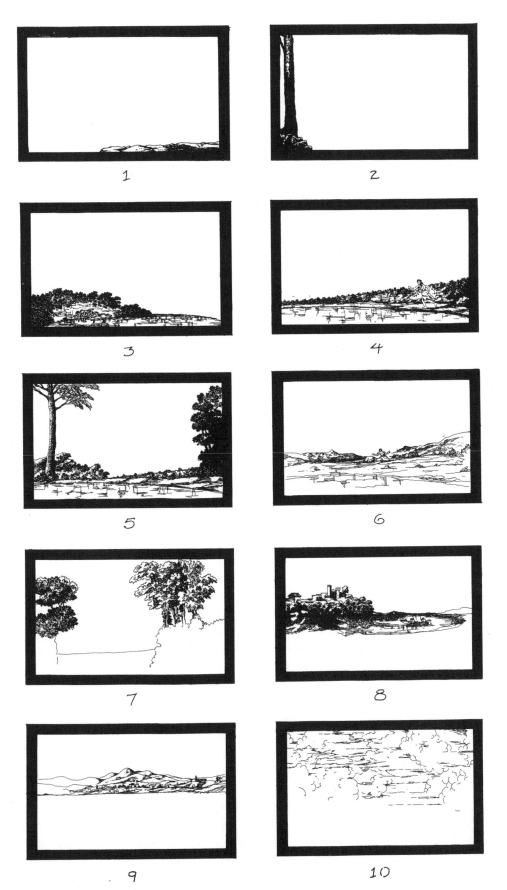

FIGURE 8–12 *Author.*
Individual spatial planes of
the classic landscape compo-
sition.
1. Picture plane and ledges
or eyedrops.
2. Foreground measure.
3. Foreground.
4. Diagonal lead.
5. Visual frame.
6. Middle ground.
7. Stage wings.
8. Diminishing right angles.
9. Background.
10. Atmosphere.

Composing the Landscape Drawing 179

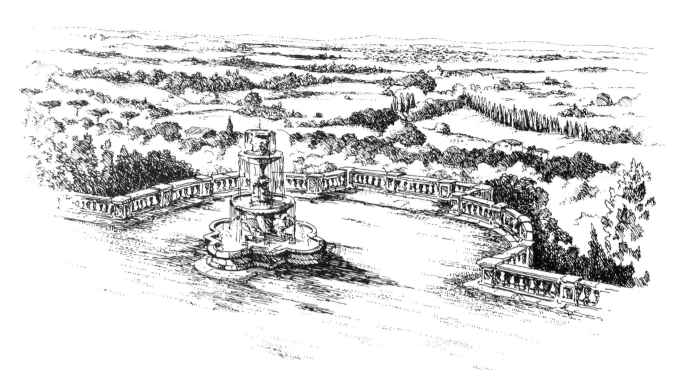

FIGURE 8–13 *Author. Landscape composition of alternating lights and darks. Pen and ink.*

The Classic Landscape Composition

This type of composition incorporates many theatrical devices. After you have selected your subject and established your picture plane, you are ready to begin to penetrate the space. Placed directly on the picture plane, an object such as a tree trunk or stump acts as a gauge to measure the space of the picture, and gives the eye something to look around and past. It also establishes the scale of the picture. The lower foreground usually contains what is called the *ledge* or *stage,* which drops away into the space of the picture. Also called the *eye drop,* it pulls the eye down and into the picture plane and is a very heavy ground plane at the bottom of the picture. Located on either side of the picture plane, the *stage wings* are similar to a theatrical scene. These are dark masses, usually of trees or rocks, that bracket the foreground, leaving the central frame of the picture open. This dark mass is sometimes called a *coulisse,* which is the space between the side scenes in the theater. Often the four corners of the foreground are in deep shadow to stabilize the picture. From the foreground a strong side of the picture is developed from which a diagonal leads off into the distance. The eye usually enters the picture from the left, which allows the heavy objects to the right to act as a counterbalance. The diagonal is often quite dramatic and may be a rhythmic curving line that leads the eye into the distance.

From the foreground stage there is a series of retreating planes parallel to the well-defined ground plane in the foreground. The parallel spatial structure helps produce a linear order of space, dividing the picture clearly into foreground, middle-ground, background, and distant atmosphere. This creates the illusion of depth and a measurable progression into the background.

To further enhance the illusion of space and to stabilize the picture, right angles are used to frame the receding lateral boundaries. This is the essence of pictorial structure. According to Clark, Poussin realized that

> *the basis of landscape painting lay in the harmonious balance of the horizontal and vertical elements in his designs. He recognized their rhythmic relation to one another could have an effect exactly like the rhythmic travee (frame) or other harmonic devices of architecture; and in fact he often disposed them according to the so-called golden section. (1979, 129)*

Poussin developed a structure to conduct the eye smoothly and rhythmically through the pictorial space to the background. Alternating lights and darks enhances the rhythmic movement of the eye through positive and negative masses of vegetation and architecture. These contrasting tones articulate the forms of the landscape while reinforcing the volumes and the pictorial depth. Proportional keys such as buildings, bridges, roads, and individual specimen trees help the viewer to perceive depth in the painting. As counterbalances, these elements slow down the progress of the eye as it moves through the picture plane. When figures are used, they are subordinate to the landscape and indicate scale in individual retreating planes.

The eye is attracted by more detailed shapes and smaller textures. Thus it is important to establish a hierarchy of shapes and textures—larger ones in the foreground and smaller in the distance. Changes in scale and points of light can be used to enhance the movement of the eye. Generally, near the center of the landscape is an area of light were the eye will come to rest. This slightly off-center spot is called the *focal point*.

FIGURE 8–14 *Author. Hierarchy of shapes and textures. Pen and ink.*

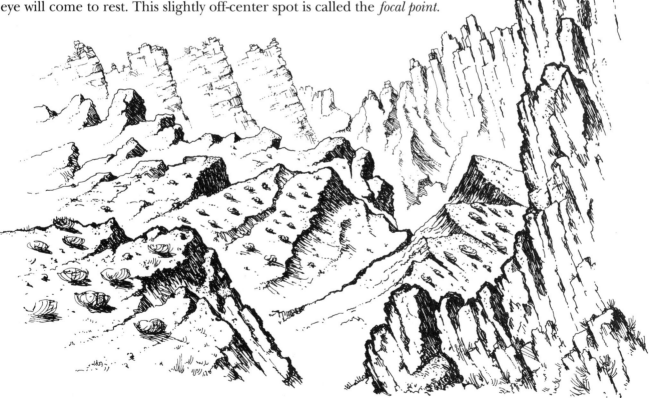

FIGURE 8–15 *Author. The macro and micro themes. Pen and ink.*

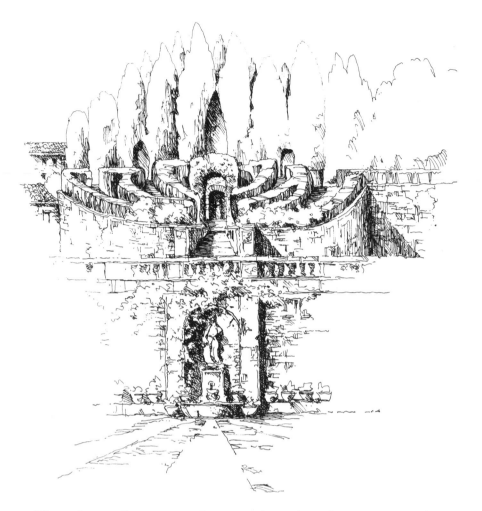

There is usually a macro-theme and a micro-theme in a landscape painting in which images are assigned a symbolic meaning to tell a story. The macro-theme establishes the context, allegory, and iconography. The macro-theme is also the primary image of the painting. When it is repeated at a much smaller scale within the picture it is called the microtheme. The micro-theme is the place within the painting where the eye will come to rest. The landscape of symbolism was born in Italy and was refined in the fifteenth century. Italian landscape paintings of the Renaissance were usually filled with allegory and strong iconography.

Optical Devices

Renaissance artists were the first to use optical devices to explore visual perception; they became widely popular with the leisure class in the eighteenth century, when the viewing and drawing of romantic landscapes became a refined pastime. These devices were used to distort perspective and make broad, expansive landscapes manageable. They create or accentuate the mood of a space. Overall, they are an attempt to understand and capture the landscape. Following are descriptions of a few of these tools and how they can be useful today.

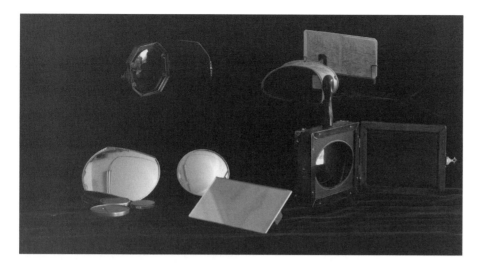

FIGURE 8–16 *Optical devices from author's collection. Clockwise from top left: Claude mirror, stereoscopic viewer, tinted Claude mirror, flat mirror, convex mirror, wide-angle convex mirror, colored camera filters. (Photo: Catherine Harris)*

A

FIGURE 8–17 *A. View of the panoramic landscape. B. Landscape miniaturized in Claude mirror. (Photo: Catherine Harris)*

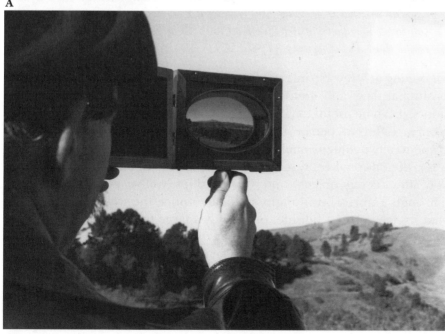

B

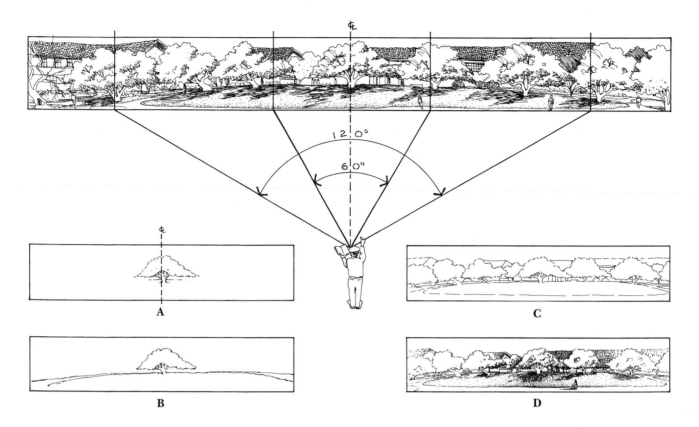

FIGURE 8–18 *Author. A. To draw the wide-angle view, take a sheet of 18-by-24-inch paper and draw a horizontal frame 4 inches high by 24 inches long in the center of the page, using any drawing media you are comfortable with. Find a center point and object directly in front of you. This will be your reference point. Draw the center line lightly, then draw the object in light construction lines. B. Determine the edge of your peripheral vision. Lightly draw in the edges of the landscape on your far right and far left. C. Draw in the ground plane line all the way across the picture plane. Now begin to draw in the landscape from left to right using your center point as a reference. As the landscape moves to the periphery it should grow a little out of focus. D. Finish by adding in the details and shadows.*

The mirror is the simplest and most familiar tool for obtaining an alternative impression of landscapes and of your drawings. Renaissance artists, in their search for the key to the mysteries of perspective, often used a mirror to help them evaluate their work. Leonardo DaVinci suggested that

> *when you paint you should have a flat mirror and often look at your work as reflected in it, when you will see it reversed, and it appears to you like some other painter's work so you will be better able to judge of its faults than any other way. (1980, 221)*

Looking at a reverse image of your drawing will help you to spot compositional flaws and areas that need refinement. When painting outdoors, it can be useful to take along a small mirror to view the landscape from a different perspective. Reducing the three-dimensional landscape to a two-dimensional reflection makes it much easier to produce a two-dimensional representation. The reversed image often helps jar you into seeing objects and relationships you've ceased to notice. Through a mirror, you might suddenly notice the web of power lines that stretch across a hillside, or the way a large tree forms a focal point in the distance. Leonardo wrote that the mind of the artist should be like a mirror, reflecting observed images.

A variation of the flat mirror, called the *Claude mirror,* was developed in the eighteenth century as a method of capturing panoramic landscapes. These mirrors were quite popular for the landscape painters of the eighteenth century and also with those who wished to contemplate

the landscape. The Claude mirror gave the landscape the varnished tones and exaggerated perspective of a Claude Lorrain painting. Lorrain revolutionized landscape painting, and his atmospheric paintings were extremely popular in eighteenth-century England. Claude was able to capture the golden sunlight of Italy, and developed a system to create illusion of depth in his landscapes. Weekend excursions by ladies and gentlemen were taken into the country to observe and paint picturesque scenes in the style of Lorrain. Ironically, Claude Lorrain never used a Claude mirror; it was developed long after his death.

The Claude mirror was a small, hand-held plano-convex darkened glass. The mirrors were backed with silver (for cloudy days) or black (for sunny days). The darkness of the mirror reduced the color of the landscape to an even, monochromatic tone, allowing the viewer to focus the basic landscape forms and the relationship of foreground, middleground, and background without the distraction of color. The curve of the lens enhanced the human perspective and produced an exaggerated, visually dynamic image. In effect, it embraced a large, expansive landscape and miniaturized it into an image that could be held in the hand. Imagine being able to possess a landscape in your palm.

Although original Claude mirrors are now quite rare, you can easily make your own with a small, inexpensive 3-by-4-inch convex mirror from an auto-supply store. Construct a box slightly larger than your mirror. Place the mirror inside the box so that you can attach a sheet of gray Plexiglas on the top of the box and you will have a facsimile Claude mirror. To use your mirror in the field, simply turn your back on the landscape composition you wish to draw, hold the mirror at eye level and draw the reflection. Draw the reverse image exactly as you see it or even exaggerate it to accentuate the distortion of the mirror to capture the mood.

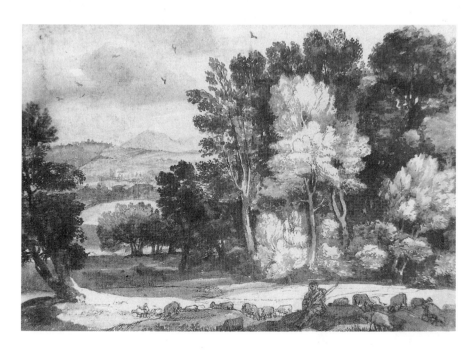

FIGURE 8–19 *Claude Lorrain. Pastoral Landscape. 1645. Chalk, pen, and brown wash on paper. 8½" × 13". (© Pierpont Morgan Library, N.Y.)*

A contraption called a *Claude lens,* another instrument never actually used by Lorrain, was also popular with the landscape painters in the nineteenth century. These lenses came in a variety of colored glasses, about an inch in diameter, attached on a frame so that they could be used singularly or in combination to view the landscape in a variety of hues. They reduced the intensity of the landscape's colors, but did not reverse the image or reduce it to two dimensions. Leonardo also suggested the use of colored lenses in the field as a way to isolate and accent the varieties of colors in the landscape. Observing the landscape through a color lens allows the viewer to study the effects different colors can have on a composition.

To create your own Claude lenses, purchase some used camera filters, hold them up to your eye, and observe the wide variety of moods produced by color. Is the landscape composition enhanced or weakened by colors of the lenses? The landscape can seem impossibly vast, and sometimes static, if you do not appreciate how your eye deals with space. Looking through colored lenses gives you the opportunity to capture drama and excitement.

The Wide-Angle View

In their quest to conquer the vastness of nature, eighteenth-century English landscape painters often depicted the landscape in a wide-angle view. They used this technique to capture broad landscape views to create the effect of a panorama. They would often paste as many as four sheets of paper horizontally to get a wide enough field to paint an inclusive vista.

The wide-angle view incorporated the painter's peripheral vision and can be used today as a method for breaking out of the limitations of linear perspective. It can emphasize the natural perspective we perceive and are surrounded by. The average human's central ray of vision extends to about 60 degrees, radiating from the pupil in a conical form; peripheral vision extends out to about 120 degrees. The cone of vision is the area that the viewer can easily see without perceived distortion. You can check the range of your own peripheral vision by extending your arms eye level out in front of you and slowly moving them to your sides until they go out of focus. This is the visual cone you should try to include in your wide-angle drawing; it will help you become aware of everything in your total cone of vision. The photograph and the computer have robbed us of our peripheral visual environment, because their imagery is in perfect focus and it does not fade out around the edges the way human vision does. In drawing and design its important to include the feeling of the total visual cone. Peripheral vision is important because it helps locate us in space and gives us a sense of place. Imagine yourself on a train, next to the window. The landscape you see out of the single window can be considered to be the standard 60-degree cone of vision. Now imaging standing back so that you can look out of all of the windows in the coach; this gives you the effect of the peripheral vision of the wide-angle view.

Optical devices can limit variables, such as color and dimensionality, to let an artist concentrate on the structure and composition of an image. They jar us into seeing aspects of the landscape we may have ignored by upending the perspective we expect. They can provide us with a new way of looking at the landscape.

EXERCISE 8–8: *Visualizing the Landscape Composition*

Spend some time looking at books of landscape paintings and studying their compositions. Notice how your eye moves through the picture. To reinforce this experiment, lay a sheet of tracing paper over the reproduction of Claude Lorrain's Pastoral Landscape 1645. Use a decreasing line weight as your lines retreat into the background. Locate and trace the following compositional elements:

1. Picture plane
2. Foreground gauge
3. Lower foreground ledge or stage
4. Frame brackets
5. Stage wings (coulisse), or outlines of tree masses
6. The diagonal lead (use a dotted line with an arrow)
7. Outlines of the retreating planes of the foreground, middle-ground, background, and distant atmosphere
8. Vertical right angles

Diagonal Composition

Most artists favor one type of compositional style. However, it is important to gain an understanding of the basic types so that you can select or combine them as needed. The diagonal is one of the most basic compositional devices used in ordering landscape space; used

FIGURE 8–20 *Author. Diagonal composition. Pen and ink.*

FIGURE 8–21 *Author. Pen and ink. Axial composition dividing the landscape into equal parts.*

properly, it can be a powerful design element. The diagonal catches the eye and directs it through the painting in either an ascending or descending motion. Depending on its emphasis, it can lead the eye directly through the landscape or let it wander slowly. It can be implied with imaginary lines and reinforced by masses of vegetation or architecture, and combined and interwoven with other compositional systems.

Axial Composition

In contrast to the horizontality of classic landscape composition is the axial composition. Near the center of the picture is the main vertical axis. Parallel to this main axis is a series of verticals. The strong repetition of these verticals creates a sense of rhythm and order, pushing the eye up toward the sky. The vertical axis can also be used to create balance and symmetry by dividing the landscape into two equal parts.

FIGURE 8–22 *Author. Pen and ink. Triangular composition leading the eye upward.*

Triangular Composition

Triangular composition is based on a strong central axis and a pyramid. It is strongly directional, since it combines two upward diagonal movements. Depending on how it is accented, it will lead the eye either

FIGURE 8–23 *Author. Pen and ink. Square composition producing a feeling of stability.*

up or down. It symbolizes stability and grandeur. Sometimes the triangle is combined into a repeating series or used as the central device in a large composition to move the eye upward.

The Square Composition

Like the triangle, a square composition will transmit a feeling of stability, and is one of the more easily recognized compositional forms. It is not usually incorporated into landscape composition, but can be used as a module within a larger composition. The major square can be divided into smaller squares or bisected by a diagonal.

Empty Space

When drawing the landscape, you needn't fill every square inch of picture space. There can be more power in empty spaces than in rendered ones. This is evident in the relative emptiness of the landscape paintings of the Sung Dynasty (A.D. 959–1279). The unpainted areas are an integral part of the whole picture; the negative spaces of the compositions are charged with meaning and energy, and contribute to the atmosphere of the painting. This emptiness provides a certain restfulness, and through emptiness, forms are born. (Calhill 1977, 66)

...

EXERCISE 8–10: *The Final Drawing*

Now you are ready to start drawing a final composition. Take all your landscape blot field drawings and all-day sketches, and begin to work out compositional studies. When you develop your compositional framework, lay it out with construction lines on a sheet of two-ply Bristol board. Follow all of the previous

FIGURE 8–24 *Author. Using negative space to create atmosphere.*

steps to build up your landscape drawing. While you are working on it, rotate the page, viewing it from all angles. It should hold together as a composition from every angle, even upside-down. Move back and observe it from a distance—sitting too close may be deceiving and can throw off your composition and proportion. Set your drawing aside and come back later to look at it with a fresh perspective. A good technique for judging your work is to look at it in a mirror; recall Da Vinci's suggestion that the reverse image will appear fresh to you so that you may judge the drawing's faults.

FIGURE 8–25 *Author. Examples of a variety of sky techniques to create depth. Pen and ink on vellum. Sky and clouds should be an integral part of all landscape drawings; they enhance the sense of mood and space.*

The composition of landscapes can open up whole new worlds of expression. Ideally, you want to internalize the systems presented in this chapter so that you can compose landscapes without thinking about the mechanics of the work. Your primary goal should be to create strong images with contents that express a sense of order and unity. All parts should relate to the whole.

Drawing is quick the line is semi-human.
Not all do I find but it's done. No
time do fingers grip. Seeing goes as
picture it does. I don't see the image
it comes. Where and I'm here.
The line from no time into time.
Not a picture but starts that come out.
To let the mind start before it.
Memories standing back. Room for nothing.
What's beyond the grip of the hand. Follow
the passage with just light enough.

(Clark Coolidge, Baffling Means)

Freehand Perspective Drawing

*Every point in space has an almost infinite capacity
to communicate information about the space around it. An
infinite number of paths move through every point.*

TOM BENDER
Environmental Design Primer

FIGURE 9–1 *Frank James, Sasaki Associates. Pen and ink. A quick free-hand perspective.*

In most fine pictures which have stood the test of time, one sees a keen appreciation of the possibilities of perspective. (Cole 1967, 9)

Prior to the Renaissance, perspective drawing was considered a feat of magic. Perspective techniques structure a drawing in response to observed spatial relationships. When combined with creativity and intuition, perspective helps evoke the emotional impact of a place. Unfortunately, today perspective is often taught as a mechanical technique with little room for creative expression. As a result, perspective drawings often look dead or analytical, as if generated by a computer. By contrast, this chapter describes how to develop a gestural approach to creating a sense of perspective in freehand. This approach emphasizes the need to explore the relationships *between* elements of the visual environment that give life to the landscape.

FIGURE 9–2 *Author. Pen and ink. Using freehand perspective to enhance the mysterious elements of the visual world.*

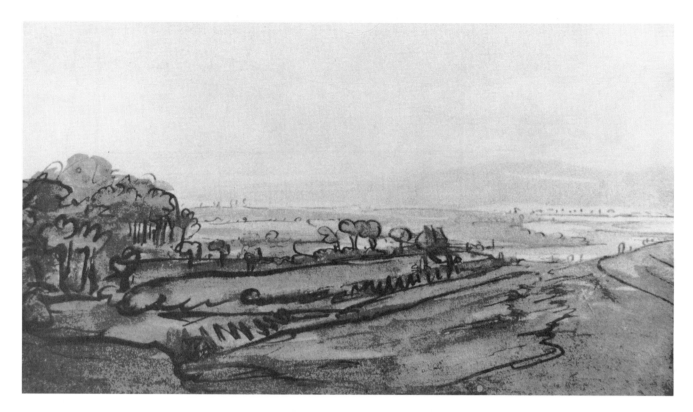

FIGURE 9–3 *Rembrandt van Rijn.* View in Gelderland. *c. 1648. Pen and brush in bister, 145 × 261 mm. A sweeping horizontal landscape. (Courtesy Dover Publications)*

Learning how to create the illusion of the third dimension in landscape drawing without mechanical means is a great challenge. In order to understand how perspective creates a perception of scale, distance, and depth, I have recommended as exercises the construction and application of perspective grids according to the old school of linear perspective. However, the goal of this chapter is to show you how to capture perspective in a gesture, as quickly and loosely as Rembrandt drew his sweeping views of Holland. If you learn to apply this intuitive approach over the long term, your landscape drawings will come alive.

Linear Perspective

Drawing freehand perspective entails borrowing ideas and vocabulary from the tradition of constructed linear perspective. This tradition was initiated during the Italian Renaissance by painters such as Masaccio (1401–1428) and architects such as Fillippo Brunelleschi (1377–1446). Their techniques reflected the values of a culture that placed humanity at the center of a world created by a divine geometrician. Linear perspective is a geometrical system designed to project the three-dimensional relationships between a pair of eyes and a landscape onto a two-dimensional page. In effect, the system mimics the way that a shadow projects an image of a three-dimensional object onto a two-dimensional wall or the way a slide projector conveys an image to a screen.

Linear perspective creates the illusion of a drawing being a window to a landscape. Thus, the term refers to a hypothetical viewer, located at a

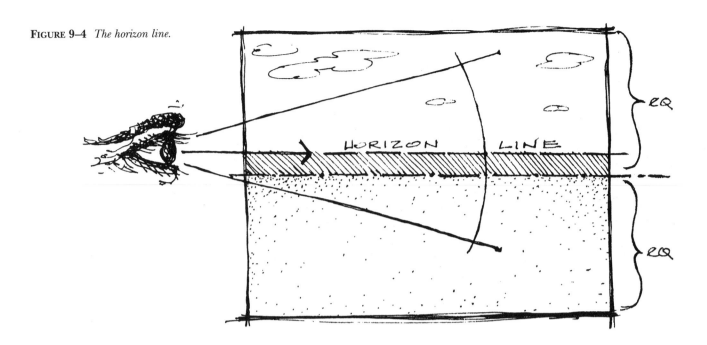

FIGURE 9-4 *The horizon line.*

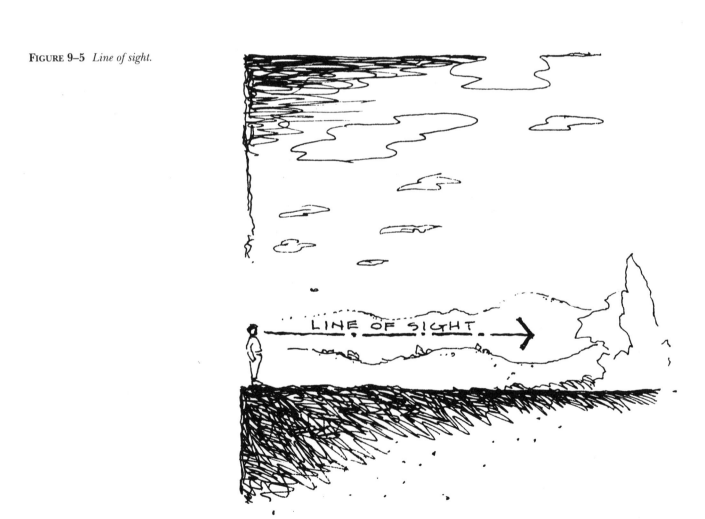

FIGURE 9-5 *Line of sight.*

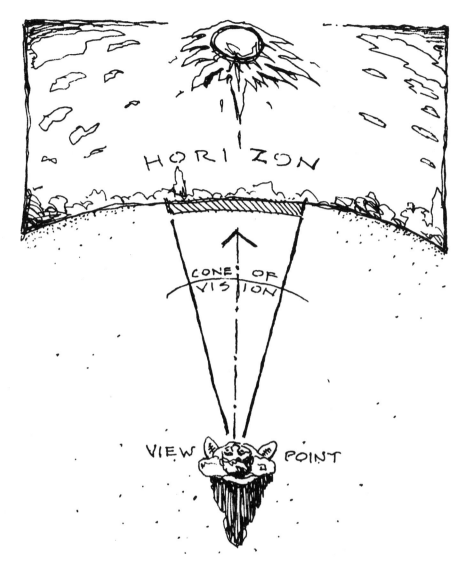

FIGURE 9–6 *Cone of vision.*

fixed spot, in relation to either the drawing or the landscape that the drawing represents. The following terms are used to describe how to draw in perspective.

Horizon line. A demarcation between earth and atmosphere that defines the upper boundary of the ground plane and the furthest extent of the viewer's terrestrial vision.

Line of sight. This is the line that a string would describe if it connected the viewer's eye to an object in the imaginary landscape.

Cone or ray of vision. The full range of the viewer's sightlines, which generally spreads over 45 to 60 degrees.

Picture plane. The surface of the drawing; it is approximately perpendicular to the viewer's cone of vision.

Ground plane. The portion of the drawing located between the horizon line and the bottom of the page that represents the ground surface. The foreground is located closer to the page edge, while the background is closer to the horizon line.

View point (or station point). This point represents the viewer's location. In the drawing, it is where the line of sight at the center of the cone of vision intersects the picture plane.

Vanishing point. A point on the horizon that represents the farthest extent of a viewer's sightlines.

Guide or construction lines. Lines used in a drawing to trace from the edge of an object to a vanishing point.

The Renaissance artist used a central viewpoint to orient the entire picture plane, and relied upon a human's height as a measure of scale. An illusion of depth is created by establishing links between the viewer's eye, objects in the composition, and a vanishing point on the horizon line. The key is to create parallel guide lines, such as the top and bottom edge of a wall, and force them to converge upon a vanishing point,

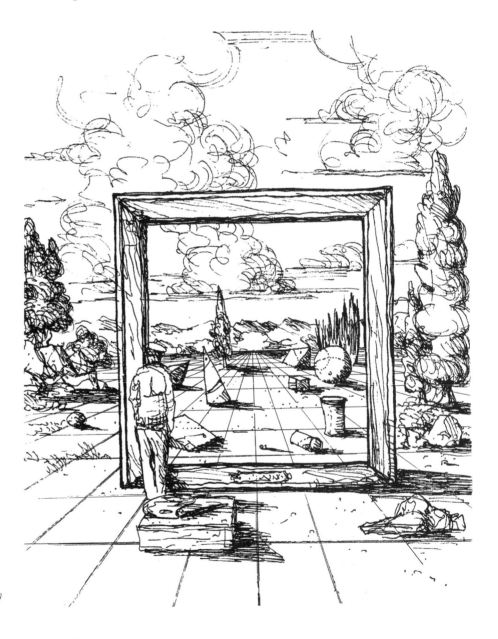

FIGURE 9–7 *The central view point with the picture plane as an imaginary window.*

the way train tracks appear to meet before they disappear out of sight. A *one-point perspective* relies on the use of one vanishing point, while a *two-point perspective* relies on the use of two.

Thus the use of perspective during the Renaissance served as a kind of radar to navigate the viewer through the space of the pictured plane. However, this type of perspective can be a very limiting format because of its constricting rules and the way it makes the world converge rather than expand.

By contrast, Chinese landscape painters during the Sung dynasty developed a much different approach to rendering perspective. Rather than using a central viewpoint, the artist relied on *parallel perspective* rather than linear. In this system, receding lines are drawn parallel to one another, without converging upon a vanishing point, to give the viewer the feeling of seeing a series of views almost simultaneously. As a result, great panoramas of time and space could be illustrated in a single drawing.

Freehand Landscape Perspective

Draw frequently, vigorously and freely, always looking at the subject of your drawing. After you have drawn an object, study the drawing and ask yourself whether it conveys properly your position in space and your relation to the object. (Mendelowitz 1976, 103)

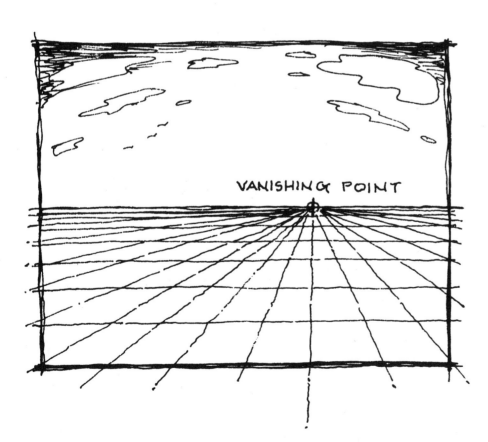

FIGURE 9–8 *Locating the vanishing point on the horizon line creates a one-point perspective.*

FIGURE 9–9 *Kuo His.* Early Spring. *c. 1072. Hanging scroll, ink and light colors on silk, 62¼" × 42½". Parallel perspective. (Treasures of Asia: Chinese Painting, James Cahill, Rizzoli)*

While the system of linear perspective generated amazing works of art, I advocate a less analytical approach to perspective. Although freehand perspective techniques borrow heavily from the tradition of linear perspective, there is less of an emphasis on strict grid constructions. Application of freehand perspective relies more on feel than rules; a certain degree of precision is sacrificed to allow for personal expression. Below are the steps generally followed to depict a sense of perspective; interspersed with these steps are exercises designed to emphasize key concepts. Once you have learned the basics of constructed linear perspective, I encourage you to proceed to violate the

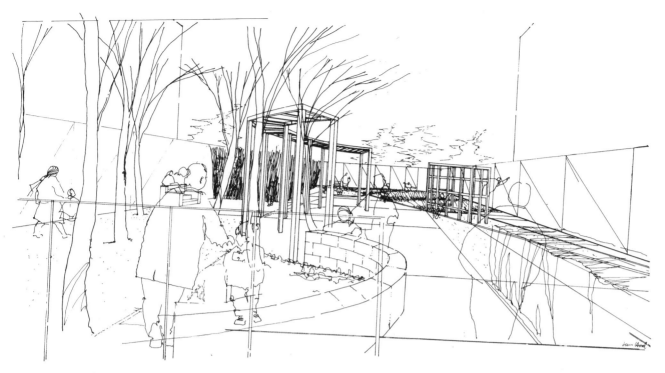

park entrance

FIGURE 9–10 *Walter Hood. Pen and ink on mylar.*

"rules" in your freehand improvisations. In freehand, your goal should be to produce a spatial order that reflects the emotional impact of the landscape on the viewer.

Heed Leonardo da Vinci's words:

The youth should first learn perspective, then the proportion of objects. Then he may copy from some good master to accustom himself to fine forms. Then from nature, to confirm by practice the rules he has learnt . . . then get the habit of putting his art into practice and work. (Richter 1970, 243)

Horizon Line

Step One—Establish a Horizon Line

The artist depicts the horizon as a straight line segment of the world's edge. The horizon is artifice; in nature a demarcation between earth and atmosphere cannot really be seen. In a drawing, the horizon directs the viewer's eyes to sweep across the composition.

The horizon line appears at the viewer's eye level and provides an upper boundary for the ground plane. In his landscape drawings of Holland, Rembrandt used a very strong sweeping horizontal to represent the ground plane. Salvador Dali's surrealistic landscapes exploit the vast horizon as settings for his strange juxtapositions. As will be discussed in later steps, objects located in the drawing close to the horizon

line appear to be farther away from you than objects located closer to the bottom of the page, to the fore of the ground plane.

It's often effective to locate your horizon line slightly above the mid-section of the page, at the horizontal midpoint of the viewer's cone of vision. Adjusting the location of the horizon line influences the viewer's sense of elevation. To give a sense of a bird's-eye view, place the horizon line toward the bottom of the page. To give a worm's-eye view, place the horizon above the center of the page.

EXERCISE 9–1: *The Quick Horizon Line*

Draw a series of 3-by-4-inch rectangles on a sheet of paper. Use your fountain pen to draw a horizon line just above the midpoint of the rectangle. Quickly draw a series of lines parallel to the horizon, spacing them farther apart as you move down the page. Repeat this exercise in the other rectangles: observe what happens to the space when you move the horizon line up or down.

FIGURE 9–12 *Adjusting the horizon line to create the desired view.*

FIGURE 9–13 *The quick horizon line.*

FIGURE 9–14 *Distant objects appear smaller.*

View Points and Vanishing Points

Step Two—Locate View Points and Vanishing Points

The view point or station point represents the location of the eyes; the effect of perspective will be achieved by drawing straight lines from the view point to a vanishing point on the horizon. Since it also occurs at eye level, the view point occupies the same elevation as the horizon line. The artist must be able to visualize the vanishing points to be used in each composition.

EXERCISE 9–2: *The One-Point Perspective Grid*

Use of the perspective grid is key to nailing down the concept of linear perspective. Draw a 4-by-6-inch rectangle and with a 6B pencil place the horizon line just above the center of the drawing. Now rapidly draw a series of lines parallel to the horizon moving from background to foreground, gradually spacing them further apart as they come forward. Select a vanishing point slightly off center on the horizon line. At the bottom edge of the page, place evenly spaced straight lines that converge at the vanishing point. What you have produced is a one-point perspective grid. Continue to draw more perspective grids by moving the vanishing point to the right and left. Notice what effect this has on the perspective. Also move the horizon line up and down. Alternate between drawing these grids fast and slow. When looking at landscapes, visualize perspective grids covering a ground plane.

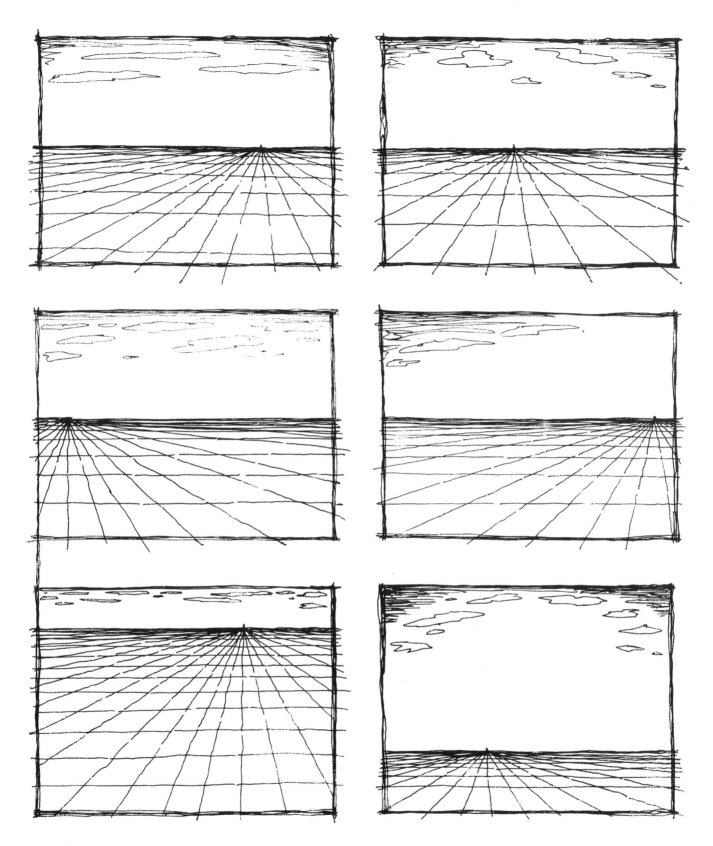

FIGURE 9–15 *Freehand perspective grid.*

FIGURE 9–16 *The many number of vanishing points in a landscape perspective.*

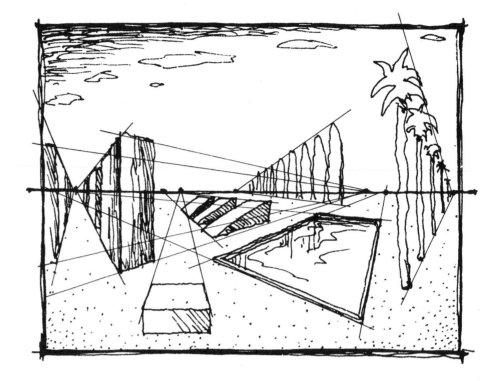

FIGURE 9–17 *Author. Proportionally diminishing size creates depth.*

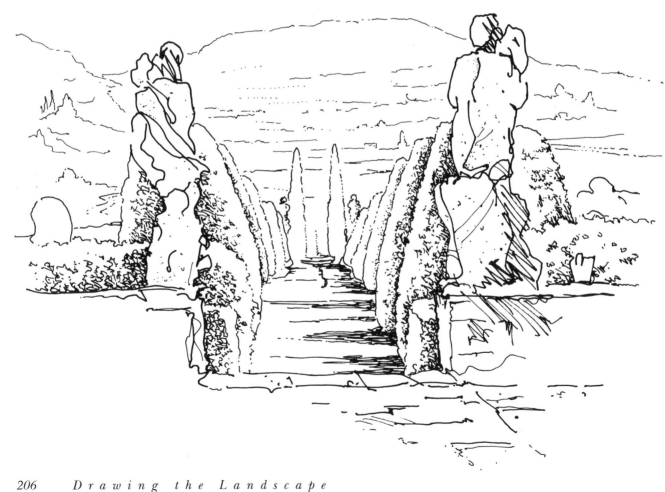

Proportional Relationships

Step Three—Establish Proportional Relationships

The spatial clues used to create a sense of proportional relationships between objects are the vocabulary of familiar landscape forms. To achieve the proper relationships, it is important that all landscape elements be drawn to scale. (Practice with the perspective grid measuring lines, as described in Exercise 9–4; they can help you to judge whether

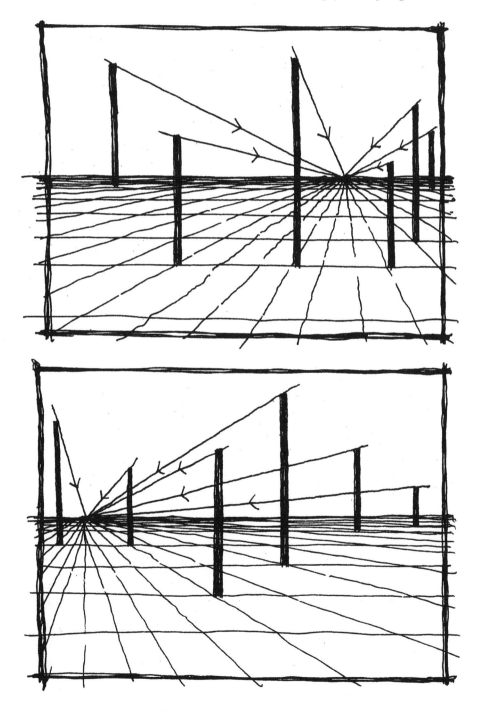

FIGURE 9–18 *Vertical receding lines.*

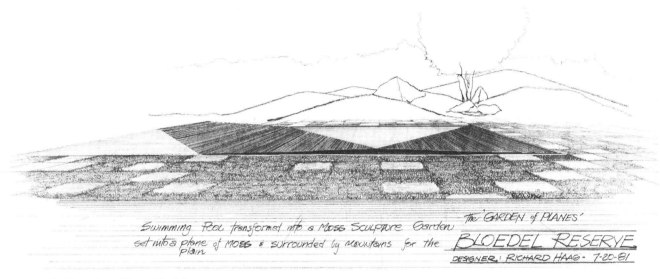

Swimming Pool transformed into a Moss Sculpture Garden The 'GARDEN of PLANES'
set into a plane of MOSS & surrounded by mountains for the BLOEDEL RESERVE
plain DESIGNER: RICHARD HAAG · 7-20-81

FIGURE 9–19 *Richard Haag. Bloedel Reserve, 1981. Pencil on paper. One-point perspective.*

or not you are drawing to scale.) Inclusion of a human figure in the foreground is a good example of a visual cue indicating scale. A series of identically sized objects, such as sheep, are drawn to progressively diminish in size as they retreat into the background. Besides using familiar objects as an indication of scale, the reduced resolution of images viewed at a distance also serves to convey depth. The farther an object is from your eye, the fewer details will be visible and the flatter it will look.

EXERCISE 9–3: *Vertical Receding Lines*

On the one-point perspective grid just completed, randomly place a series of heavy vertical lines at various heights in different locations throughout the ground plane. Use light construction lines from the tops of these verticals to project back to the vanishing point.

FIGURE 9–20 *Garrett Eckbo. Landscape forms help create relative size. Note smaller perspective, inset, lower left. (College of Environmental Design Documents Collection, University of California, Berkeley)*

EXERCISE 9–4: *Drawing to Scale with a Two-Point Perspective Grid*

A perspective grid can allow you to use grid lines like the contours of a topographic map to establish the relative dimensions of landscape features. In this exercise you will draw a ground plane perspective grid in one-foot intervals as a tool to establish proportional relationships.

Figure 9–21A shows how to create a grid on a picture plane that recedes off the page to the left. On an 18-by-24-inch sheet, draw a right-hand vertical measure 10 inches high. In this exercise, we will use a 1:1 scale; that is, one inch equals one foot. Then pull a horizontal line 20 inches to the left at 90 degrees from which we will pull all of our other 1 foot increments from. They are the only ones that do not recede. Draw in your horizon line (also called line of sight) at 5 ½ inches. This is considered typical eye level. This line should extend 20 inches to the left at 90 degrees to the right vertical measure line. At the left side of the horizon line, place your ³⁄₄-inch scale at 90 degrees with the horizon line at the 5 ½-inch mark, and draw a line down to the zero mark on your scale. This is your left vertical measure line. It is shorter than the right vertical measure line because the lines are diminishing to the left toward a vanishing point off your paper. To get your 1-inch receding intervals, simply connect the lines from the numbers on the left to the same numbers on the right. Your drawing should now look like Figure 9–21A.

Figure 9–21A *Tony Whall. Ink on vellum.*

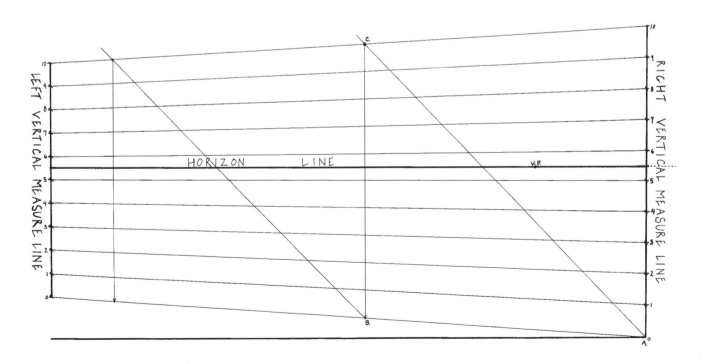

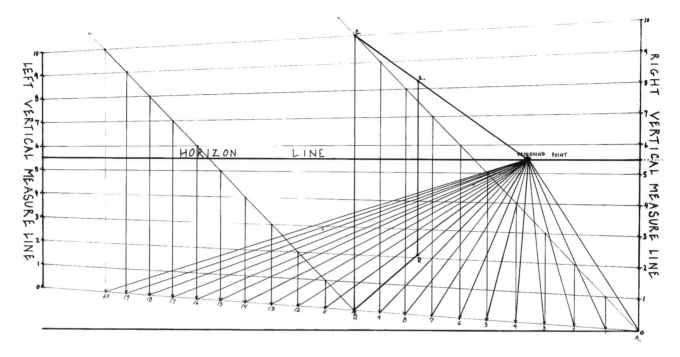

Figure 9–21B *Tony Whall. Ink on vellum.*

Figure 9–21B creates a grid that recedes to the second vanishing point. This vanishing point is seen within the picture plane, unlike the left-hand vanishing point discussed above. To draw this grid, start by pulling a line from point A at a 45 degree angle from the true *horizontal line at the bottom of the grid; continue it until it hits the 10-inch line (point C). Where the two lines meet, drop a line down to the zero line parallel to the left- and right-hand measure lines (point B). This point is exactly 10 feet from from point A. Repeat this process to obtain the second, 20-feet increment. Then, where line AC crosses your horizontal lines, drop lines down to the zero line, parallel to the left- and right-hand measure lines and make a tick mark on the zero line. These marks represent 1-foot increments receding to the left. Repeat again with line BK to get your second set of points. Now that you have a set of points receding toward the left-hand vanishing point, establish your right-hand vanishing point on the horizon line. Typically this vanishing point is placed about 2 inches from the right side of the page. Draw lines from your zero-line increments, just as you did to the right-hand vanishing point. Your drawing should now look like Figure 9–21B.*

Figure 9–21C describes how to navigate back toward the right-hand vanishing point in 10-foot increments. Line CB defines the left-front edge of a 10-foot cube that will recede toward the vanishing point. You already have a line from point B to the vanishing point, so draw a line from point C to the vanishing point. Now take half of the vertical distance from the zero line to point A to the horizon line and measure that distance back along the line from point B to the vanishing point and make a mark (point D). This is exactly 10 feet back toward the vanishing point, and this is how you will establish your receding grid. Draw a heavier line between point C and the vanishing point (point E). This line is the back-left side of your 10-foot cube. You cannot use the method

in this first step to go back 10 feet further because it will not produce an accurate measurement. You need to draw a line approximately 20 inches high perpendicular to the horizon line from the vanishing point. Next, draw a line from point B to point E and extend it until it meets the perpendicular line from the vanishing point. Mark the point where these two lines intersect with an X. This point will be used to determine all of your recessional points in reference to the right-hand vanishing point. Draw a line from point D to point X. Where that line intersects the line between point C and the vanishing point, pull another line down to the line between point B and the vanishing point. This is another 10 feet back toward the vanishing point. You can continue this process for at least one more recession of 10 feet toward the vanishing point and should repeat it in the 10 feet section to the left. You no longer need to establish point X. You can use this point to move back in space in your left-hand cube. Draw lines from the zero and 10-foot marks on the vertical line CB to the vanishing point. Extend a line from the 20-foot mark on the zero line to point X. Where that intersects the line between point K and the vanishing point, drop a line down to the line receding toward the vanishing point. That is 10 feet back in space.

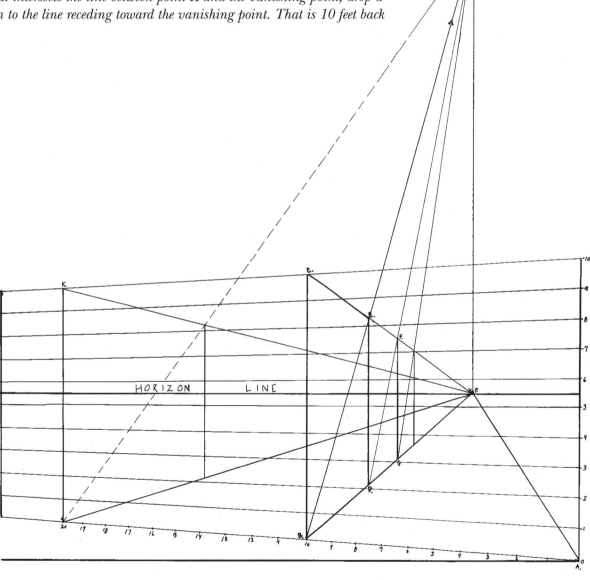

Figure 9–21C *Tony Whall. Ink on vellum.*

Figure 9-21D. *The only thing left to do is create receding lines on the horizontal plane, as shown in Figure 9–21D. First, draw lines from your 10-foot vertical line (line CB) to the vanishing point. You have the 10-foot and zero lines already. The rest of the points on line CB are available in Figure 9–21A where you extended the lines from the left side of the grid to the right. Make tick marks every time the bisecting line BE crosses the lines that recede to the vanishing point; then drop lines down to BE and mark where they intersect. These points indicate the 1-inch recessional points along the ground plane line between point B and vanishing point. Use this same process to establish the recessional increments farther back on this line and the recessional ground plane points along the line from the 20-inch mark on the zero line to the vanishing point. You now have two lines that extend from the zero line across the ground plane and to the vanishing point. Each has 1-foot recessional increments marked. Simply draw lines connecting the same points horizontally (1 foot back on the left connected to 1 foot back on the right, and so on) as far back as you need to go. You should have a drawing similar to Figure 9–21D.*

Figure 9–21D *Tony Whall. Ink on vellum.*

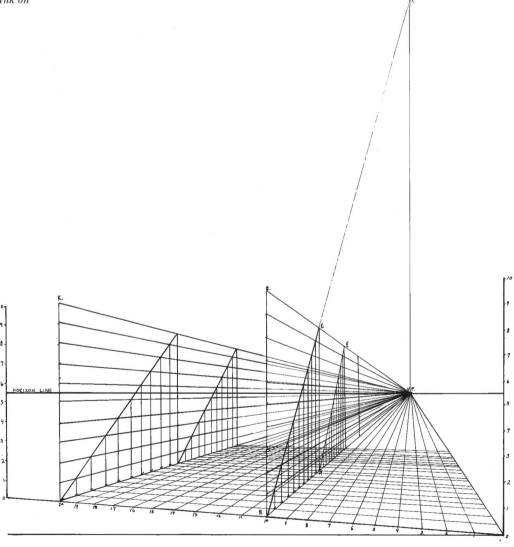

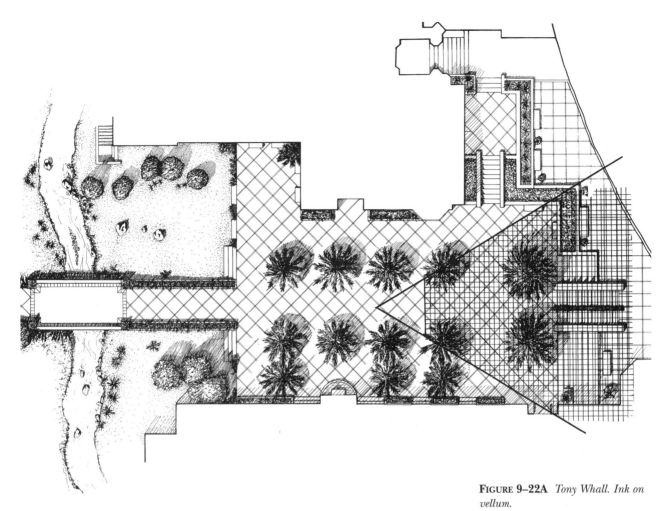

FIGURE 9–22A *Tony Whall. Ink on vellum.*

Now that you have created a two-point perspective grid, you can use it to practice drawing in perspective and to scale. You can use tracing paper to copy and reuse the grid. When locating objects in the ground plane, practice using the measuring lines for horizontal and vertical distances. For example, a tree 20 feet high should span two contour lines regardless of its location in the ground plane.

You can adapt perspective grids to fit your subject or compositional choices. For example, your grid should be relabeled to measure ten-foot intervals rather than one-foot intervals in order to reduce the scale to fit more of the landscape into your drawing.

EXERCISE 9–5: *Practicing the Two-Point Perspective Grid*

Use a system of grid overlays with tracing paper and colored pencils. Practice drawing two-point perspective grids until you can draw them without referring to the preceding directions. Vary the location of grid elements, such as the forward vertical measuring plane or the right-hand vanishing point, to see what kind of an impact it has on your drawing.

Figure 9–22A will be used as a demonstration on how to transfer a plan drawing onto your perspective grid. Place a one foot grid over the area of your plan that you intend to draw. The grid should be at the same scale as the

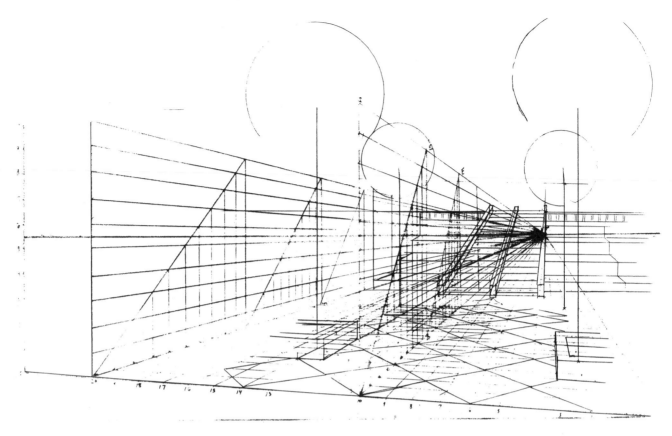

FIGURE 9–22B *Tony Whall. Ink on vellum.*

plane. If the grid is too small and obscures details, you can use larger increments as long as the grid is still the same (for example, $^1/_8$ inches = 1 foot, with the grid at 2 foot intervals). Just double the size of the grid you overlay on your plan. Each square on the plan should correspond to the squares on your perspective grid. To establish your cone of vision, place a 60-degree triangle on the plan. The corner of this angle is the location of the viewer. Where the two rays of the angle meet, the grid becomes the picture plane. Place the viewer in such a location that the angle encompasses the items you would like to include in your perspective. The viewer should be at least 5 feet in front of the picture plane to avoid distortion. Hint: Orient the grid so that the viewer is facing the picture plane directly. This makes navigating the two grids much easier.

Figure 9-22B. Once you have located the viewer and grid, you can begin to construct your perspective. Figure 9–22B shows the image in progress. Using the grid on the plan, locate an object—a tree, for example. This data point can be translated to the perspective grid, giving you a ground plane location for the object. For example, one of the trees is 6 feet from the picture plane and 14 feet to the left of the viewer. Go to the perspective grid and find this point. This is the base of the tree. Establish the height of objects by navigating along the ground-plane line to the closest vertical measure line and move up that line. Once you find the correct height, extend a line from that point through the same vertical measure point on the vertical line to the right or left. After you have done this you can return to the base of your object and pull up a line vertically until it intersects with the horizontal line you just drew. As you move over in one direction or another you are changing your relationship to the two vanishing points.

FIGURE 9–22C. *Tony Whall. This figure depicts the completed perspective. A 60-degree cone of vision is the maximum used in order to avoid distortion, but you can always decrease the size of the cone. Ink on vellum.*

Exercise 9–6: Gauging Proportional Relationships

Da Vinci suggested "giving your eye good practice in judging accurately the breadth and length of objects." (Richter, 1970, 253) In other words, in observing the landscape, always study the proportional relationships of objects and plant forms and their distance from your eye. It can be helpful to carry your viewfinder (described in Chapter 7) as an aid in visualizing a perspective grid.

Exercise 9–7: Relative Size

Draw a few freehand one-point perspective grids. Draw a large sphere in the foreground and a small one in the background; add shade and shadow. On another grid, place the small sphere in the foreground and the large one in the background. What is the spatial difference between the two? Does the smaller object automatically recede into the distance? On other grids, play with the location of these spheres.

Step Four—Overlap Objects to Show Spatial Relationships

Landscape elements appear to overlap based on their location in the ground plane relative to one another. Care must be taken in using overlap as a compositional device to ensure that a sense of scale is maintained.

FIGURE 9–23 *Relative sizes of objects in the landscape.*

EXERCISE 9–8: OVERLAPPING TO CREATE DEPTH

Draw a series of abstract shapes of different sizes and textures on one of your perspective grids. Overlap different shapes on top of each other. By varying the degree of overlap, can you make the shapes appear closer or further apart on the ground plane?

Step Five—Adding Shadow and Details

After establishing a perspective framework in freehand, elaborate on the composition using tools such as shade, shadow, and texture discussed in Chapters 6, 7, and 8. Here is your opportunity to really show your creativity in the context of a perspective drawing, now that you have the fundamentals in place.

Developing the Gestural Quality of Freehand Perspective

The aim of this step-by-step outline and included exercises is to give you enough confidence in applying the basics of perspective that you will be inspired to improvise with your landscape compositions. Refer to earlier sections on how to establish a gestural quality of line and form and apply it freely to the landscape as a whole. Allowing yourself to experiment will equip you with a breadth of ways to capture the impact of a huge variety of places.

EXERCISE 9–9: *Contours of Gesture*

Find a hilly, sparsely vegetated site. Lay out a perspective grid and use vertical measure planes. Lightly draw in the outlines of the contours of the hills; visualize the lay of the land. Make the contour lines express the bulk of the earth; draw them loosely with expressive gesture. Build up the mass of the earth the same way you draw a warm-up sphere. Draw a series of landscapes for about an hour a day, until you can use gesture to build landforms quickly.

Architectural Perspective

Drawing the landscape also includes drawing architecture. Begin with a couple of thumbnail sketches of the site; use your viewfinder. Locate the horizon line, sketch in a scale figure, and rough out a perspective grid. Visualize the basic geometry of the structures. What are their architectural shapes? Are the buildings square, rectangular, or round? Systematically analyze their order and the proportion of the façades. Sketch in the building forms with light guidelines, and construct the vanishing lines of the major masses. Find the modules: most buildings are composed with some type of proportional module. Search for the

FIGURE 9–24 *Author. The overlapping of landscape elements can create depth through spacial sequence.*

FIGURE 9–25 *Author. Landscape contours in gesture.*

Freehand Perspective Drawing 219

anatomy of the building; is the ordering system a grid of column lines? Often there is a central vertical axis that is subdivided. Usually there is also a major horizontal axis, evident from sills, windows, or doors. Smaller building parts will be increments of the whole. Determine what areas to emphasize and what areas to imply. Remember, what is left out is often more important than what is put in. Use successive overlays of lines, building up the overall masses and details. Add the details and highlights. Finally, work on areas of emphasis and use shadows for drama and depth.

EXERCISE 9–10: *Drawing Architecture*

With your daybook, go into an urban environment and select groups of buildings to draw. Select some dramatic compositions and lightly draw in the horizon line. Locate a few critical vertical and horizontal dimensions and lightly sketch a simple perspective grid. Always work from light to dark. Draw in the geometrical masses, adding details last. Use gesture to draw the buildings, and imply the details with shadow. Do a series of five- to ten-minute sketches, always working to capture the essence of the spaces. Try sketching buildings for an hour a day until you can rapidly capture the feeling of your subject.

Figure 9–26 *Author. To draw architectural details, start with a center line and then use construction lines to block in the forms. After the portions have been defined, add the details.*

You must continually practice your freehand perspective to draw it with ease and sensitize your eyes so that you can depict the world as you see it. Only after you have mastered the basic rules of freehand perspective will you be able to violate them.

No work of art is really ever finished. They only stop at good places. (Henri 1923, 179)

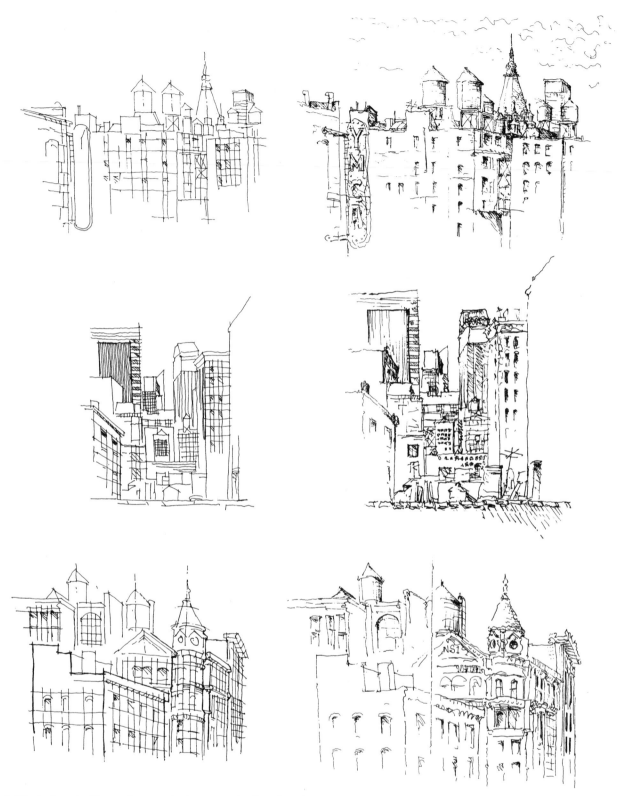

FIGURE 9–27 *Author. Architectural perspective in gesture. Analyze the order and proportion of the façades. Sketch the ordering modules of the buildings in light construction lines. Add areas of emphasis and use shadows to produce drama and depth.*

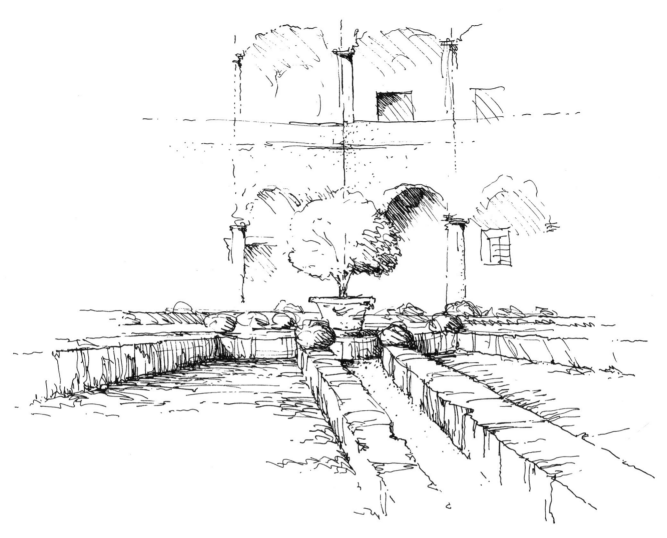

FIGURE 9–28 *Author. The rapid free-hand perspective gesture.*

Drawing the Landscape in Plan, Elevation, and Section

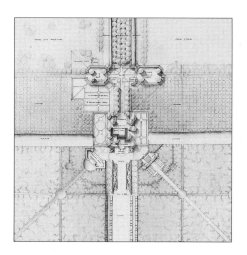

The act of creation agitates the picture plane,
but if the two-dimensionality is lost, the picture reveals holes
and the result is not pictorial, but naturalistic imitation
of nature.

HANS HOFMANN
The Search for the Real

FIGURE 10–1 *Garrett Eckbo. Estate in the Manner of Louis XIV. Pencil with graded wash. 1934. (Courtesy of the collection of the Department of Landscape Architecture, University of California, Berkeley)*

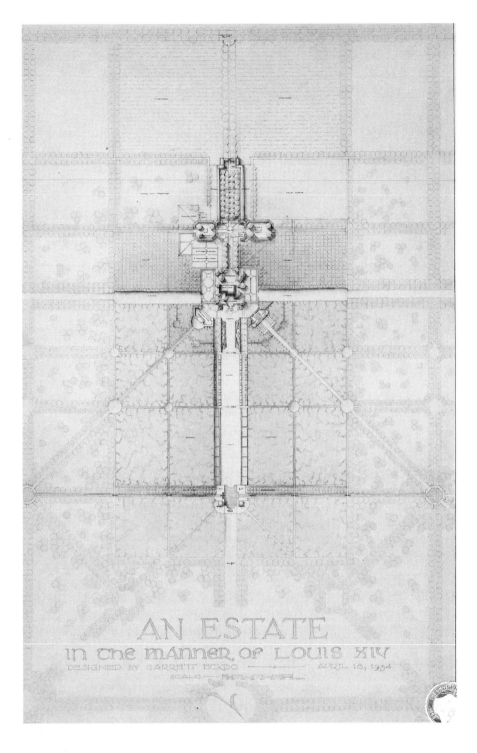

For the child, with few exceptions, magic and art are fun. Art translates curiosity and wonder into mastery over the environment. (Shlain 1991, 141)

Apart from the freehand sketch and the measured perspective, the primary methods for representing landscape concepts and designs are with plans, elevations, and sections. These are the fundamental tools

FIGURE 10–2 *Author. Working through the design process with plan, section, and elevation to refine the concept.*

used to illustrate ideas about the environment. The plan, elevation, and section are extremely useful for analyzing the natural features of the ground plane. They allow you to conceptually study the solid-void relationships between vegetation and architecture throughout the design process and as you refine your ideas. They are correlated to your knowledge about the landscape forms you create. These tools are also diagrams of information through which we explore the creative process and bring it to closure. Along with your freehand sketches, they are the main tools used for presenting your final design.

The Landscape Plan

A *plan* represents the landscape from a single, aerial viewpoint. The landscape plan is a way to view the site from a measured distance, as if you were floating above it. Being able to see the landscape in this manner requires you to "get small" and visualize yourself flying above your design. It is magic and fun.

FIGURE 10–3 *Imagine yourself very small, flying above the landscape and walking through it as you design it.*

The plan is not just a drawing but a miniature landscape. When you draw a plan you are in effect making a miniature map. Plans are topographic reports from the air, in which you produce memories. In producing a plan you are creating an experience; a miniature world where objects and locations are tabled and measured. No matter how accurate you are, you will exaggerate. You are free to create unique and special places. The plan view is an illusion; a magical world you enter through the scale in which you are working. Imagine yourself being very small and walking through it.

There are limitless methods to depict the landscape from this point of view. You must first determine the type of information that you want to illustrate, and its level of detail. In the landscape plan we move from idea to image. Studying your design in plan is a way to eliminate the distortion inherent in perspective; with a plan you can create a realistic, measured interpretation of your idea. For a plan to hold the viewer's attention it must contain many elements not known. We use the site plan to gauge our knowledge of the places we are designing. Plans are metaphors that record our process of learning through the design stage. As Robert Harbison writes, "All maps are abbreviated places expressing the strong impatience of the mind." (1977, 133)

EXERCISE 10–1: *Creating a Resource File*

Keep a file of landscape illustration techniques that you like. When you see something interesting, either draw it in your daybook or make a photocopy of it and file it in a special place or book. Keep a record of any new drawing techniques you develop yourself. Don't limit yourself to present-day landscape drawing techniques; look at Renaissance, arts and crafts, and cubist movements, too.

Frame of Reference

Indicate your frame of reference. In other words, what is the location of your site? This will give the viewer a relationship to the plan's sur-

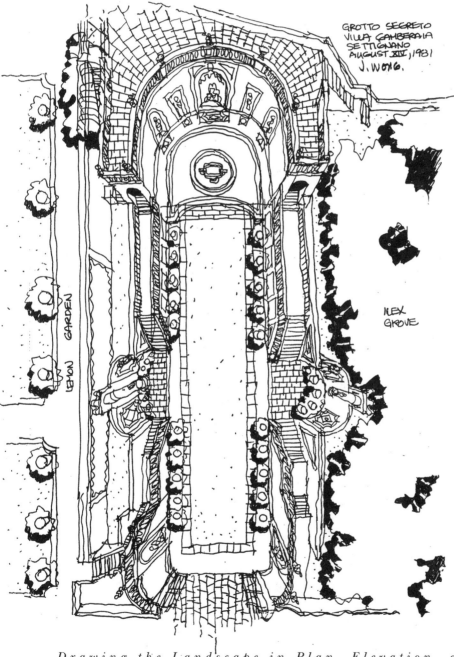

FIGURE 10–4 *John Wong. View point above the grotto segreto, Villa Gamberaia, Italy, 1981. Pen and ink in sketchbook.*

FIGURE 10–5 *Annie Amundsen.*
Fragmented Muir Beach Lagoon.
Collage, maps, watercolor, and pastel.
Illustrates mapping a site at different
scales to show telescoping levels of con-
text information.

roundings. Always illustrate the context and the location. When draw-
ing the site plan, first determine the boundaries. Every site will have
some type of boundary; the site boundary is the space that will be trans-
formed. Consider this the way a painter considers a picture plane. Hans
Hofmann said the picture plane is "the creative element of all the plas-
tic arts, painting, sculpture, architecture and all related arts." (1967, 65)
The essence of the picture is the picture plane.

Scale

There are scales which seem proper to different kinds of motion . . . Like
maps, metaphors often seem propelled by a change of scale, and change of
scale seems to qualify as a kind of thought by performing a transformation
in which everything is altered but remains the same. (Harbison 1977, 133)

A

FIGURE 10–6 A AND B. *Garrett Eckbo. Garden for Wm. A. M. Burden. Ink on paper. Scale will determine the amount of information to be read in the plan view. (College of Environmental Design Documents Collection, University of California, Berkeley)*

B

Drawing the Landscape in Plan, Elevation, and Section 231

Drawing in scale means depicting in a given ratio the true size of the landscape. Scale is simply a measurable way to study space. Before beginning a landscape plan, determine what scale to use. The determination of scale indicates the amount of detail and information that is visible. Figure 10-6A illustrates the complete site and provides the context for Figure 10-6B, which is a detailed plan at a larger scale. The scaled landscape, accurately measured, gives the precise notation necessary for carrying out a design. It is a way to accurately test your thoughts and spatial references. We usually relate everything we see to our own size, so in design our body is used as a reference point. This is done not only consciously but also subconsciously. When working on your landscape drawings always indicate their scale and always include scale human figures.

EXERCISE 10–2: *Understanding Your Proportions*

It is important that you understand your own proportions. Measure your pace, arm span, and finger spread, and write them down in your daybook. When you move through spaces that feel good, use your own measurements to gauge the proportions of the space.

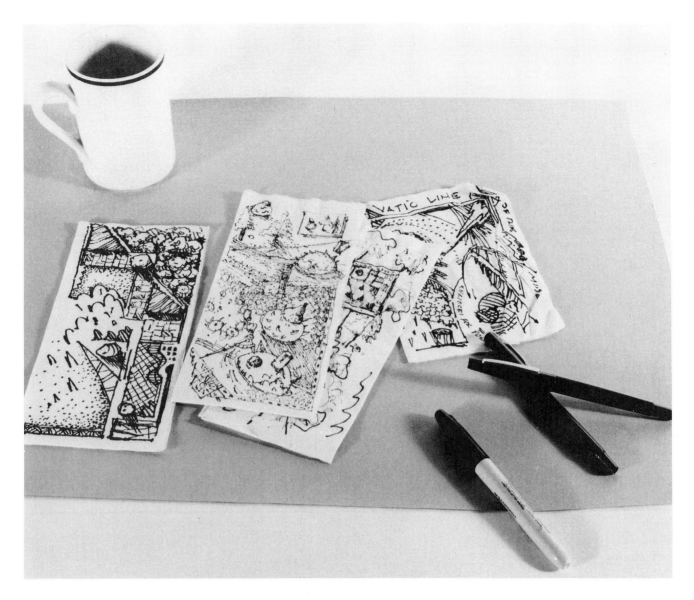

EXERCISE 10–3: *The Paper-Napkin Sketch*

As you work out your thoughts in plan, try sketching out your first impressions and ideas on a paper napkin. This can be fun and relaxing. Select a comfortable cafe and get a variety of paper napkins along with a good cup of coffee. Use felt-tip pens with different point sizes such as a Pilot Razor Point, Flair, and Pentel Sign Pen. Sketch, letting your mind flow; wander and wonder with your pen. Combine different pens on each drawing to produce different effects. The benefit of working in this manner is that you cannot be too precise because the felt-tip points will bleed and your lines will take on a very abstract feeling. This allows you some freedom. Some designers can design only on paper napkins. They go to a cafe to work out their designs, then go back to the office and tape all the napkins together. They then lay a sheet of tracing paper over this mock-up to create the final design.

The Freehand Conceptual Plan

The conceptual plan initiates the design process by capturing your first thoughts. The conceptual plan done as a gestural study is central to the design process. It is a quick analytical tool used to produce a measured plan. It also helps you find your way to a design solution that arouses your emotions, and gives your drawings a spontaneous quality. It allows you to interpret space and respond to a variety of design options. When working in this method, first determine the plan scale with which you wish to work. It should not be so large that you lose your ability to draw quickly in gesture. Smaller is better.

Work through conceptual-plan stages in a series of tracing-paper overlays. Start with a site-plan sketch of the existing conditions, then overlay a sheet of tracing paper to work through your first thoughts. When you have completed the first concept or idea as a quick gesture, tape down another sheet of tracing paper and develop the next idea. Keep repeat-

FIGURE 10–10 *Author. Use a series of overlays to work out quick plan concepts in gesture. (Photo: Steven Brooks)*

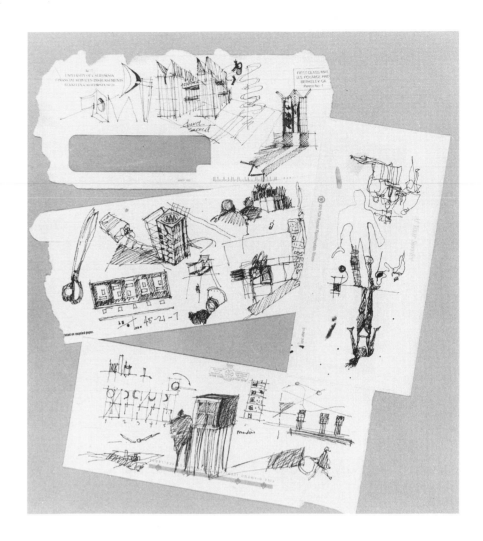

FIGURE 10–11 *Walter Hood. Use envelopes to jot down quick design ideas. (Photo: Steven Brooks)*

ing this process until you have exhausted every idea you have. Use the edges of the page for quick sketches of new thoughts, fast miniature perspectives, and so on. When you reach a solution that you are satisfied with, move on to the measured plan.

EXERCISE 10–4: *Envelope Plan Sketching*

Carry various sizes of envelopes with you. When you have an idea for a plan, jot it down on an envelope. Later, when you have time, pull out the envelope and immediately write or draw. There is something very pleasant and unintimidating about working on an envelope, especially those that have been addressed to you and received in the mail. Try sketching on a variety of envelope sizes.

The Measured Plan

The measured plan can be done freehand as opposed to drafting it. When designing in the measured-plan view, you study your concept with accurate placement of the landscape elements in true dimensions.

You record the design process with dimensions. Thus you can examine the data of your design.

As in sketching, the hierarchy of line weights is extremely important to make the plan composition read clearly. Begin by drawing your site plan with correct measurements and dimensions. Always work from light to dark; work out your general layout and landscape elements with light construction lines. Draw from the ground plane up, delineating the various surfaces. Next, add detailing. Only as a last step do you draw the shadowed edges and cast shadows.

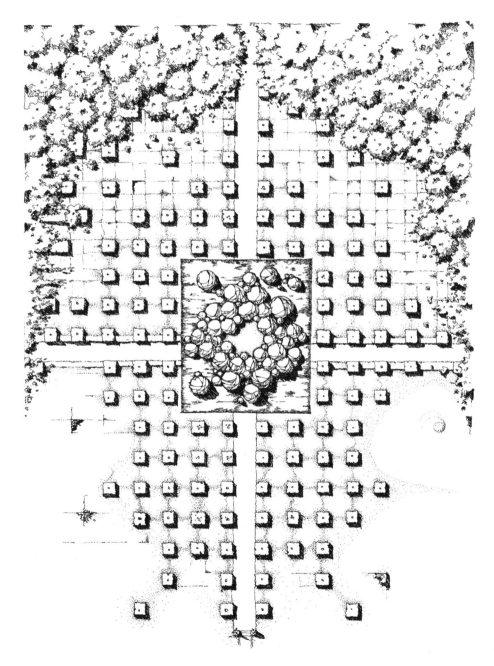

Figure 10–12 *The measured plan in freehand with detail and shadow. Pen and ink on vellum.*

FIGURE 10–13 *Marc Treib design, Dorothee Imbert drawing. Loomis residence, El Dorado Hills, California. Courtyard plan, 1991. Oil pastel and color pencil on blackline print.*

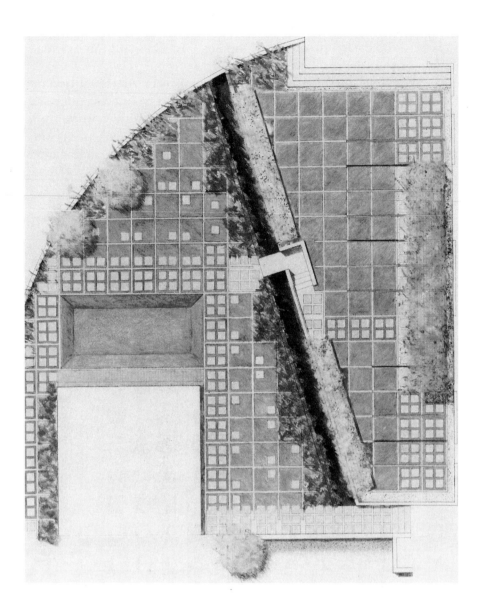

Ground Plane Treatments

Usually a ground plane will be indicated with some type of texture. This is where the texture exercises you did in chapter 5 become very important. The physical topography, or contours, of the ground plane will be the first thing to lay out. You can start by working out your contours in gesture, getting a feel for their form. The most common way to indicate contour is through the use of a dashed or dotted line. You can also use parallel lines drawn perpendicular to the contours and vary their spacing. Although somewhat dated, hatchures can also be used for special effects. Another effective way to delineate contours is to densely stipple along the contour line.

FIGURE 10–14 *Indicating ground plane contours.*

Stippling

Stippling is simply a series of dots used to indicate texture or tones. It is one of the best techniques for the rendering of the ground plan and other objects. It can be a very effective and versatile technique, but if you are not careful it can be overdone. In other words, don't be too busy with the dots; learn when to stop.

You can build texture by varying the density of the stipple. Make perfect round dots with a constant intensity, none darker than the others. No tails or dashes; hold your drawing instrument straight up and twist it lightly in a circular motion. It is best to place the dots in threes using a constant rhythm. When two planes come together, intensify the stippling along their edges; gently fade to white in the centers of the ground plane.

···

EXERCISE 10–5: *The Stipple*

Draw some 4-by-4-inch boxes on a sheet of vellum or tracing paper. Practice your stippling in pencil and ink by drawing to music in dot-groups of threes. Work on building up the intensity of the stipple along the edges of the boxes, and fade them out toward the center. Develop a constant, even rhythm. Draw some stipples with a 0-point technical pen, then go back over them with a heavier pen to see what effects you get. Achieve as many different effects as you can with your stipples.

···

Ground Plane Textures

The ground plane is basically anything that covers the surface of the earth. The larger the scale of your landscape plan, the more ground plane texture you will have to imply. Determine the degree of surface detailing you will need. Learn which textures make your plan the most

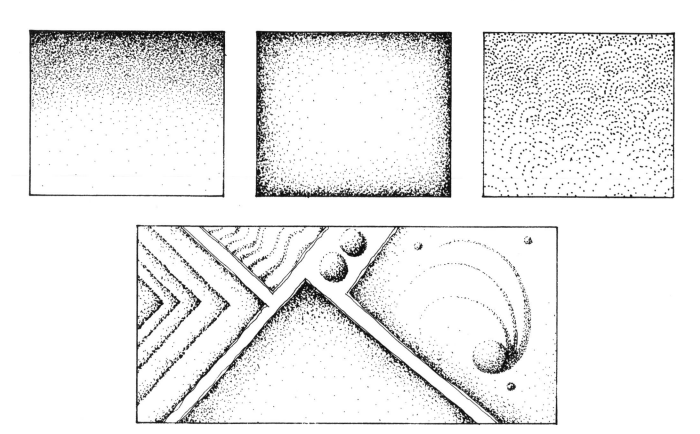

Figure 10–15 *The versatile stipple.*

descriptive, and then use them sparingly; otherwise your plan can become chaotic. Soft ground plane textures include such things as ground covers, low plants, shrubs, and hedges. Hard surfaces would include wood, brick, concrete, rocks, gravel, roads, and walks. To illustrate these elements, develop a simplified gesture that matches the ground-plane material and will read as a texture. Practice developing a vocabulary of abstracted notations for hard and soft ground plane surfaces using lines learned in chapters 4 and 5. Cross-hatching will be most valuable for creating a wide variety of textures. When rendering large ground plane areas you can imply the entire surface area by drawing texture along the edges. Use ground plane textures to emphasize contrasts and highlights. Always look down at the ground plane. Observe the surfaces you walk on and abstract them in your mind.

Water

When illustrating water, your lines should portray movement and fluidity. Water can be an expressive and dynamic scene in a plan, capturing mood and emotion. But the movement, reflection, and transparency of water are difficult to capture. The gesture of line will be quite different from the lines used for hard and soft surfaces. It is important to study

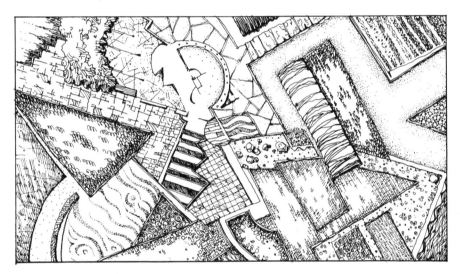

FIGURE 10–16 *Using the gesture to produce ground plane textures.*

the movement and moods of water before attempting to draw them. Look at da Vinci's masterful renditions of water to see how he captured the dynamic quality of its movement and flow. When drawing water, first delineate its edge with a strong line, then abstract its movement and mood with expressive lines.

EXERCISE 10–6: *Studying Water*

Spend some time studying and recording the movement of water in your day-book. Capture its different moods with gestures that you can later incorporate into your plans, sections, and elevations.

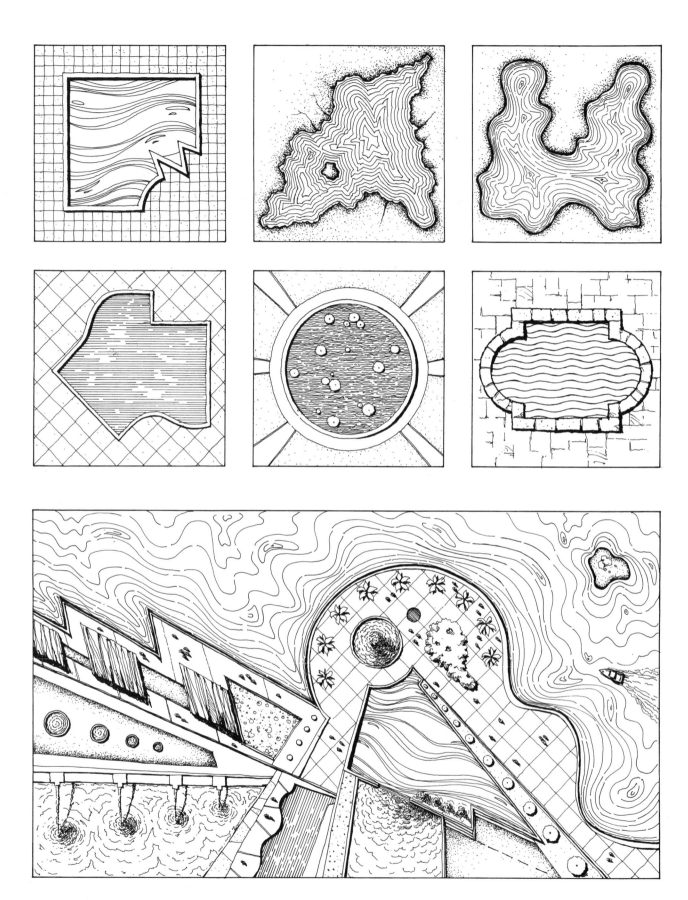

FIGURE 10–17 *Capturing the expressive quality of water with line.*

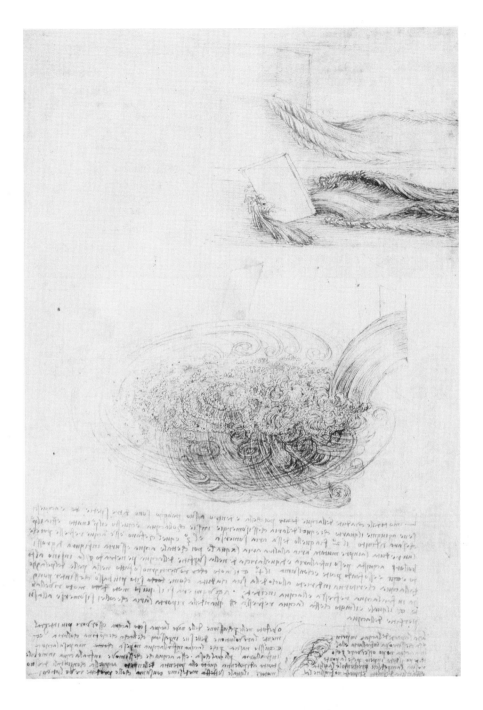

FIGURE 10–18 *Leonardo da Vinci. Sheet of Studies of Water Passing Obstacles and Falling Into a Pool, with Notes. c. 1508. Pen and ink over traces of black chalk. 298 × 207 mm. (The Royal Collection © 1993 Her Majesty Queen Elizabeth II)*

Architecture

As an artist you will have to indicate the plans of buildings. Should they be illustrated as roof plans, floor plans, or building masses? What is the relationship of the architecture to the landscape? Do you want the plan to read as realistically as an aerial view? If you wish to show the relationship of the interior floor plan to the landscape, then draw the building's floor plan. If it is necessary to show the positive and negative spaces of the architecture, then show roof plans of the buildings. Are

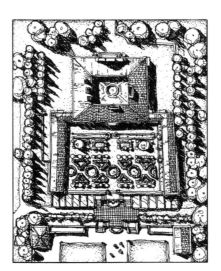
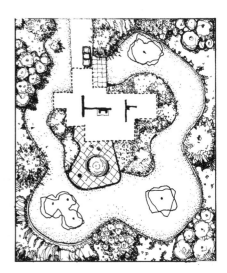

you going to show the architecture as an abstraction? The scale will also determine how detailed you make the roofing material. Adding such things as roof tile, wood shakes, chimneys, or smoke stacks will help make the drawing come alive.

Trees and Vegetation

Determine the scale of your trees. Remember, the further you are from the vegetation the less detail you see. Before drawing your trees, locate the position of the sun and decide what season you will depict. Will the trees be in winter habit or in spring flower? Individual trees will read as solid forms. When you begin to place your trees, start by locating the center point of the main trunk with a dot. Draw in the canopy with a circle template or, better yet, draw it in freehand. Use the same procedure for drawing trees and vegetation in plan view as described in chapter 6.

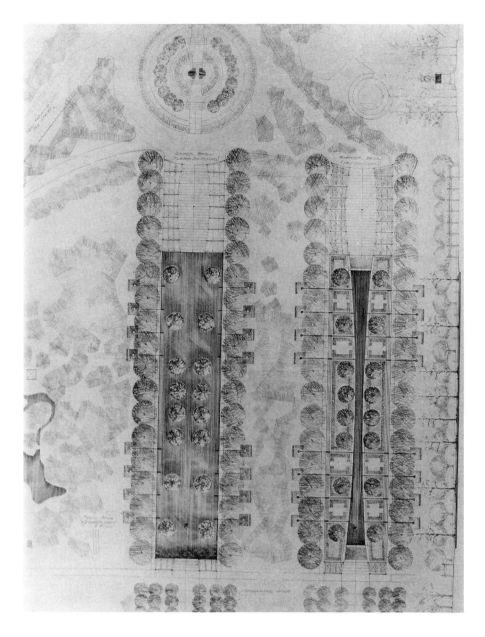

FIGURE 10–20 *Gary Strang. Pencil on vellum. Using cross-hatching to build vegetative mass.*

Trees are not perfect circles; you can make them appear more dynamic by not drawing them as spheres. Draw the branching structure using light construction lines. Start with the main trunk and extend to the canopy edge with a hair line. Abstract the leaf texture, and from the shadowed edge draw the leaves from dark to light.

One of the problems with drawing trees is that the tree canopy may obscure the detail of the ground plane. One way to remedy this is to draw transparent trees. Draw the canopy of the tree in a lighter line weight than the ground plane. If you want a little more detail you can lightly sketch in the branching structure.

Shadows

Shadows indicate the passage of time and if used properly can make a plan dramatic. They can also be used to accent landscape shapes. First decide whether you are going to use shadows; some designers do not. It is not a requirement, for some plans look excellent without them. Whether or not to use shadows depends on the statement you wish to make. If you want the added dimension of depth, shadows should be placed on your site plan.

As the final stage of a drawing, I savor adding shadows. This is the point where the drawing starts to come alive. Shadows make the plan three-dimensional. The type of shadow you use should correspond to the drawing style of the plan and to the texture of the ground plane. Shadows drawn as solid black lines are overbearing and should be avoided. It is best to vary line weights. Shadows don't have to be accurately measured. Place shadows through feeling. Draw the shadow of one object in your plan and from it judge the placement of remaining shadows. Shadows should always fall to the bottom-right or bottom-left

FIGURE 10–21 *Drawing trees in plan.*

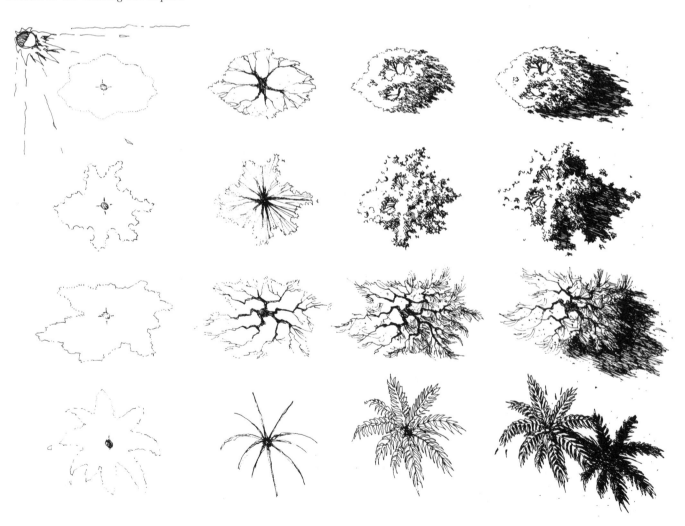

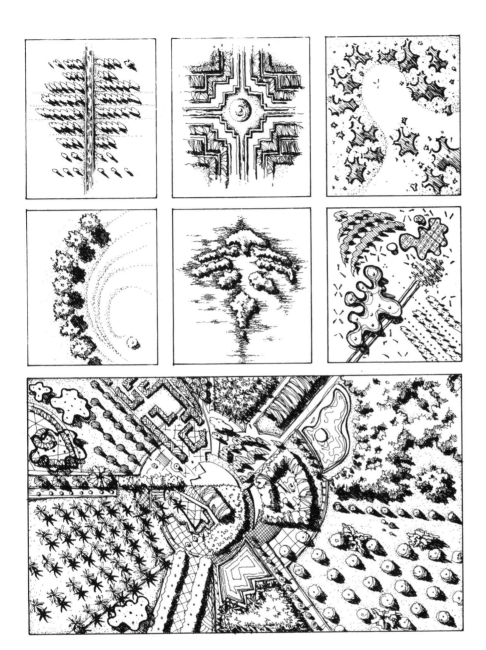

FIGURE 10–22 *Using shadows in plan view to create depth.*

of the page. After you have placed your first shadow, lay a long rule parallel to it to use as a guide for the rest of the shadows. Be consistent. Exaggerate a little sometimes for added dimension. Along the object's edge the shadow should be very dark, fading out along the opposite edges. Let some dappled light show through inside the shadow.

The Elevation

The elevation is a standard architectural drawing view that provides the designer with many opportunities to understand a design in scale. The elevation is a simple convention used to quickly understand the variations in design schemes. When designing a site it is helpful to work back

and forth between plan and elevation to test your ideas as they evolve; the elevation allows you to visualize the design in a way that a plan and perspective cannot. When an elevation is drawn two to three times the size of the plan the relationships of the various site elements are much easier to understand. Some professional offices will even draw full-scale elevations of site elements, which may be taped to a wall to study scale and proportion.

The elevation presents the side view of landscape objects and exterior views of architecture in scale. It also shows building façades in detail. In an elevational view, all planes are parallel to the picture plane, and they appear in the drawing without angular distortion. It is best to locate your study elevations at those positions in the plan that give the most information about your design. The elevation is taken from a line drawn on the site plan and has arrows indicating the direction of the view. This line is called the *cutline*. The elevation can be scaled from this line, indicating those elements that occur beyond it.

The Section

The section is a continuous slice through a plan that reveals architectural interiors, landscape structures, and ground-plane contours. It does not have to be a continuous straight line; it can be staggered to include as much information as possible. The section cutline should be labeled on the plan with directional arrows. The section is an excellent tool for illustrating the relationship of architecture to landscape. Additionally, it illustrates how the landscape design relates to the

FIGURE 10–24 *Frank James, Sasaki Associates. The elevation as a tool to quickly understand the variations in a design scheme.*

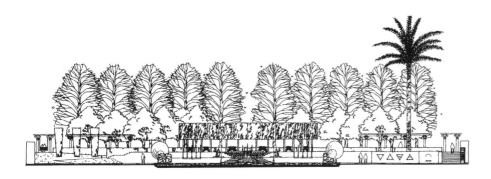

FIGURE 10–25 *Jill Ann Gropp. Pen and ink. This elevation allows visualization of the design in a way that plan and perspective cannot.*

FIGURE 10–26 *Author. The section as a tool for showing the relationship of landscape forms to the earth.*

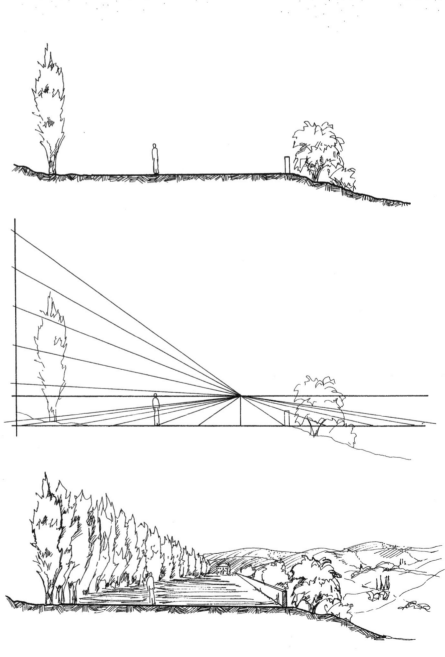

ground plane. Whereas an elevation shows the relationship of architectural exteriors to the landscape, the section is a cut away of the building. It is an incision through the building, revealing the thickness, materials, and construction of its surfaces.

The section is also a good tool for showing the relationship of landscape forms to the earth. Cut through the plane that shows critical information. The sections of walls and landscape structures closest to you are drawn with the darkest line. Slices through walls or other building masses can be shaded to create relief. This technique is called *poche* and is quite dramatic. Shading the interior of the structures will add depth to the drawing. These shadows can be drawn at about a 45-degree angle. It is not necessary to show the below-grade geology and infrastructure unless it is critical to your design.

Illustrating the Elevation and Section

The baseline on the elevation should be a heavy line to create a strong base for the drawing and to accent the ground plane. Texture, cross-hatching, or shading can be added under the baseline to give the drawing a frontal plane that counterbalances the landscape above. This is a good way to keep the elevation or section from "floating," or getting lost on the page. Label the direction the views face. In both elevation and section, it is important to accent the ground plane. Elements in the foreground should be drawn with heavier lines; as landscape elements recede into the background they become lighter. Embellish the foreground, middle-ground, and background with distinctive line weights, using your darkest line weight for the foreground. Use as much depth as possible to make the views realistic. Locate the sun and draw the shadows. To animate the drawing, include figures standing alone and in groups. Sky and clouds add atmosphere and help to frame the drawing. The elevation and section provide many opportunities to create informative drawings.

FIGURE 10–29 *Author. The sectional perspective.*

Elevational Perspective

An elevation can easily be turned into a one-point perspective. An elevation combined with perspective creates the illusion of depth in a landscape setting.

1. Draw a horizon line across the elevation at eye level and place a vanishing point near the center.
2. Along the ground line or baseline of the elevation, mark off one-foot points.
3. From each point along the baseline, project a line to the vanishing point. These lines are called the *vanishing-point lines*
4. Select a point on the horizon line to the right of the vanishing point.

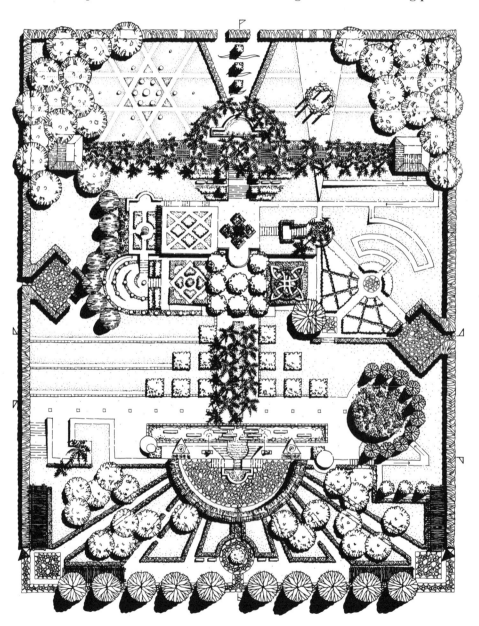

FIGURE 10–30 *Jill Ann Gropp.* Garden Plan. *Pen and ink.*

This is called the *diagonal point*. From this point, draw a diagonal line to the left corner of the baseline.

5. Where this diagonal line intersects each one of the vanishing point lines, draw a horizontal line. This will produce a ground-plane perspective grid.

6. To locate vertical heights, place a vertical line upwards from the left corner of the baseline. Mark off one-foot points up this line. From each point on this vertical line, project a line back to the vanishing point. This gives you a vertical height measure.

Now with this quick ground-plane perspective grid and the vertical height measure you can begin to embellish the landscape. This same technique can be applied to produce a sectional perspective.

For these basic tools of the designer to have profound effects on the design process, their use must become second-nature. Plan, section, and elevation drawings should be synthesized into the total design approach, and should not be considered isolated views. Design should function not only as an intellectual fact but also as an emotional impression. As Hubbard and Kimbal said in *An Introduction to Landscape Design,*

Landscape composition is to the landscape architect, as it is to the landscape painter, the arrangement of the elements of his design into an ordered whole. (1959, 88)

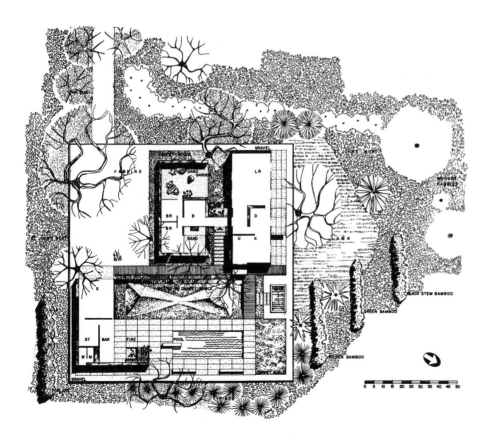

FIGURE 10–31 *Rich Haag. Case study house.*

Axonometric and Isometric Landscape Drawing

In the arts the image is the statement.
It contains and displays the forces about which it reports.

RUDOLF ARNHEIM
Visual Thinking

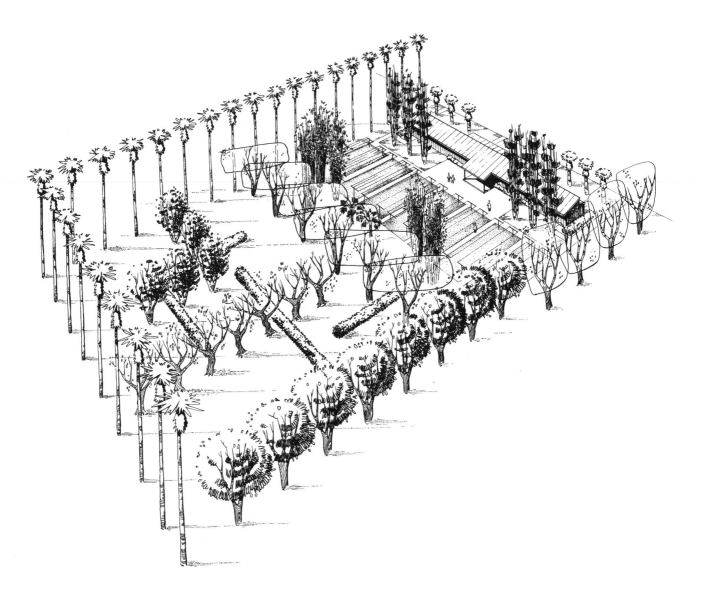

FIGURE 11–1 *Garrett Eckbo.*
Harlingen Farm Workers' Camp.
Ink on paper. (College of
Environmental Design Documents
Collection, University of California,
Berkeley)

The power a visual image can have is enormous. Artists do not realize the impact their images can have on the world. Axonometric and isometric drawings are also called *paraline* drawings. Paraline drawings have been used traditionally by architects and have recently enjoyed renewed popularity after declining during the Beaux-Arts movement. They are not commonly employed by landscape architects as a rendering tool, though they have unlimited potential for expressing landscape and design analyses. The paraline drawing provides us with another framework to visualize our designs. Clients usually can read a paraline drawing easily. Once you understand how to produce them you will find them much easier to construct than a perspective.

Paraline drawings allow the viewer to quickly visualize a complete landscape scene in one moment, viewing a site as a place, while observing its three-dimensional forms. This technique allows you to experiment with new ideas and with transparent overlays to rework them again and again. In this type of drawing everything is in true measure;

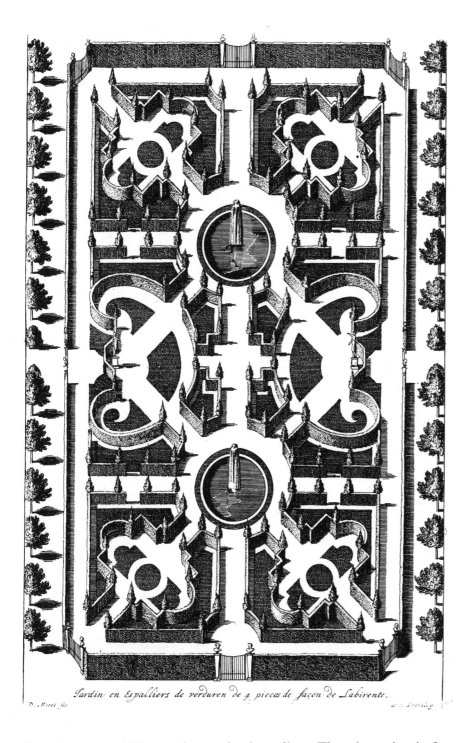

FIGURE 11-2 *Daniel Marot (1661–1752).* Livre de Parterres. *Engraving. The paraline drawing is another tool for visualizing landscape design. (College of Environmental Design Documents Collection, University of California, Berkeley)*

Jardin en Espalliers de verduren de 4 pieces de façon de Labirente.

D. Marot fec. av. privileg.

there is no vanishing point or horizon line. The viewpoint is from above, looking down onto the landscape—almost like a bird's-eye perspective, but not quite. In paraline drawings the plan, elevation, and section meld into one drawing. This is probably one of the reasons they are so popular with architects.

In the paraline drawing, all the constructed parallel lines remain parallel, whereas in the perspective drawing they converge to a vanishing point. Also, the vertical lines remain vertical and all the elements in the

A x o n o m e t r i c a n d I s o m e t r i c L a n d s c a p e D r a w i n g 257

drawing stay true to scale. Perspective drawing shows the landscape as it appears to the eye, but its lines cannot be measured directly. Paraline drawing combines the pictorial effects of perspective drawing with the ability to measure principal lines directly. The disadvantage is that it can sometimes appear distorted because we see the world in perspective and not in paraline.

This chapter examines several types of paraline drawings: the axonometric, the isometric, the freehand bird's-eye view, and the exploded view.

FIGURE 11–4 *Author. The dramatic potential of the paraline drawing.*

The Axonometric

Axonometric is being or prepared by the projection of objects on the drawing surface so they appear inclined with 3 sides showing and with horizontal and vertical distances drawn to scale but diagonal and curved lines distorted.

Isometric is relating to, or characterized by equality of measure, especially relating to or being a crystallographic system characterized by three equal axes at right angles.

Learning to draw an axonometric will lead you to a new exploration of visual space. The axonometric is a drawing that shows a landscape in three dimensions. The landscape plan is set up at a satisfactory viewpoint and the verticals are projected to scale, thus making all the dimensions on the horizontal and vertical planes to scale. The axonometric is a descriptive method that shows a broad range of landscape elements at once, all at true scale. But it is still somewhat of an abstrac-

tion. In landscape drawing one of the advantages of using the axonometric for study is that it helps you see the positive and negative space of plant massing, as well as the overlapping planes of landscape in conjunction with architecture. This is an excellent tool for studying the interlocking spaces of the site because you see the site in altitude. Axonometrics were used to full advantage by Garret Eckbo in his book *Landscapes for Living*. He used them very artistically and with great flourish to study the relationships of plants and groundscape in his plans. Eckbo developed a unique vocabulary of vegetative forms. Plant forms were abstracted into simple but strong silhouettes expressing the essence of the plant. Many of the vertical plants were drawn as ghostlike transparent shapes, allowing you to see detail of the ground plane below and behind.

EXERCISE 11–1: *Constructing an Axonometric*

FIGURE 11–5 *Author. Freehand axonometric for quickly studying design alternatives. Pen and ink in daybook.*

In the axonometric drawing a plan can be rotated in a number of positions.
There are an infinite number of axonometric positions, only a few of which are

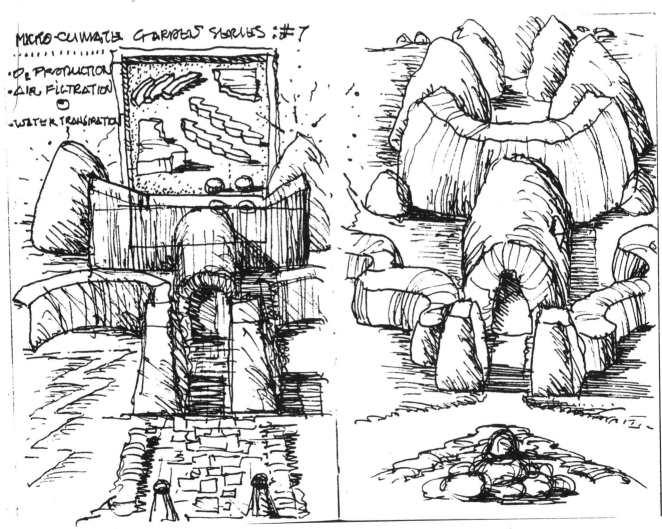

ever used as the basis for landscape drawing. Determine the scale that will best represent the design. Place your plan on your drawing table and rotate it while visualizing the best viewpoint. You can also decide by making copies of the plan and pinning them up at different angles on a wall. Look for the viewpoint that will direct the viewer's attention to the major design relationships in the plan.

The most commonly used angles are 45 degrees, 30 degrees, and 60 degrees. The 45-degree axonometric has a higher viewpoint than an isometric, and the horizontal ground plane will be more visible. The 30 degree and 60 degree also have high viewpoints, and their foreground planes receive more emphasis than the other angles. There will also be some exaggeration in the verticals. The 45-degree view tends to be the best because it presents equal views of both x and y planes.

Think ahead and plan what you want to show in the drawing. Use thumbnail sketches on tracing paper to construct what you are trying to get across. After you have decided on a view, tape down the plan in your selected position. Project in true scale the vertical dimensions from their positions on the plan. Lay out the vertical dimensions at the bottom of the page first, moving up to the top of the plan. Work out all the details using transparent overlays with light guidelines. After you have worked out the correct forms, trace them onto the final sheet.

When you begin the axonometric do not use a lot of detail; keep the forms simple. Draw the landscape with elemental forms. Determine how you want the building mass to read. Working from simple to complex forms makes it easier to read a design as it develops. After you have worked out all of the forms in construction lines you can begin to add detail, tone, and shading.

FIGURE 11–6 *Garrett Eckbo.* Farragut Drive School–Flagpole Unit. *Ink on paper. The expressive potential of the axonometric. (College of Environmental Design Documents Collection, University of California, Berkeley)*

The Isometric

Like the axonometric, the isometric is a geometric drawing that shows a site in three dimensions. The landscape plan is set up with lines at an equal angle (usually 30 degrees) to the horizontal, while all the verticals remain vertical. Every line is drawn in true scale. The isometric drawing produces a more realistic looking landscape than the axonometric, but the diagonals and curves are slightly distorted. In the isometric landscape all three visible surfaces have equal emphasis. The major disadvantage of the isometric is that you have to completely construct the plan in isometric, whereas in the axonometric you have only to rotate the plan and project up the landscape elements. However, there is less distortion in the isometric than in the axonometric.

EXERCISE 11–2: *Constructing an Isometric*

Unfortunately, you cannot directly transfer a plan view to the isometric. First, decide on the angles and scale that will best represent your design. Make a thumbnail sketch of your proposed layout, and on a sheet of tracing paper draw out the plan in isometric. Work out the vertical dimensions on an overlay. Make all your compositional decisions on the tracing paper. When you have finalized all your design decisions overlay your final sheet.

Freehand Bird's-Eye

This type of view is based on the axonometric, but it is a freehand interpretation that allows for the creation of wild landscape inventions. The true perspective has been modified to create a distortion and a surreal sense of space.

EXERCISE 11–3: *The Bird's Eye View*

From a bird's-eye view, rough out slightly diminishing parallel lines. Draw a diagonal line from the front right to the back left. Where the diagonal intersects the receding lines, draw horizontal lines. You now have a rough perspective grid from which you can draw vertical landscape elements. Place a vertical height line in the foreground and estimate one-foot increments to scale. Use this measure to project your vertical heights.

FIGURE 11–8 *(above) After selecting the desired position of the axonometric, project the true vertical dimensions of the design.*

FIGURE 11–9 *(below) To construct an isometric, determine the angles and draw the plan to scale.*

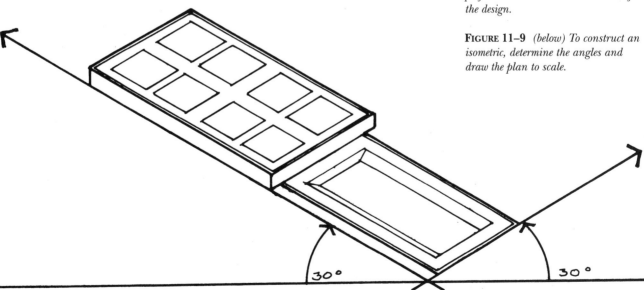

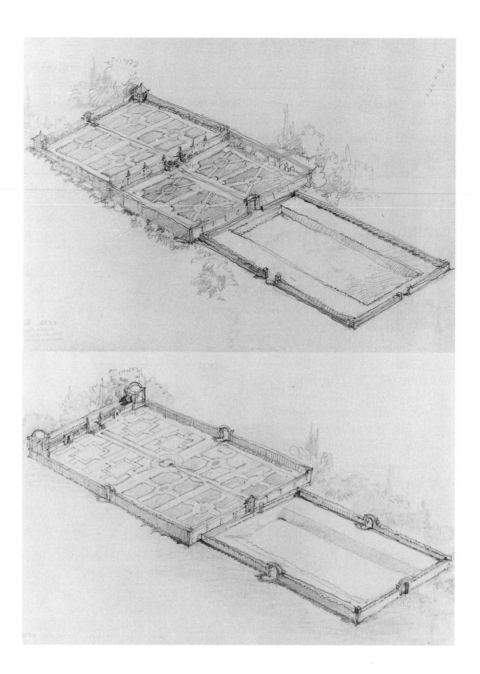

The Exploded View

This is not a true paraline drawing by any stretch of the imagination. But it can be an exciting device when you want a strong visual impact. Take extreme liberties in its composition. In the exploded view the elements of the design seem to be flying through the air above the plan. This allows the viewer to see each of the landscape elements independently; it is almost like seeing a cubist painting. The locations are shadowed or dotted in on the site plan of the elements. The flying landscape parts can be attached to the site plan with dotted lines or light construction lines.

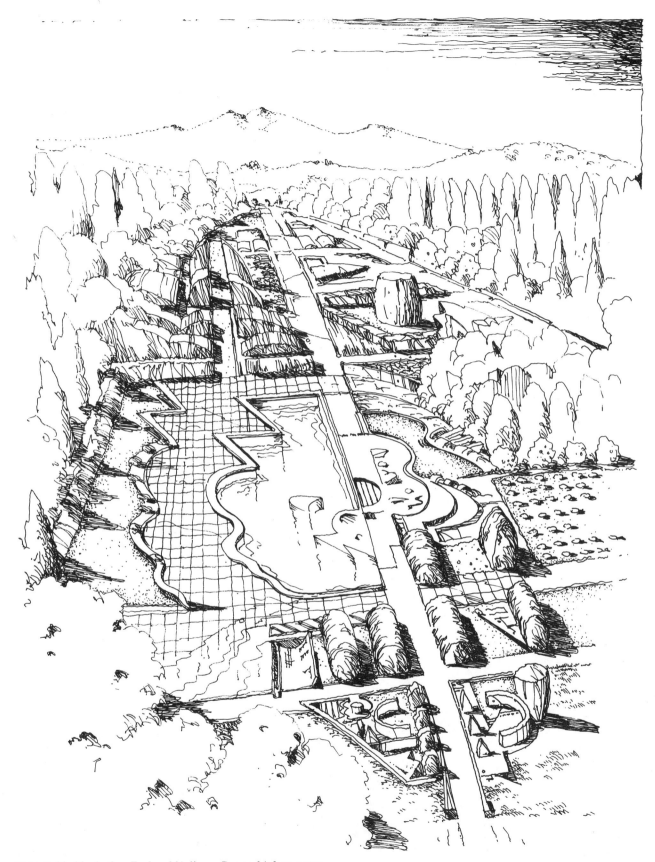

FIGURE 11–11 *Author. Freehand bird's eye. Pen and ink on paper.*

EXERCISE 11–4: *The Exploded View*

To construct an exploded view lay out the plan in an axonometric or isometric view. Then project the design elements; they can be placed in almost any position, but keep the overall composition in mind. Attach the element to the plan with dotted lines or construction lines if you wish. This allows the viewer to make some connection to their location on the plan. Other than these basics there are no rules, so be as inventive as you like.

Illustrating the Axonometric and Isometric

The Ground Plane

To create groundscape surfaces use the same techniques for illustrating a plan as described in chapter 9. Pay attention to the use of line weights and what areas of the plan you want to emphasize. If the tree canopy assumes the greatest importance, then the ground plane should be fainter. If the surface of a plaza is the area of emphasis, the vertical

FIGURE 11–12 *Andie Cochran, Delaney & Cochran, Inc.* Children's Hospital. *Pencil. Projecting vertical elements up from the plan illustrates the spatial relationships of the design.*

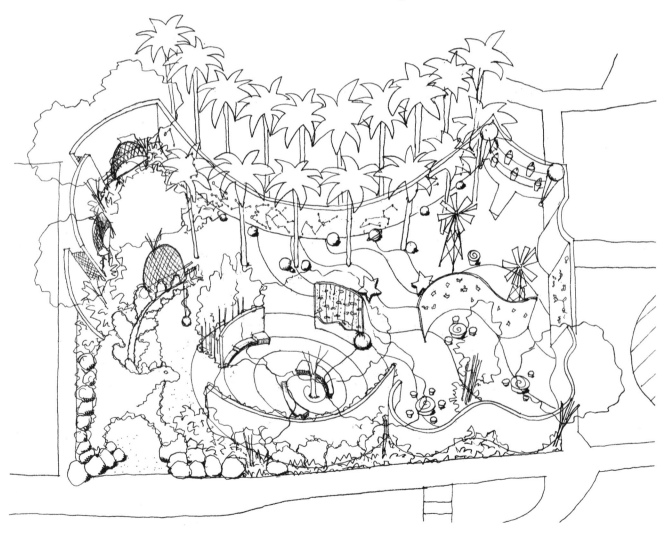

elements such as trees, lights, walls, and so forth may be ghosted. When the landscape dominates, use light lines for the architecture. Pavements and other groundscape elements can be illustrated with the stippling or cross-hatching techniques described in chapter 9.

Trees

Before drawing trees you must determine what you are trying to express. If it is important to show the ground plane design, make the trees simple transparent shapes, but abstract their form into silhouettes. A fine brush is a good tool for drawing trees in outline. Be expressive with it; let the line vary. Begin by drawing the location and sizes of trees and other plant material on a sheet of tracing paper. When you have them all located, place the tracing paper under your plan and draw them on your final drawing. The background trees, or framing vegetation, can often be drawn as a solid mass. Sketch them on tracing paper and transfer this information onto the final drawing. Draw their mass as an outline, adding texture as necessary. If you want to show vegetative masses and their resulting positive and negative spaces, use an overlay and draw each individual tree using light construction lines. Outline them with a heavy line. Transfer this information to the site plan and shift the tracing vertically up to the proper height, delineating the sides of the plant masses. These techniques can also be used for hedgerows, allées, ground cover, and so forth.

Architecture

You will first have to decide whether to draw the architecture as a floor plan, cutaway, or complete structure with exterior surfaces. Is it important to see the interior spaces of the plan in relation to the landscape, or is it better to see the mass of the architecture. What are the

FIGURE 11–13 *Garrett Eckbo.* Tulare Unit. *Ink on paper. A drawing illustrated with expressive lines. (College of Environmental Design Documents Collection, University of California, Berkeley)*

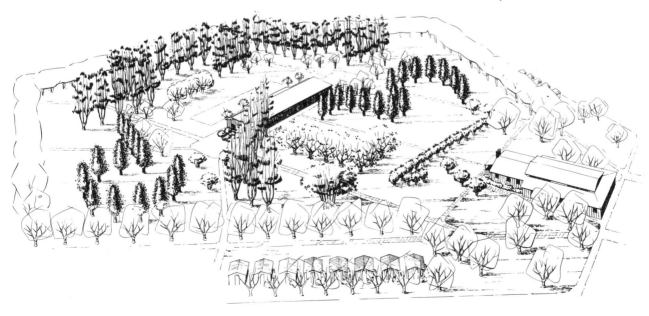

FIGURE 11–14 *Walter Hood. Trees projected from the ground plane.*

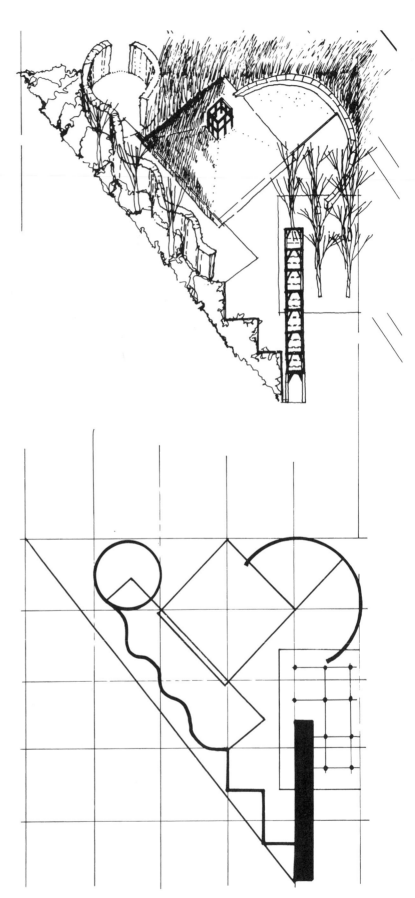

FIGURE 11–15 *Catherine Chang. Axometeric drawing illustrating the relationship of architecture and landscape.*

layers of information you wish to illustrate with the structures. You can make the architecture transparent or use dotted lines to ghost the structures so as not to cover up the details of the landscape. To get a roof plan, trace the floor plan, put it under the drawing, shift it up to the proper vertical height, then trace it.

Shadows

Applying shadows to the plan is extremely important to achieving a three-dimensional quality; add them only after the drawing has been completely composed.

FIGURE 11–16 *Michael Seroka,*
Falcón and Bueno. *Axonometric
drawing illustrating relationship of
house and garden.*

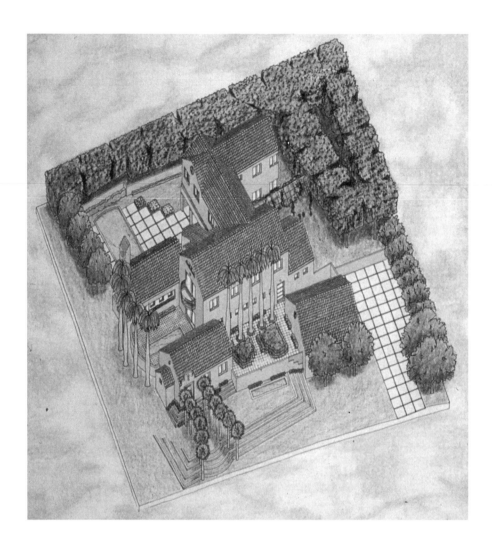

Shadows should fall to the right or left side of the drawing, never straight up or down. Don't draw the shadows in solid black; let some light shine through and let them fade out along the opposite edges. A shadow should pick up the texture of the ground plane over which it falls, and should be darkest along the shadowed edge. Don't forget to use shadow to accent plant forms; this will help to define the content of the space you are trying to portray.

Composing the Paraline Drawing

A paraline drawing tends to be placed in the center of the page, but there are many possibilities. Develop a strategy for laying out the composition. If you have a series of drawings, how will you organize them into a harmonious composition? How will you direct the observer's eye through the drawing to hold his or her attention? Laying out a grid can be useful for organizing the placement of drawings. A central axis or diagonal can also be used as an organizational system. You can use a frame around the edge of the page to help hold the space, or you can

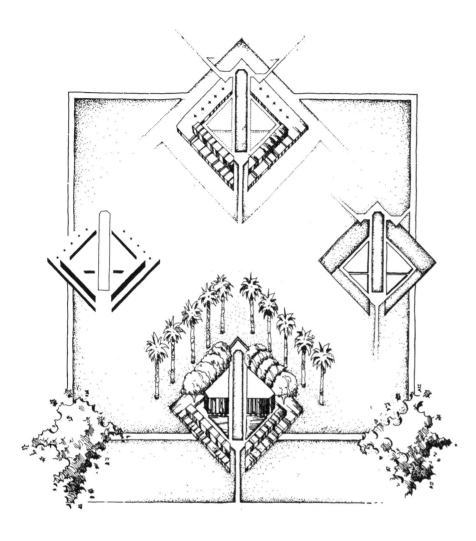

FIGURE 11–17 *Author. A composed paraline drawing.*

use a textured background as a foil for the image. Copy the images and lay out mockup compositions. Whatever device you use, it should complement the drawing rather than compete with it.

> *When you've worked at it long enough, you arrive at the point where you make images you have always known: Images that you knew, as a child, were your own definition of art. (Flack 1986, 21)*

The Figure in the Landscape

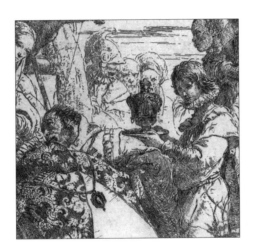

For Michelangelo, every drawing is an action
determined to grapple, grasp and subdue the human body,
to subdue and constrain its energies long enough
to compel them into the order of a plastic image.
The body is for him the Great Ark, the container of all
emotive experience. Energy, movement,
a sequence of muscular forms twisting in space become a sign.

EDWARD HILL
The Language of Drawing, 1966

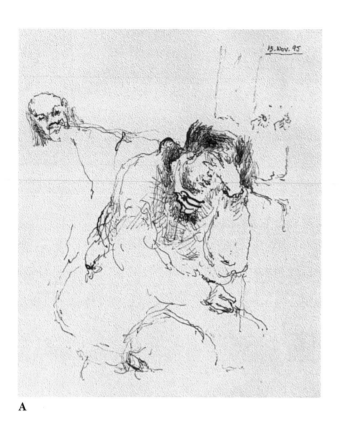

A

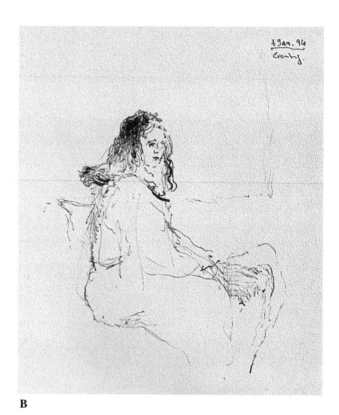

B

FIGURE 12–1 *Tony Dubovsky. Observations of people in Long's Drug Store. Ink on paper.*

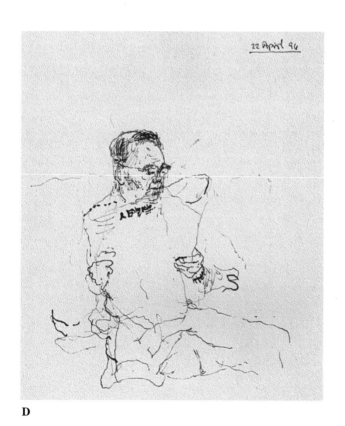

D

E

C

F

How can the design arts possibly create environments for human beings without studying the body and its movement? How can we design comfortable spaces for sitting, moving, and living if we don't understand human proportion and the mechanics of the bones and muscles? Environmental design has been isolated by the dearth of anatomy- and figure-drawing classes in our design schools. Since the postwar period, figurative art has fallen out of favor in universities and galleries as artists search for new forms of art for the modern age. The resulting rise of abstract and conceptual art, in its attempt to reinvent the body and to transcend it, has bypassed classical study, and there are now few art schools and fewer design schools that offer a basis in figurative training. However, there are exceptions to the general trend. Some modern artists, such as Philip Pearlstein and David Hockney, understand the importance of the figure; painter Tony Dubovsky uses it to dynamically inhabit his drawings and paintings while telling a story.

The human body is the primary indicator of scale in the design process. Learn to understand and draw the figure by first becoming familiar with your own body, its scale and movements. Measure and draw your body and begin to pay attention to how you move through spaces you like. In the drawing of landscapes, the human figure should be the common denominator; because we all relate to it, it should be our point of departure in design. Without it, there can be no sense of scale or proportion. In fact, drawing the figure can give us the most direct experience of the living form, allowing us a close examination of the form for which we are designing. Unfortunately, many drawings of architecture and landscape are devoid of figures. Even when they are included, isolated figures tend to appear flat, stiff, and contrived, rarely exhibiting the dynamic quality of the movement of the body or the beauty and glory of the human form. The importance of understanding the body in order to design space and draw dynamic figures cannot be overemphasized.

To express rhythm in drawing a figure we have in the balance of masses a subordination of the passive or inactive side to the more forceful and angular side in action, keeping constantly in mind the hidden subtle flow of symmetry throughout. Bridgman (1961, 35)

I highly recommend taking figure drawing classes, no matter how advanced or skillful you are, because it helps you stay visually alert. Even after you have developed skill in drawing the model, it is helpful to continue once or twice a week in order not only to fine-tune your ability to observe, but to keep yourself aware of how the body moves. Many artists continually draw from life even though it is not the main focus of their work; they find it keeps their hand-eye coordination sharp.

Drawing the Figure

The picture surface is indeed a window through which the world is seen, but in this world figures will occupy the center stage, and their setting, and hence landscape, will be subordinate. Richard Turner, The Vision of Landscape in Renaissance Italy *(1966, 4)*

After learning to draw the figure with confidence you will need to begin to think about how individual and groups of figures will inhabit your landscapes. It can be helpful to study the paintings and drawings of artists who use the figure. Observe how their figures inhabit the landscape of the drawing. What do the body movements indicate? What does the gesture of the figure express and how does it relate to the content of the painting? Where are the gazes of the figures focused; in other words, who is looking where? These are the questions to ask yourself before you begin placing figures in the drawing.

Each figure in Tiepolo's "Adoration of the Magi" signifies its relationship to the others through body language. The gestures of each individual are telling a story. The figures dominate the foreground of the picture plane, which reinforces the importance of this event by displaying the tremendous joy and hope bound up in the birth. Through the movements of legs, arms, hands, and torso, each person makes a contribution to the centrally focused composition. Combined with the attitude of the poses, each individual's facial expression is meaningful. Even the bull in the right foreground appears to contribute to the emotion of the event.

In the ink and wash drawing "Piazzetta with a Campanile Under Construction" Canaletto uses the placement of his figures as an integral part of the urban plaza. Where Tiepolo's composition shows an intimate private group, Canaletto's describes space. Instead of the figures being the central focus of the picture, the gestures of the individuals animate the setting by interweaving the groups in lively discussion. The people are an integral part of the plaza, giving it human scale. Canaletto's careful orchestration of individual and group body gestures

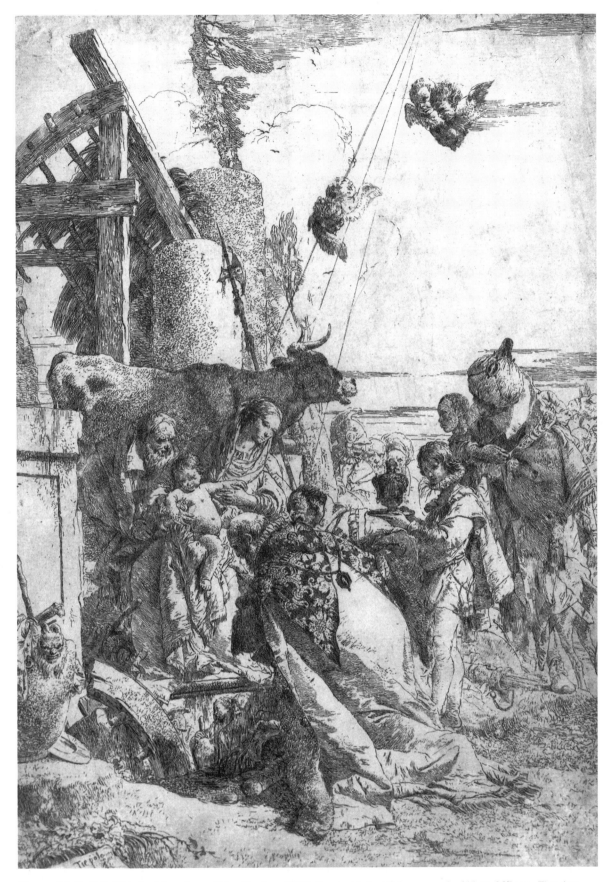

FIGURE 12–2 *G.B. Tiepolo.* Adoration of the Magi. *c. 1753. Pen and ink with brown wash. 410 × 287 mm. Fine Arts Museums of San Francisco.*

FIGURE 12–3 *Canaletto.* Piazzetta with Campanile under Construction. *Pen and ink, 339 × 291 mm. Fine Arts Museums of San Francisco.*

makes the area teem with a variety of human activity, thus illustrating how this Renaissance urban plaza was used.

In one of Moucheron's "Eight Landscapes" engravings, the vista dominates, and figures are included to demonstrate the power of nature. Upon first glance your eyes take in the sweeping vista of trees, valley, and distant mountains. Only on closer inspection do you begin to notice two small figures hidden in the lower left of the composition. The glory of nature is overpowering: humans are only bit players in this play; nature is the unquestioned star. This is a marked contrast from the central location of the figures in "Adoration of the Magi." Here the humans are diminutive, moving through an immense natural landscape panorama.

A similar theme of figure and landscape is repeated in a woodcut by the nineteenth century Japanese artist Hokusai entitled "Mino no kuni yoro no taki." He has placed the waterfall in the center of the composition so that it commands the view. The two human forms at the bottom of the picture plane seem to merge into the waterfall, thus portraying the attitude that humans are an integral part of the flow and dynamic process of nature. Hokusai uses the circular hats of the two people to mimic the form of the mist from the waterfall.

The twentieth-century American painter Edward Hopper used the figure, or more often its absence, to express the isolation of urban life in

FIGURE 12–4 *Moucheron. (One of)* Eight Landscapes. *Pen and ink, 169 × 255 mm. Fine Arts Museums of San Francisco.*

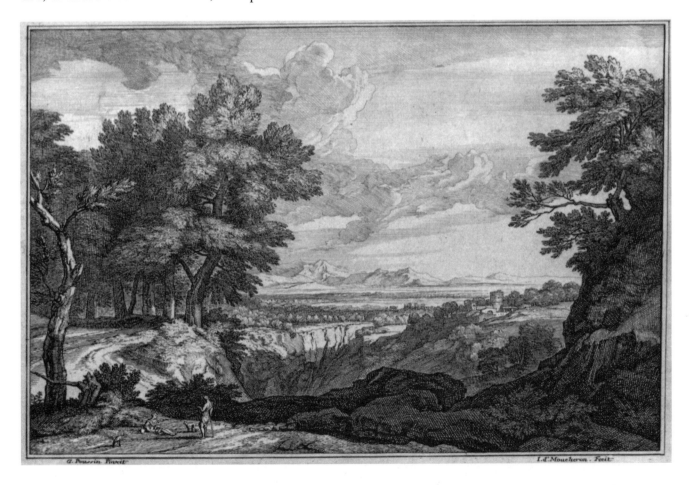

strong architectural settings. In his work the mood of the architecture often dominates because of its large scale, which dwarfs the figures. In Hopper's etching "Night Shadows," the loneliness and isolation of the lone figure walking down a deserted street late at night is accentuated by the long shadows and the dark and empty storefronts. The figure seems to be rushing away from us; we see only his back. This body language translates into isolation, as does the observer's angular, removed, elevated point of view.

Reginald Marsh, a contemporary of Hopper, uses the body in a completely opposite way. Marsh's characters usually fill the space of the picture, making a very different commentary about the crowded conditions of urban life. In his etching "Tattoo-Shave-Haircut," the picture plane is teeming with life, activity, and movement. The figures are squeezed together, almost bursting off the page. We are confronted with their strongly individual characteristics in a very claustrophobic setting; although they're crowded together, they seem very isolated within their private worlds. Each person's gaze is looking off in a different direction; no one in the picture is looking directly at anyone else. The drawing is a landscape of people, each unique and idiosyncratic, creating a human explosion.

The Life Drawing Session

It wasn't until I had finished graduate school and was working in a large landscape architecture firm that I decided to take a night course in figure drawing; I felt that I just didn't have enough time to draw in the office. It turned out to be one of the most stimulating and refreshing things I've ever done. The sessions met every Tuesday and Thursday, and often I couldn't wait for the next class. I found that because of the concentration and focus they required, the drawing sessions erased the stress I had accumulated during the day at the office.

FIGURE 12–6 *Edward Hopper.* Night Shadows. *1921. Etching, 176 × 210 mm. Fine Arts Museums of San Francisco.*

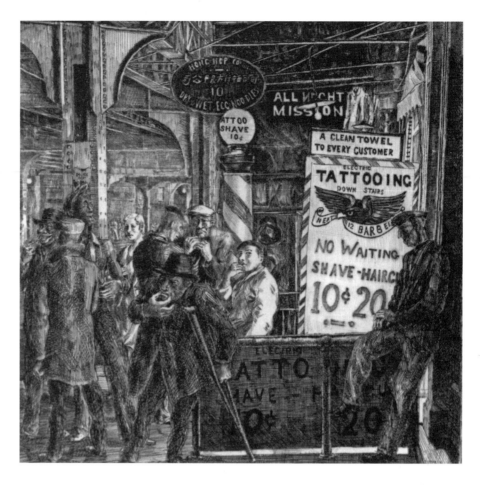

I recommend weaving figure drawing into your work schedule, as an officewide activity if possible. One of Walt Disney's many innovations was to hire Chouinard Art School instructor Don Graham to conduct night classes at the animation studio in 1932. Disney hired Graham to conduct life-drawing classes, not only to train young animators, but to get all of his artists to sharpen their ability to visualize action and the mechanics of motion. In Disney's memo to Graham he described what he thought these night courses should accomplish.

Many [artists] do not realize what really makes things move. Why they move—what the force behind the movement is. I think a course along that line, accompanied by practical examples of analysis and planning, would be very good. In other words, in most instances, the driving force behind the action is the mood, the personality, the attitude of the character—or all three. Therefore, the mind is the pilot. We think of things before the body does. (Maltin, 1987, 43) Of Mice & Magic

One has only to watch the great animated shorts and features from this era to see that these results were successful and produced a sense of realism and beauty of form. One of the most important elements of figure drawing is that it teaches how the body moves through space and that it is animated, fluid, and gives life to space.

EXERCISE 12–1: *Office Modeling Session*

If you work in an office get together with your coworkers and hire a model. The model could come in once or twice a week in the evenings for three hours. Drawing together creates a sense of excitement and creativity, helping to create a communal learning atmosphere similar to that of a Renaissance guild or studio. If you are new to drawing from life you will probably be a little shy about drawing the nude at first; but you'll be amazed at how quickly your nervousness disappears and once you begin concentrating on the form.

To structure these model sessions, start with one-minute poses, slowly building up to five-minute poses, on to fifteen-minute poses and then finishing with two long poses of thirty minutes each. The model usually takes a five minute break every thirty minutes.

> *In the twisting and bending of the body there is a harmony of movement, a subtle continuity of form, ever changing and elusive, that is the very essence of motion. (Bridgman, 1961, 45)*

EXERCISE 12–2: *Informal Model Groups*

If you don't work in an office, organize an evening drawing group with friends. You can hire a model or draw one another; for example, members might model for twenty minute stretches, working through poses of varying lengths. Chose a place to meet once or twice a week where you can draw uninterrupted for two or three hours. You don't need an instructor.

Informal gatherings work well for many people. They have the advantage of being free, and more important, everyone gets to pose. The opportunity to not only draw the model, but also be a model helps artists to understand the weight and motion of the poses they attempt to capture. The social aspects of a drawing group are almost important as the model in learning to draw. You can talk with your group about your work, and learn from the way they see the poses. Your group will encourage you and point out your progress. I suggest that the group bring refreshments, eat, relax, and discuss the drawings.

EXERCISE 12–3: *The Figure Sketchbook*

You don't have to be in a drawing session to practice drawing the figure. Keep your sketchbook with you so you can draw people whenever you have the opportunity to observe them. This can be especially fun when traveling on the bus, subway, or train. Anywhere there are people, there is an opportunity to draw them. Parks and plazas are good places to find people in motion—and since you don't know how long you'll be able to draw someone, you'll get faster at capturing a pose. Drawing in public like this will give you a variety of poses that you wouldn't see in a modeling session, and helps you to see how drawing a clothed figure differs from drawing a nude, where the structure of the pose is more revealed.

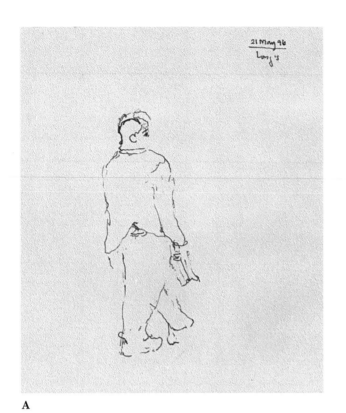

A

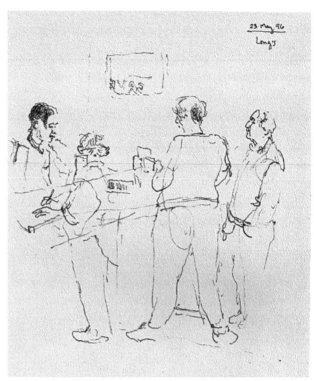

B

FIGURE 12–8 *Tony Dubovsky. Drawing on Bay Area Rapid Transit (BART). Ink on paper.*

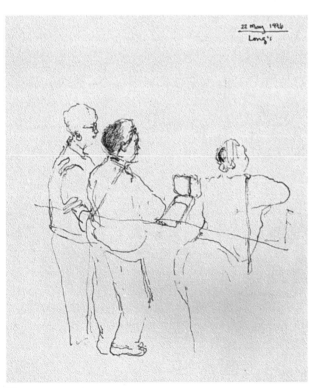

D

E

C

F

I always encourage my students to draw while commuting on the bus or subway. Recently I got on the subway, sat down and turned to look out the window. Soon I began to get an eerie feeling, so I looked across the aisle, and there was a hip young guy with a sketchbook, carefully drawing me. At first I thought it was one of my past students playing a joke on me, but it wasn't. Someone else has discovered the wealth of interesting character to be observed on public transit. It was very strange to have the shoe on the other foot, but I settled back into my seat and gave him a perfect profile view.

The Skeleton

Necessity requires that the painter pay attention to the bones sustaining and supporting the flesh situated at the joints, which enlarge and diminish on bending. (da Vinci, 1989, 127)

Before you can embark on drawing the body you must first comprehend the skeletal system. The most direct way to accomplish this is to copy male and female skeletal diagrams. Unfortunately, these are only two-dimensional. Ideally it is best to draw the skeleton from a three-dimensional model, though these are hard to find. Small-scale plastic skeletons can be purchased at many art supply stores. The Renaissance artist would construct figures by first studying anatomy. In Alberti's treatise on painting, he describes this process:

"Just as for a clothed figure we first have to draw the naked body beneath and then cover it with clothes, so in painting a nude the bones and muscles must be arranged first, and then covered with appropriate flesh." (Alberti, 1991, 72)

The bones are the structure and support for the human form. They afford the surface for the attachment of the muscles; they also bear the weight of the body and act as the levers for movement. Try to learn the workings of the human skeleton by studying the diagrams in the classic artists' reference *Gray's Anatomy*. The skeletal sys-

FIGURE 12–9 *Annie Amundsen.*
Skeleton diagram. Ink on paper.

Some of the mechanical principles of the human frame.

Weight of head 12 to 15 lbs.

Heads 3¾

1¾ Heads

Height of pelvis 1 head.

Female pelvis wider and shallower than male.

The sacrum performs the function of a keystone in the arch of the pelvis.

7½ Heads

The heavy line indicates how shocks are deflected in walking, running and jumping.

The feet placed together form an arch.

The bones of the foot are so arranged as to form a springy arch.

Heads 3¾

Line of gravity

The astragalis bone acts as a keystone to the arch of the foot.

The skeleton in simplified form to illustrate curves which deflect shocks and give springiness to the frame.

tem primarily helps you to understand how the body distributes weight and how the bones fit together. There is tremendous variation in the proportions of skeletons, and if you understand how it works, you'll understand how a live model differs from anatomical drawings.

EXERCISE 12–4: *The Skeleton*

Copy the diagrams in Figure 12–9 at a larger scale using a 6B pencil on an 18-by-24-inch sheet. Begin by marking out the horizontal proportional lines, each one head high. Concentrate on getting the proportion correct, relating the whole to the module of the head. The average body is 7 1/2 heads high.

The Muscles

The painter who has a knowledge of the chords, muscles, and tendons will know well in moving a limb which chord is the cause of its motion.

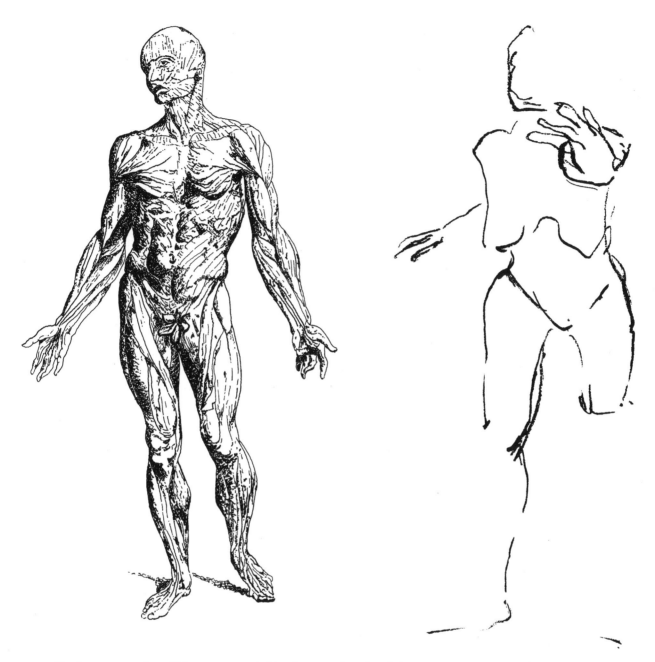

. . . By these means he will become a varied and comprehensive demon-strator of the various muscles according to their various effects in the figure and he will not, as many do, render diverse actions in such a way that the figures always display the same features in their arms, backs, breasts and legs. Such things are not to be counted as minor errors. (da Vinci, 1989, 131)

After gaining an understanding of the workings of the skeleton, you must then begin to develop a visualization of how the muscles attach themselves to the bones and how they provide movement to the body. As a starting point, practice drawing just the muscles by copying the illustrations in Gray's Anatomy.

FIGURE 12–10 *(above left) Kimberly White. Muscle diagram. Ink on paper.*

FIGURE 12–11 *(above right) Catherine Harris. Getsure drawing showing movement. Pencil on paper.*

FIGURE 12–12 *Drawing the figure*

A) *Draw a point indicating the top of the head and then, with a few quick lines, indicate the general proportions of the body so that you express the form of the figure. Capture the body as a gesture rather than with tone.*

B) *Block in the head and locate the direction of the shoulders, hips, and knees, again with rapid gestural strokes.*

C) *Find the lines that carry the weight of the pose; these lines define the movement. Capture the feeling and complete movement of the model as gesture. Try not to lift the pencil from the paper, thinking of the figure as a single connected motion. Next, begin to sketch in the mass of the body. How does the figure distribute its weight?*

D) *The outline of the body is never straight; it consists of alternative rounds and hollows of plane and curved surfaces. These should be brought out by varying the weight and thickness of line. Look for the fluid motion of the pose rather than for individual muscles.*

E) *Add the details using a continuous line. Keep building up the form with gesture. From the repetition of gestural strokes volume should emerge.*

F) *Complete the gestural drawing darkening areas of shadow. For longer poses always start with this procedure. Once you have captured the overall gesture of the pose, you can begin to add more details; definition of hands and face, for example. Build up tone using your finger to blur hard edges and darken. Use your kneaded eraser to blend and smooth out the tone, and to pull out highlights.*

(Drawings: Kimberly White)

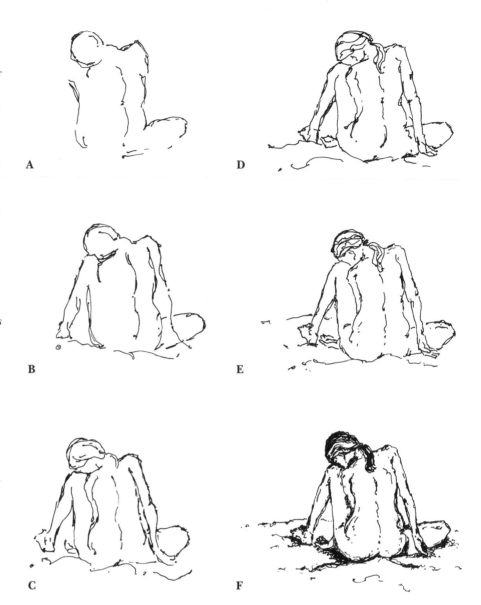

A D

B E

C F

The mass of the figure is composed of levers, which are moved by the muscles, tendons, and ligaments. The muscles are always paired, one pulling against the other. No muscle acts purely by itself.

EXERCISE 12–5: *The Muscles*

Draw the muscles in Figure 12–10 with a 6B at a slightly larger scale, on a sheet at least 8½-by-11. This will help you gain knowledge of the overall mass of the muscles. It is important to understand the interaction and shape of the muscles so that you can see how they give shape to the thin layer of skin that covers them. Just try to get a feeling for the muscle groups, how they overlap and interweave. Try to imagine how they might form the topography and shape of the skin.

Proportional Systems

How surprisingly different are the proportions from one person to another, and how endless are the variations from pose to pose, each a new landscape. (Hill, 1966, 82)

Many great designers, from da Vinci to Le Corbusier, have developed human proportional systems that they used as a foundation for their designs. You could use your own body as a proportional module by measuring your height, arm length, hands, and the span of your outstretched arms. Drawing your body to scale can make it your own personal design canon of proportion.

All of the historical proportional systems—and they are many and varied—divide the body into parts of equal measure. The study of proportion should be given first attention before beginning to draw your figure. Find the proper relation of each individual part as a proportional relationship to the total figure. For instance, when blocking out a figure, use the pencil to gauge the size of the head and then measure the length and width of the torso using the dimension of the head as a unit of measure.

Every part of the whole must be proportional to the whole. (da Vinci, 1989, 119)

Drawing the Figure in Gesture

The study of gesture is not simply a matter of looking at the movement that the model makes. You must also seek and understand the impulse that exists inside the model and causes the pose which you see. The drawing starts with the impulse, not the position. (Nicolaides, 1941, 23)

Using the gesture in figure drawing has many advantages. It allows you the freedom to capture the true motion of the figure. It is quick and thereby honest—less clouded by editing and assumption. Finally, it enables you to capture the mood of the model. After developing an understanding of the bones and muscles you should begin to practice drawing the figure in gesture. The best situation is to practice in one of the previously mentioned life-drawing sessions. Short poses at the beginning of the session are ideal for practicing the gesture. However, you can also practice while sitting in a cafe or any place where you can comfortably observe people in various forms of activity. The hierarchy of figure drawing is as follows: first understand the gesture of the pose, then the weight, and finally, the movement. In other words, how does the figure occupy its space? Beginners often tend to get too detailed too quickly without understanding the proportions of the figure—then they are discouraged by their drawings because they don't look right. Always begin your drawing session with quick loose studies. Look at the pose as an abstract form, something unfamiliar, before you begin to add

detail, tone, and volume. Remember that to draw the figure well will require all of the aesthetic elements of drawing—line, tone, and texture—as discussed in previous chapters.

Guidelines for Gestural Studies

To do a gestural study, you must begin by seeing beyond the gesture. What is the impulse of the pose? Use a 6B compressed charcoal stick, because its softness allows a great variety of line weight with very little pressure, and it can be rubbed and blended to create smooth tones. Warm up with one-minute poses. Always begin by forming a vivid mental image of the figure in its entirety, trying to see it in your mind's eye. First evaluate your position in relationship to the model by determining your distance from him and his relationship to the setting. Now concentrate on proportion, balance, and form. Next define the weight of the pose, then convey the idea of the figure; don't try to produce a photographic likeness of it. Rather than beginning with a small section, look for the sensation of movement and volume. Try to locate the center of gravity, which is in the stomach area. Block in the relationship between the head, shoulder, and hips. What reveals the rhythm of the figure and the structure beneath its surface? Also note that the body is never totally symmetrical. The gesture should express rhythm. Rhythm is everything in drawing the figure; it is the flow of the gesture. For specific drawing steps see Figure 12–12.

Bridgman in his classic book, *Bridgman's Life Drawing* states it perfectly:

Without rhythm there could be no poetry or music. In drawing and painting there is rhythm in outline, color, light and shade. (1961–34)

EXERCISE 12–6: *Continuous Line Gestures*

When drawing one-minute gestural sketches, draw in a continuous line without lifting your pencil or pen off of the page. Drawing with a fluid motion will help you understand the interconnectedness of the pose and its fluidity. Many beginners treat certain parts of the body, such as the head or hands, as more important than the figure as a whole. Drawing the figure with a continuous line will help eliminate the biases that hinder the flow of the composition and stifle its movement.

Try doing a continuous-line drawing while looking only at your subject and not at the paper. The more you look at the page the more you are fabricating from what you think a person should look like—and the key to drawing the figure is to realize that when you think you know, you don't know. You need to look at the figure because all the information is there.

EXERCISE 12–7: *Mass Studies*

Use a brush pen to draw quick studies of the mass of the figure. A brush pen has a fine tip marker on one end and a flexible nylon fiber brush tip on the other to make fine to bold strokes without changing pens. The brush pen allows

you to capture the mass more easily so you won't get hung up on the details. Try to capture the gesture of the movement and the mass of the silhouette in one- to three-minute sketches. These drawings can be done in the life session after you have warmed up with the gesture in the early poses. In this exercise you are not trying to create graded tone, only mass. You can also use this brush pen in the field when you are trying to capture quick movements of people in action.

EXERCISE 12–8: *Action Line Sketches*

Action line sketches can help you visualize the essence of movement, and are your very first impulse to the figure's movement. Quickly draw just the center lines, which indicate the motion of the body. These should be done very rapidly, in roughly 30 seconds. Action lines are only those lines that express the pure movement of the figure. If possible, practice this exercise where you can sit comfortably and watch people engaged in sports, such as basketball or baseball. Use your fountain pen and a small portable sketchbook.

Fashion Illustration

Study the quickness of fashion designers' illustrations. You can find fashion illustrations in the *New York Times Magazine*, women's fashion magazines, and the newspaper. These drawings are quite remarkable for the immense amount of physical information and drama conveyed with a few slashes of the pen. These expressive gestures can easily inspire with their evocative colors and textural combinations. Its not the amount of information you include in a drawing, it's the importance of the information. The old adage is often true: Less is more. It is useful to keep a file of the compositions that strike you. Collect those drawings that express a style you find attractive and want to keep for future reference.

Exercise 12–9: Fashion Illustration File

Create a file of fashion illustrations that catch your attention or spark your imagination. Practice copying them quickly either in pen or pencil, adding color with pastels. Write words that express the emotion of the drawing. Is the subject haughty? Angry? Calm? Then try to figure out what it is about the drawing that conveys emotion. Is it the tilt of the head? The small, timid stride? The next time you're trying to draw a figure, refer to these poses for help.

Exercise 12–10: Photographic Reference

Keep a photographic file of pictures of people and groups of figures doing a variety of tasks. These make excellent references for poses, clothing, and groupings; They can be reduced on a photocopier and cut and pasted together to study the composition of figures in groups. These collages can be created to convey certain moods, emotions, group dynamics, or certain attitudes.

FIGURE 12–13 *Annie Amundsen.*
Action Sketches. *Ink on paper.*

Conclusion

> *[One] should come to understand the body as a vital architecture. (Hill, 1966, 77)*

As a designer, figure drawing should become part of your life. After learning the basics, continue to draw from life. Try to make drawing models as an integral part of your life, either in model sessions or informally where ever you find interesting figures. Understanding the proportion of the human figure, its motion and beauty, is the essence of good design, and the study and drawing of the model should be a lifelong activity for the artist. It brings us back to the foundation of all the arts: the human form. In his book, *The Language of Drawing*, Edward Hill quotes Henry Fuseli on the figure:

> *It is to life we must recur—to warm, fleshy, genial life—for animated forms. (1966, 92)*

Composing the Final Drawing

*This synthesis is attained as the conclusion
of a process of gradual conquest, by way of study and practice,
through the acquisition of the essential.
It is an expression of simplification.*

GASPARE DE FIORE
Composing and Shading Your Drawings

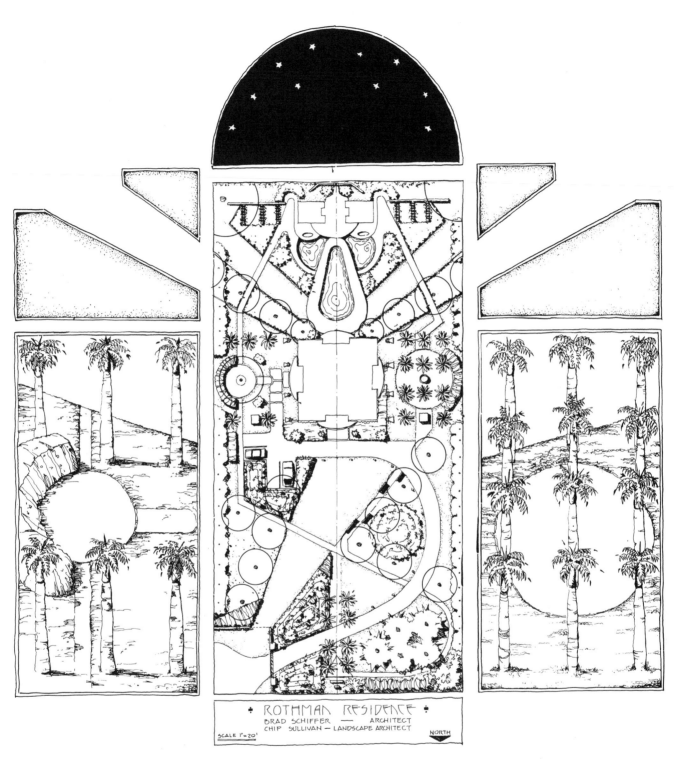

FIGURE 13–1 *Author. Pen and ink on paper. The final drawing captures the heart of your idea.*

The final stage of the drawing process is the most exciting, and you must give it everything you've got. This is the moment where drama and poetry become reality. The composition is an environment in which you choreograph every mark. You are orchestrating the finished drawing to hold the interest of the viewer. You want the viewer to interact with your

FIGURE 13–2 *Author. Rome Series, 1984. Pen and ink on paper. The finished drawing should be fully expressive and go beyond technical proficiency.*

vision. In a single drawing you capture the whole process of your design and the very heart of your idea. It is the completion of a creative cycle to which you impart life. Through this artistic birth, the work reaches beyond yourself, and is no longer under your control. It should be fully expressive and go beyond technical proficiency.

When you lay out the final drawing there should be no limitations for expression. The finished drawing should be a completed act of the organization and relationships of the forms in your design; therefore you must decide what pictorial device to use to convey what you have to say. How are the individual elements arranged on the page? How do you get everything into the drawing and stay in control?

The amount of time you spend on the final drawing should depend on its purpose and intent. All preliminary studies should be completed before beginning the final presentation. You will have to make key decisions on format and style. The final drawing is a synthesis. All the elements of your vision are harmoniously distributed and organized. You will approach this challenge with apprehension, anxiety, and excitement.

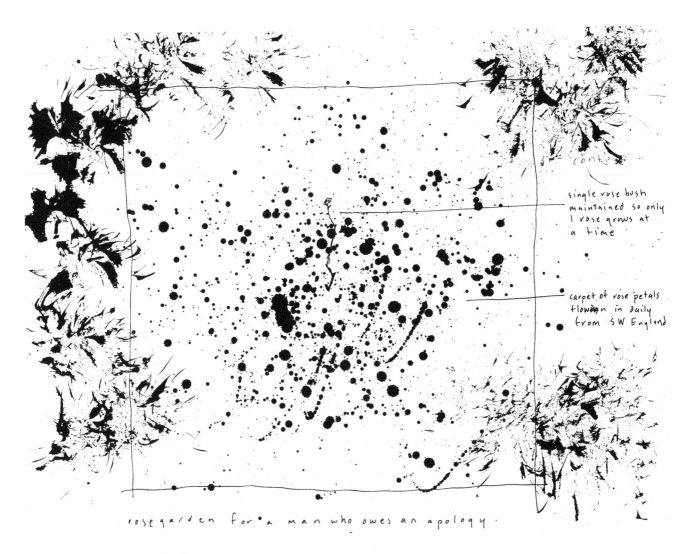

Within the figure (handwritten annotations):

context

single rose bush maintained so only 1 rose grows at a time

carpet of rose petals flown in daily from SW England

rose garden for a man who owes an apology.

FIGURE 13–3 *Chisel.* Man Who Owes an Apology. *Ink and brush on vellum. This drawing illustrates an innovative ink-splatter technique.*

The Mock-up

To produce this fusion, determine the page size. How will the drawing work with the proportions of the page? The page size is the framework that dictates the handling of its interior space. When laying out the final composition, begin with a series of thumbnail sketches and pin them up like a storyboard. Improvise and use your imagination. Stand back and pick out images that have the most visual impact. These can be enlarged to the final scale as mock-ups on tracing paper. Use photocopies, enlargements, and reductions to compose. The copy machine can be very useful for manipulating images to help you visualize the composition. Cut the copies up and move them around on tracing paper to study the figure-ground balance. It may be helpful to place a grid over the mock-ups to organize the space. Decide on how you want to organize the positive and negative spaces of the page. Just as the design must have a strong concept, so should the final composition. Will you be using a central focus, sequential or overlapping images, or a diagonal

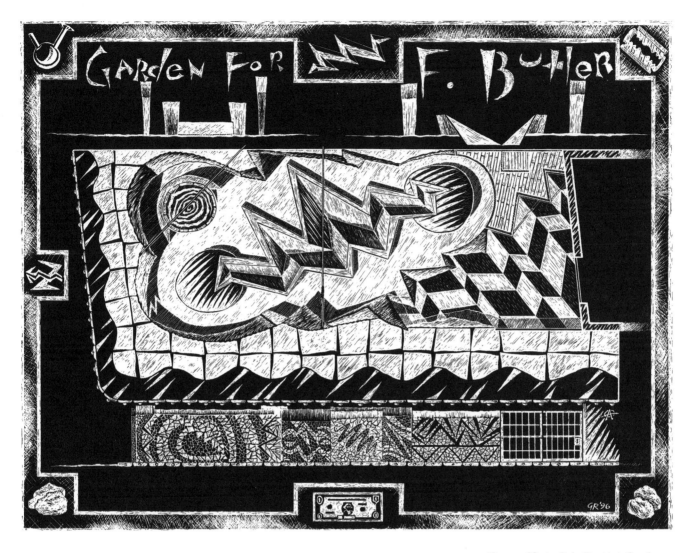

FIGURE 13–4 *Gabe Ruspini.* Garden for F. Butler. *This illustration is drawn on scratchboard, a heavy paper coated with a black layer. Black layer is scraped away to produce white lines.*

composition? For inspiration, look at the compositional page layouts of George Herriman's Krazy Kat and the intricate page layouts in Marvel Comics. Observe how borders are used as strong design elements. You will have to decide whether to use borders or allow the image to fade off to the sides. Borders can be quite elegant when integrated with drawn images.

Once the mock-ups are finished, pin them up and look at them from a distance. Turn them upside down and sideways. Look at them in a mirror. If they are well-composed they will look good from any direction. The pop artist Roy Lichtenstein has a special spinning easel so that he can paint an image upside down and on its side. Select the compositions that bring together all the concepts you've learned into an ordered, clear presentation. The last step is the selection of the media that will best illustrate the mood of your idea with strength and power. Don't be afraid to experiment with the mixing of various media. When working on the final drawing be sure to step back often to observe its impact. To help me judge a completed drawing I will leave it out overnight in my

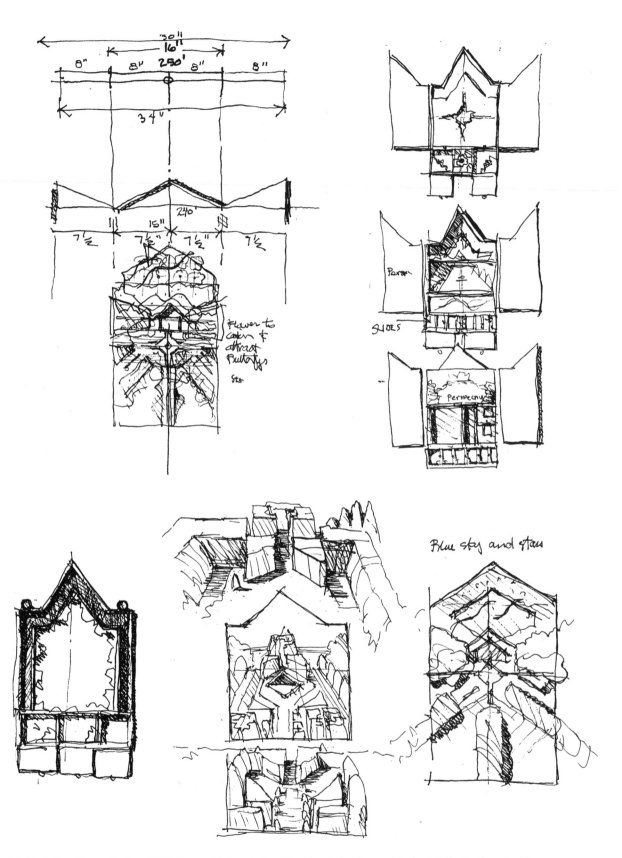

FIGURE 13–5 *Author.* Rome Series, *1984. Pen and ink on paper. Thumbnail sketches used to develop the final composition.*

FIGURE 13–6 *George Herriman. Krazy Kat. 1917. An example of wonderful compositions. (Courtesy Eclipse Books/Turtle Island Foundation)*

FIGURE 13–7 *Neal Adams. X-Men. 1969. An intricate page layout from Marvel Comics. (Permission to reprint X-Men granted by Marvel Comics. TM & © 1993 by Marvel Entertainment Group, Inc. All rights reserved.)*

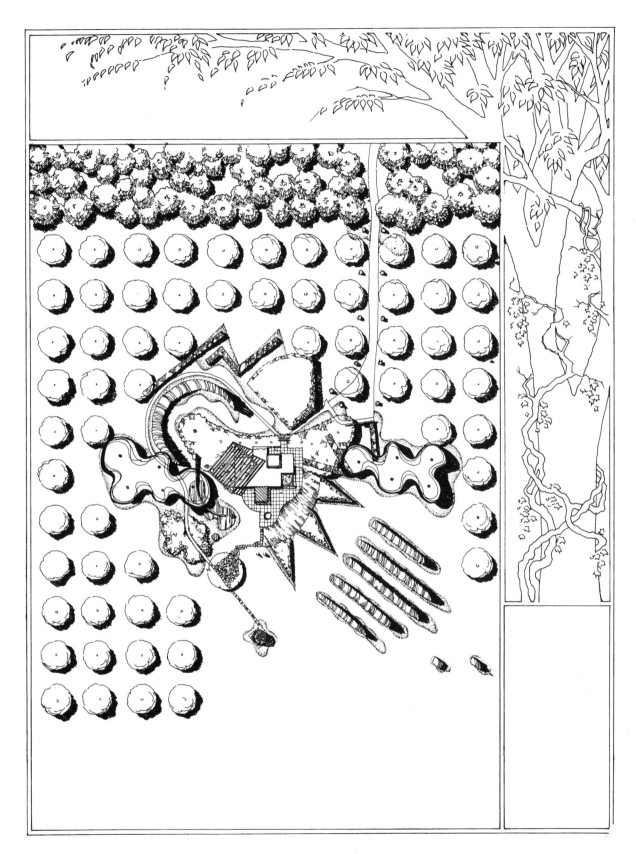

FIGURE 13–8 *Author.* Passive Garden. *1980. Pen and ink on paper. Borders integrated with the central image.*

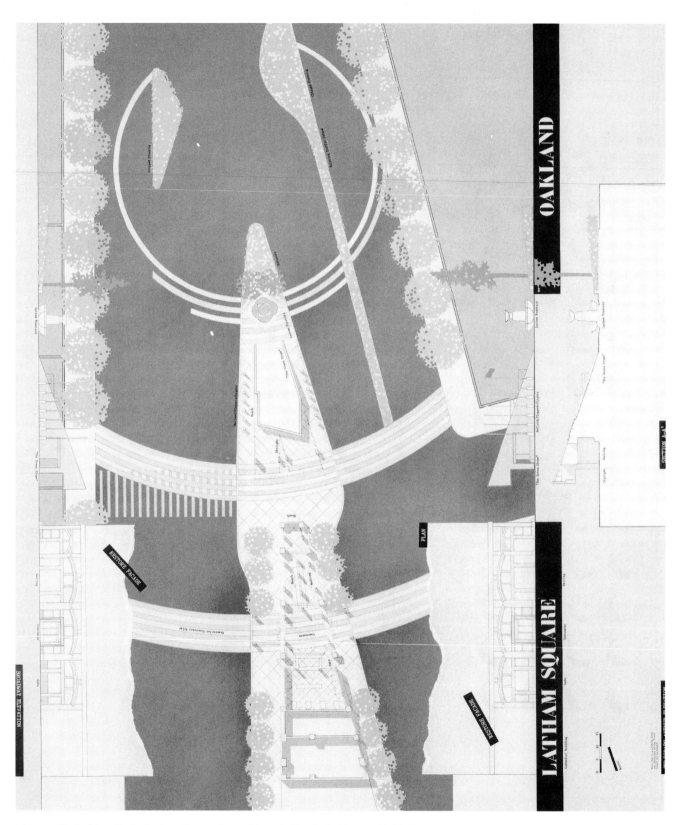

Figure 13–9 *Marc Treib. Latham Square Competition. Oakland, California, 1984. Cut and punched collage, Pantone paper and photostats on blackline print.*

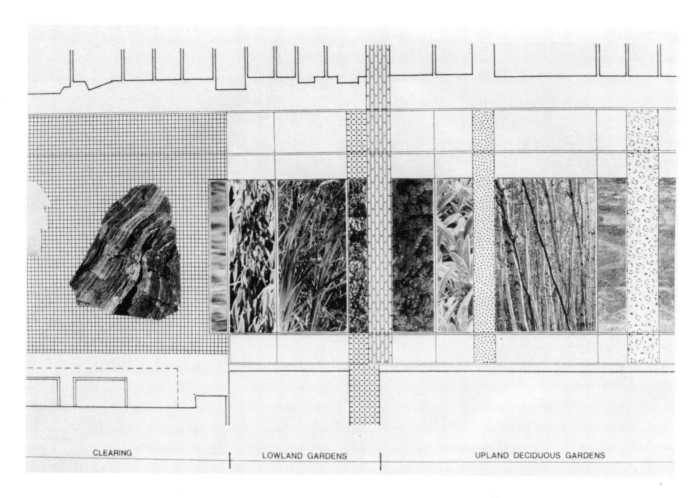

CLEARING LOWLAND GARDENS UPLAND DECIDUOUS GARDENS

studio. When I come into the studio the next morning, if I am startled, wondering where that unusual work came from, I know it's good!

FIGURE 13–10 *Ken Smith. Village of Yorkville Park, Toronto, 1991. Photocollage used to illustrate the landscape diagram.*

Lettering

Lettering can be a strong compositional element that reinforces the concept of the drawing. Decide what level of prominence you want your lettering to have in the drawing; do not allow it to detract from the image. The selection of typeface should correspond to the style of the drawing. Should it be elegant, bold, refined, or simple? The type style should also be consistent throughout the page or series. Another major decision to be made is whether or not the lettering will be done by hand. The Speedball Lettering Manual or any press-on type catalogs are a good source for lettering types. You can also cut letters out of magazines or newspapers and trace them onto the drawing. Type from catalogs can be enlarged or reduced and traced onto a drawing. Keep a file of type, lettering styles, and printed compositions that you find interesting. The Corbu stencils are extremely practical and useful in the creation of a variety of lettering styles. They can be outlined in pencil or ink, shaded, or darkened completely. The Corbu letters can also be employed as bold compositional images, and are an elegant addition to

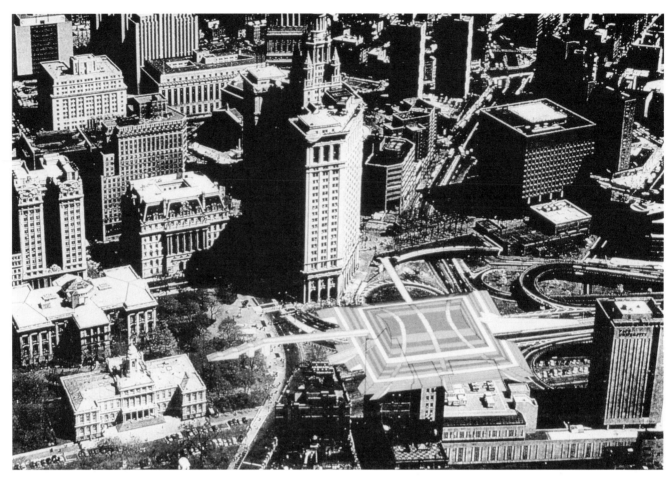

FIGURE 13–11 *Ken Smith,* Bridging the Gap, *First Prize, Brooklyn Bridge Competition, 1990. Photocopied enlargement of bird's-eye photographic view of site. The collage element is pen and ink on vellum, then transferred to a KP5 print, accented with color plastic film. 30" × 30".*

any drawing. They are extremely practical because they can be used again and again with simple hand tools.

A basic principle becomes evident over and over again, whatever technique is used—the original character of the sketch or preliminary drawing should not be lost. (Patrick Woodroffe 1986, 31)

The Competition Drawing

Competition drawings differ from ordinary presentation formats in that they have to stand alone. Basically, you don't have the opportunity to present competition drawings; they have to present themselves. There are two kinds of competitions, the invited competition and the open competition, and they require different types of drawings. In the invited competition you compete with four or five invited designers. In this kind of competition your entry should be treated as an all-out schematic design with specific information and detail. The other, more common type of competition is called an open competition; it might receive anywhere from 200 to 500 entries. For these competitions you are often limited to one or two 30-by-40-inch boards in a defined format that requires specific drawings and text.

FIGURE 13–12 *Topher Delaney. Delaney & Cochran. Greg Taylor Garden. Mixed media. 32" × 23".*

Landscape architect Ken Smith has been successful in competitions and has won several first prizes. He has some very good advice for competition presentations based on his experience in practice in New York City, and as an adjunct professor in the Urban Landscape Architecture Program at the City College of New York. Smith is also a visiting design critic at several schools, including Harvard Graduate School of Design and the University of Virginia. Following are some of his suggestions for creating visually powerful competition entries.

Since the jury usually convenes for only about four hours, you have to get your idea across to them very quickly. The real challenge is to express your ideas clearly enough to communicate your design concept in about fifteen seconds. Smith uses two tests to see if he thinks his boards will make it past the first cut and into the more intensive second round.

First, your boards must read from across the room; in other words, they have to get the jury's attention! Second, your main idea has to jump off the page by being bold, unique, and exciting.

Once you've made it to the second round, the design and presentation have to have enough depth to hold up under closer inspection. In other words, your entry has to be more than just a "one liner." The jury will usually select 15 to 20 percent of the entries for the second round. Don't put a lot of text on your board; the jury doesn't have the time to read detailed descriptions. Try and anticipate what questions the jury will be asking, and include that information graphically and in concisely written statements. The text should emphasize only the main points of the design, the key concepts or phrases. Also, the text should not be in a large single block, but spread out over the sheet to illuminate key points while balancing with the imagery.

Smith likes to use the collage technique as a graphic device, because it is flexible and quick. Instead of redrawing elements, you can save time

by photocopying photographs or existing drawings. In the competition process, time is usually of the essence. Try not to use time-consuming graphic techniques. Go for your strengths.

Competition entries have to have two levels of information: a quick, clear, exciting graphic representation of your idea, and easy-to-grasp information for closer inspection.

Experimental Media: A Gallery of Ideas

As drawing becomes more challenging you must continue to push into new realms of expression. When you reach a creative plateau you may find it helpful to merge the boundaries between different media.

FIGURE 13–13 *Maria McVarish.* The Story of Architecture. *Mixed media.*

Collage

As mentioned earlier, the collage is a wonderful way to integrate into a drawing a diversity of collected materials. Recycling materials from another time and place and using them out of context in a new work gives them new meaning. If you wish to make collages you must build up a supply of images. Always be on the lookout for interesting images and keep them in a file for later use. Carefully cut out the image you want to use with an X-Acto knife so that when it is placed on the drawing the edges appear seamless. To attach the collage to the drawing surface, mix glue with water, and paint on a thin coat. Acrylic matte or gloss medium can also be used to fix the work. In a photomontage you can enlarge a photo of a landscape and collage a drawn image onto it to create a very realistic effect. Photomontage can help you to understand how the completed design will look in the landscape, and it can also be used to produce some very surrealistic effects.

Three-Dimensional Constructions

Assemblage is combining found objects into a three-dimensional environment. With this technique one can develop very evocative presenta-

FIGURE 13–14 *Author.* Passage to Algiers. *Mixed media, box construction. A landscape diorama placed inside a box creates a miniature environment. (Photo: Steven Brooks)*

FIGURE 13–15 *Author. Mixed media. Folding screens illustrate landscape as a sequence of views. (Photo: Steven Brooks)*

FIGURE 13–16 *Author. Pop-up book as a delightful and humorous way to portray design. (Photo: Steven Brooks)*

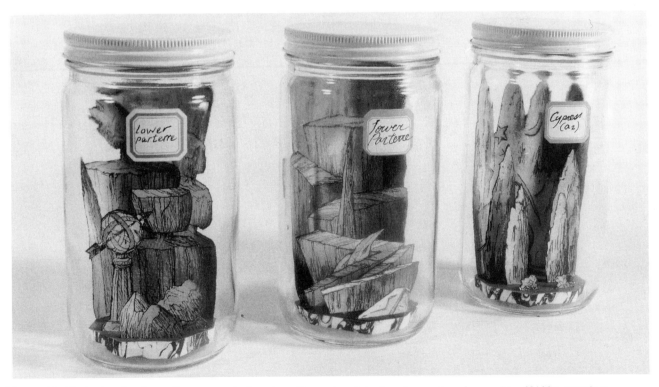

FIGURE 13–17 *Author. Landscape Preserves as specimen jars. Unusual contained environments evoke a variety of hidden meanings. (Photo: Steven Brooks)*

FIGURE 13–18 *Dante Sullivante. Cypress trees in cigar case illustrating the potential range of expression. (Photo: Steven Brooks)*

tions. Landscape dioramas placed inside boxes create miniature environments that are fun to look at. This type of 3-D landscape can really focus the viewer's attention. Another advanced style of presentation is the folding screen. On a folding screen you can illustrate the landscape as a sequential series of views. Both sides of the screen can be used. A hand made pop-up book can be a delightful and humorous way to portray landscapes. A jar can also be used to contain miniature landscapes or garden elements. Such unusual contained environments can be used to evoke a variety of messages about landscape.

These are just a few ideas about the potential range of expression you can use to project a vision. Whatever media you use, it is important to be very clear about the statement you wish to make. Complete your drawing with honest and clear purpose. A philosophical position is necessary for those who undertake any worthy artistic presentation. Although it's difficult at times, always follow your intuition.

Without intuition, the artist is incapable of producing art in the highest circle, where the secretive begins and where the intellect lamentably expires. (Klee 1964, 57)

FIGURE 13–19 *Maria McVarish.* Learning. *Mixed media, hinged book.*

Conclusion

Thus the world of drawing belongs not only to the great artists,
but also to the rest of us who draw what we see in reality or our minds,
or who use it daily to solve practical problems.

GASPARE DE FIORE
Composing and Shading Your Drawings

FIGURE 14–1 *Author.* A Meteor Named Vince. *Ink on watercolor paper.*

More than anything else, you should draw for the pure enjoyment and love of it. The present diversity of techniques, media, styles, and philosophies in landscape architecture has opened up many possibilities in the drawing arena. Drawing is not just a technique, it is also a fulfilling, creative way of life. Though the boundaries between the arts merge and vanish, the landscape remains in need of continual artistic attention. The design of landscapes can be an art form. Through drawing you interpret the surrounding environment and give your vision form. It is my hope that this book will inspire you not just to draw, but also to invent creative solutions to improve the quality of life and restore the environment. The secret of drawing is to bring life to an image or idea.

Hence, for these and other reasons which might be given, first strive in drawing to represent your intention to the eye by expressive forms, and the idea originally formed in your imagination; then go on taking out or putting in, until you have satisfied yourself. (Richter 1970, 252)

—*Leonardo da Vinci*

FIGURE 14–2 *Author.* Chinese Take-out Gardens. *Pen and ink and watercolor on watercolor paper.*

References

ALBERTI, *Treatise on Painting* London, England: Penquin Books Ltd.

ANDERSON, DONALD M. *Elements of Design.* New York: Holt, Rinehart and Winston.

ARNHEIM, RUDOLF. 1969. *Visual Thinking.* Berkeley: University of California Press.

BAIGELL, MATTHEW. 1976. *Charles Burchfield.* New York: Watson-Guptill Publications.

BAUR, JOHN I. H. 1956. *Charles Burchfield.* New York: The MacMillan Company.

BENDER, TOM. 1973. *Environmental Design Primer.* Minneapolis, Minn.: Tom Bender, Publisher.

BERGER, JOHN. 1985. *The Sense of Sight.* New York: Pantheon.

BLUNT, ANTHONY. 1979. *The Drawings of Possin.* New Haven, Conn., and London: Yale University Press.

BRADSHAW, P. 1964. *The Magic of Line.* New York: New York Studio Publications.

BRAMLY, SERGE. 1991. *Leonardo: Discovering the Life of Leonardo da Vinci.* New York: HarperCollins.

BRIDGMAN, GEORGE B. 1961. *Bridgman's Life Drawing.* New York: Dover Publications, Inc.

BYNE, ARTHUR, and MILDRED BYNE. 1924. *Spanish Gardens and Their Patios.* New York: J. B. Lippencott Co.

CALFRITZ, ROBERT C., LAWRENCE GROWING, and DAVID ROSS. 1988. *Places of Delight: The Pastoral Landscape.* New York: Clarkson H. Potter, Inc.

CALHILL, JAMES. 1977. *Chinese Painting.* New York: Rizzoli International Publications.

CARLSON, JOHN E. 1958. *Carlson's Guide to Landscape Painting.* New York: Dover Publications Inc.

CASSADY, CAROLYN. 1990. *Off the Road: My Years With Cassady, Kerouac and Ginsberg.* New York: Penguin Books.

CHADWICK, WHITNEY, and ROBIN SCHARIFMAN, eds. 1993. *Significant Others: Creativity and Intimate Partnership.* London: Thames & Hudson, Ltd.

CHAET, BERHARD. 1979. *An Artist's Notebook: Techniques and Materials.* New York: Holt, Rinehart and Winston.

CHAMBERS, BRUCE W., ET AL. 1978. *Charles Burchfield, the Charles Rand Penney Collection.* Catalog of the Smithsonian Institution Traveling Exhibition Service.

CHING, FRANK. 1975. *Architectural Graphics.* New York: Van Nostrand Reinhold, Inc.

CHIPP, HERSCHEL B. 1974. *Theories of Modern Art: A Sourcebook for Artists and Critics.* Berkeley: University of California Press.

CLARK, KENNETH. 1976, 1979. *Landscape Into Art.* New York: Harper & Row.

COLE, VICATE REX. 1965. *Perspective for Artists.* New York: Dover Publications, Inc.

COOLIDGE, CLARK, and PHILIP GUSTON. 1991. *Baffling Means.* Stockbridge, Mass.: o-blek editions.

CRUMB, R. 1992. *Sketchbook, Volume 1 and 2,* Seattle, Wash.: Fantagraphics Books.

DA VINCI, *The Notebooks of . . . Leonardo on Painting*

———. 1983. *Composing and Shading Your Drawings.* New York: Watson Guptill Publications.

———. year? *Learning to See and Draw: The Drawing Course, Volume I.* Gruppo E Ditoriale Fabbri, SpA Milano.

DILLARD, ANNIE. 1989. *The Writing Life.* New York: HarperCollins.

FARRIS, EDMOND J. 1961. *Art Students' Anatomy.* New York: Dover Publications, Inc.

FINCH, CHRISTOPHER. 1979. *The Art of Disney.* New York: Harry N. Abrams, Inc.

FLACK, AUDREY. 1986. *Art and Soul.* New York: E. P. Dutton.

FRAYLING, HELEN, and CHRISTOPHER VAN DEN. 1992. *The Art Pack.* New York: Alfred A. Knopf.

FRENCH, THOMAS E. 1924. *A Manual of Engineering Drawing for Students and Draftsmen.* New York: McGraw-Hill Book Company Inc.

GARFIELD, PATRICIA. 1974. *Creative Dreaming.* New York: Ballantine Books.

GILOT, FRANCOISE. 1990. *Matisse and Picasso: A Friendship in Art.* New York: Anchor Books.

GOLDSCHEIDER, LUDWIG. 1966. *Michelangelo Drawings, 2nd revised edition.* London: Phaidon Press.

GOLDSTEIN, NATHAN. *The Art of Responsive Drawing.* Englewood Cliffs, N.J.: Prenctice-Hall.

GRIFFIN, BILL. 1990. *Waiter Get Me a Table Without Flies.* Seattle, Wash.: Fantagraphics Books.

GUPTILL, ARTHUR. 1930. *Drawing with Pen and Ink: And A Word Concerning the Brush.* New York: The Pencil Points Press Inc.

GUPTILL, ARTHUR. 1977. *Rendering in Pencil.* Susan Meyer, ed. New York: Watson-Guptill Publications.

HADEN, DETLEV, FREICERR VON. *The Drawings of G.B. Tiepolo. 2 vols.* New York: Harcourt, Brace and World Inc.

HALPRIN, LAWRENCE. 1972. *Lawrence Halprin—Notebooks 1957–1971.* Cambridge, Mass.: MIT Press.

HARBISON, ROBERT. 1977. *Eccentric Spaces.* New York: Avon Books.

HENRI, ROBERT. 1923. *The Art Spirit.* Philadelphia: J.B. Lippencott Company.

HILL, EDWARD. 1966. *The Language of Drawing.* Englewood Cliffs, N.J.: Prentice-Hall Inc.

HOFMANN, HANS. 1948, 1967. *The Search for the Real.* Sara T. Weeks and Bartlett H. Hayes Jr., eds. Cambridge, Mass.: MIT Press.

HOFFPAUIR, STEPHAN, and JOYCE ROSHER. 1989. *Architectural Illustration in Watercolor: Techniques for Beginning and Advanced Professionals.* New York: Whitney Library of Design, Watson-Guptill Publications.

HUBBARD, HENRY VINCENT, and THEODORA KIMBALL. 1959. *An Introduction to the Study of Landscape Design.* Boston: Hubbard Educational Trust.

JARDOT, MAURICE. 1959. *Pablo Picasso Drawings.* New York: Harry H. Abrams, Inc.

JOHNSON, JOYCE. 1983. *Minor Characters: The Romantic Odyssey of a Woman in the Beat Generation.* New York: Pocket Books.

JONES, EDITH H., ed. 1968. *The Drawings of Charles Burchfield.* New York: Frederick A. Praeger in association with the Drawing Society.

KANDINSKY, WASSILY. 1977. *Concerning the Spiritual in Art.* New York: Dover Publications.

KAUFMAN, EDGAR. 1955. *An American Architecture.* New York: Horizon Press Inc.

KEROUAC, JACK. 1955 and 1957. *On the Road.* New York: Signet.

KLEE, FELIX, ed. 1964. *The Diaries of Paul Klee 1898–1918.* Berkeley: University of California Press.

KOBERG, DON and JIM BAGNALL. 1976. *The All New Universal Traveler.* Los Altos, CA: William Kaufmann, Inc.

LERUP, LARS. 1987. *Planned Assaults.* Montreal: Canadian Centre for Architecture.

LEVEY, MARK. 1993. *Technicians of Ecstasy: Shamanism and the Modern Artist.* Norfolk, Conn.: Bramble Books.

LOCKARD, WILLIAM KIRBY. 1982. *Design Drawing.* Tucson, Ariz.: Pepper Publishing.

MALTIN, LEONARD *Of Mice & Magic: A History of American Animated Cartoons.*

MAYER, MUSA. 1988. *Night Studio: A Memoir of Philip Guston.* New York: Penguin Group.

MAYER, RALPH. 1948. *The Painter's Craft.* Middlesex, England: Penguin Books.

McKIM, R. 1972. *Experiences in Visual Thinking.* Monterey, Calif.: Brooks/Cole Publishing Co.

MENDELOWITZ, DANIEL M. 1967 and 1976. *A Guide to Drawing.* New York: Holt, Rhinehart and Winston.

NICOLAIDES, KIMON. 1941. *The Natural Way to Draw.* Boston: Houghton Mifflin Company.

NICOSIA, GERALD. 1983. *Memory Babe: A Critical Biography of Jack Kerouac.* Middlesex, England: Penguin Books Ltd.

OCVIRK, OTTO G. ET AL. 1975. *Art Fundamentals, Theory and Practice.* Dubuque, Iowa: Wm. C. Brown Company.

OPPE, A.P. 1954. *Alexander and John Robert Cozens.* Cambridge, Mass.: Harvard University Press.

PEDRETTI, CARLO. 1980. *Leonardo da Vinci: Nature Studies from the Royal Library at Windsor Castle.* Florence, Italy: Johnson Reprint Corporation.

POPHAM, A. E. 1945. *The Drawings of Leonardo da Vinci.* New York: Reynal and Hitchcock.

RICHTER, JEAN PAUL, ed. 1970. *The Notebooks of Leonardo da Vinci.* New York: Dover Publications Inc.

RIMMER, WILLIAM. 1962. *Art Anatomy.* New York: Dover Publications, Inc.

ROTH, ED. 1992. *Confessions of a Rat Fink.* New York: Pharos Books.

ROTHLISBERGER, MARCEL. 1968. CLAUDE LORRAIN: THE DRAWINGS, 2 VOLS. Berkeley and Los Angeles: University of California Press.

SAMUELS, MIKE, AND NANCY SAMUELS. 1975. *Seeing with the Mind's Eye: The History, Techniques and Uses of Visualization.* New York: Random House Inc.

SHLAIN, LEONARD. 1991. *Art and Physics: Parallel Visions in Space, Time and Light.* New York: William Morrow & Company Inc.

TAYLOR, JOHN. 1964. *Design Expression in the Visual Arts.* New York: Dover Publications.

TURNER, RICHARD, A. 1966. *The Vision of Landscape in Renaissance Italy.* Princeton, N.J.: Princeton University Press.

VANDERPOEL, JOHN H. 1958. *The Human Figure.* New York: Dover Publications, Inc.

WATTS, ALAN. 1957. *The Way of Zen.* New York: Alfred A. Knopf, Inc.

WESCHLER, LAWRENCE. 1982. *Seeing Is Forgetting the Name of the Thing One Sees: A Life of Contemporary Artist Robert Irwin.* Berkeley: University of California Press.

WHEELER, ARNELL, and BUCKFORD WHEELER, eds. 1982. *Michael Graves Projects and Buildings 1966–1981.* New York: Rizzoli.

WIEL, MORETTO, and AGNESE M. CHIARI. 1990. *Titian Drawings.* New York: Rizzoli.

WOODROFFE, PATRICK. 1986. *A Closer Look: The Art Techniques of Patrick Woodroffe.* Limpsfield, Surrey, Great Britain: Dragon's World Ltd.

Index